Painting Nature's Hidden Treasures

Painting Nature's Hidden Treasures

by Zoltan Szabo

WATSON-GUPTILL PUBLICATIONS/NEW YORK

I am the product of all the blessings I have received in Canada,
my home country and in the United States, my new country.
 After my dear parents had raised and educated me, I had to leave
the uncertain future in my homeland, Hungary.
 To you, the people of these two wonderful lands who so generously
offered all the opportunities of my adult life, I dedicate this work.

Acknowledgement

I wish to offer my gratitude to Don Holden for his untiring interest,
support and friendship during the past twelve years.
 To Christine Wright my dear friend and assistant who's help with the
text and typing of all five of my books contributed so much to their success.
 To Marsha Melnick, Bob Fillie, and Marisa Bulzone who made sure that this
book looks beautiful too.
 To my little Linda for her patient encouragement during the lean months
of production. We have dreamed together about this book. Now that it has
come through she is as much a part of it, emotionally, as I am.

Paperback Edition
First Printing, 1987

First published 1982 in New York by Watson-Guptill Publications,
a division of Billboard Publications, Inc.,
1515 Broadway, New York, N.Y. 10036

Library of Congress Cataloging in Publication Data
Szabo, Z. G.
 Painting nature's hidden treasures.
 Bibliography: p.
 Includes index.
 1. Landscape painting—Technique. 2. Water-color
painting—Technique. I. Title.
ND2240.S94 1982 751.42'243 82-11145
ISBN 0-8230-3723-1 (Pbk.)
ISBN 0-8230-3722-3

Published simultaneously in Canada
by General Publishing Co. Limited
30 Lesmill Road, Don Mills, Ontario, Canada

Manufactured in Japan

CONTENTS

INTRODUCTION

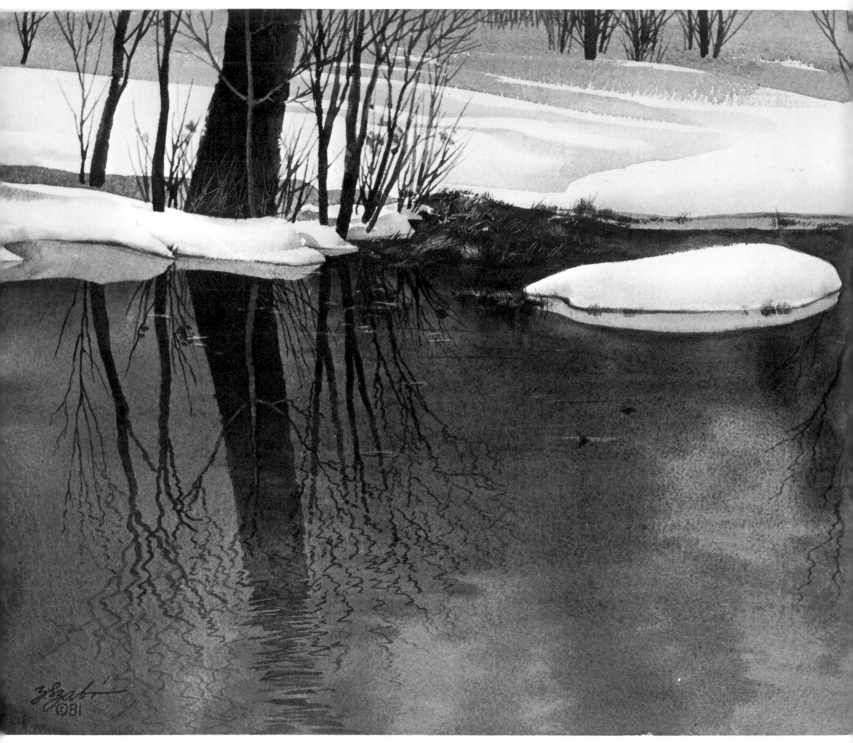

Melting Mirror. Bare, winter trees, silhouetted against the snow and reflected in the icy water, create a beautiful design for a closeup. The actual subject was cluttered with detail, but I've reduced the number of trunks and branches. I've also simplified the shapes of the snowdrifts and the shadows on the snow. In the snowy background, I've reduced the contrast of values to make the dark trunks and branches stand out more sharply. The pattern of the reflections is particularly fascinating. *Melting Mirror* is 15″ x 22″ (38x56 cm).

My purpose in writing this new book is to open the door to a new and fascinating realm—a whole new world of subject matter that too many watercolorists overlook. In the process of painting all those awe-inspiring panoramas, we often pass by countless numbers of small, magical subjects that are hidden in the quiet corners of nature. The delicate tracery of weeds in the snow, the charming shapes and colors of wildflowers nestled among rocks, the pattern of the cracks in a tree stump or a boulder—all are less obvious than the grandeur of a sunset. Yet these intimate glimpses of natural beauty have extraordinary poetry. They're often hidden, but they're all around us, waiting to be discovered by the curious and searching eyes of the artist.

I often use a new phrase to describe these intimate closeups of nature: I enjoy calling them *live stills*. As the phrase indicates, a *live still* is the opposite of a *still life*. The traditional still life is a small collection of objects, all assembled, composed, and lit in the artist's studio. Conversely, a live still is something that nature has assembled, composed, and lit in the quirky, accidental way that nature does best. The elements of the live still are untouched by the human hand, and illuminated by natural light. The subject takes on a unique kind of life because it's part of the environment, rather than a studio setup.

In the pages that follow, I'm going to show you how I paint the closeups of nature that I call live stills. I'll explain my techniques and my working methods in detail. But there's something even more important: I hope that I can communicate the emotional impact that makes such paintings so haunting and so challenging to the many artists who are beginning to discover this new approach to watercolor. These emotions are beyond words. They're hidden between the brushstrokes.

As you'll soon see, *Painting Nature's Hidden Treasures* is essentially a series of step-by-step demonstrations in full color. But before I begin these demonstrations, I'll try to make some helpful suggestions about how to select and record various subjects in sketches and photographs. I'll show you how I reorganize, sim-plify, and dramatize the subjects I've recorded in the sketches and photos—so that the final painting is far removed from these preliminary studies. I'll make a few suggestions about painting equipment, but I'm going to assume that you already have the basic tools for watercolor painting, perhaps following the recommendations I've made in my earlier books. And this introductory section will close with some tips about painting various kinds of closeups. You'll find a page of tips on each of the following subjects: light and shadow, forest closeups, the patterns in water, winter closeups, flowers in their natural surroundings, nature's abstractions (the surprising designs created by natural phenomena), closeup subjects found around the house, and painting a *series* of pictures, each of which takes a different look at the same subject.

From this point on, you'll look over my shoulder as I paint forty step-by-step demonstrations, with every step reproduced in color. The demonstrations will be grouped in the same way as those pages of painting tips. That is, you'll watch demonstrations that focus on light and shadow, forest subjects, water, winter, flowers, nature's abstractions, subjects found around the house, and painting a series.

As you turn these pages, I think you'll be particularly interested in the many full page details of the finished paintings, as well as the various steps in the process. These segments of the actual painting will be reproduced as close as possible to lifesize, giving you the opportunity to study the pages of the book as if you're looking at the actual paintings in progress.

However, as you turn these pages, I'm sure you'll see that I have a hidden intention, which goes beyond merely teaching the techniques of painting closeups. I hope to entice you to pick up the brush and paint your own discoveries—*live stills* in your own personal way. If you're willing to let your heart and soul—not just your hand—control your brush, painting closeups will not only give you a whole new range of subject matter for your watercolors, but will add a whole new emotional dimension to your work. For as you explore the hidden treasures of nature, you also explore the hidden riches of your own creative personality.

SELECTING AND RECORDING YOUR SUBJECT

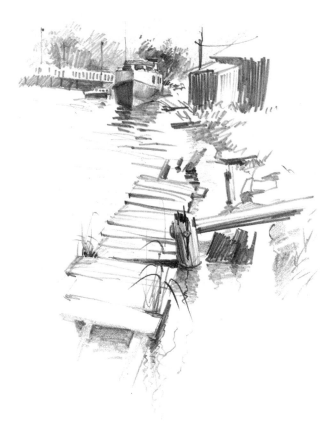

It's a lucky day when a visual image, or an idea for a painting, pops into your mind out of a clear, blue sky. But it's far more likely that a visual brainstorm will be triggered by something that you actually see. You've got to *hunt* for a subject.

I go out to find a subject as I might conduct a hunting trip. But I'm never really sure what I'm hunting *for*! I don't start out by deciding what subject I'm after. I start with an open mind and I look for anything that excites me. *Anything!*

I drive to an area where the mood looks right and then I get out of the car. I take a slow walk and I study everything around me—right, left, up, down, ahead, and particularly behind.

Anything may trigger an idea for a painting. A beam of light may do it, perhaps a half-buried shell, maybe a clump of snow on a dried-up Queen Anne's lace, or possibly a muddy tire mark. I may have passed these spots indifferently many times before, but I know that each time is different. I search with a hungry mind, knowing that God has walked there before me and left behind some little jewel that's ready to present itself—if I can only see it.

I look for shapes, not things. These shapes can be objects, patches of light, patterns of shadow, or any shape that has a sudden emotional impact. My eyes stop first at the largest shapes of the subject. I relate these shapes to each other, as well as to the total area that will be shown in my painting.

I imagine that I'm looking through a window that encloses my subject. (Some artists actually make a window with their fingers or with a cardboard viewfinder.) When I know the shape of the window, I can decide the proportions of my paper, and I know whether the painting will be horizontal or vertical. Naturally, I may change my mind later on, when I'm planning my composition more precisely.

Searching for shapes means searching for both positive and negative shapes. The simplest way to define negative shapes is to say that they're the spaces between and around the objects you're painting. When you paint a tree, the spaces between the branches are just as important as the branches themselves.

I start to plan a painting by making a sketch, taking a photo, or both. When I want to do a particularly thorough job, I begin with a Polaroid photograph (usually in black-and-white) that records conditions of light, shadow, and atmosphere, which often change in minutes. After I shoot the Polaroid, I make a pencil sketch. Because I have the Polaroid as a backup, I can be bolder with the pencil and I can concentrate on shapes and values, rather than details. My final composition begins with this sketch.

I generally sketch with a wide graphite stick that has a rectangular tip; 6B is my favorite. The graphite stick can put down broad areas of tone in a jiffy. And the sharp corner of the stick can indicate precise details.

LEFT
Broken Pier. The foreground details—the broken shapes of the old pier and the reflections—are the focal point of the sketch. But I took time to record the background details because I wanted to *suggest* them in the painting.

BELOW
Old Maple and Fence. In this pencil sketch, I was particularly interested in the contrast of the static and dynamic elements: the straight shapes of the split rail fence moving across the lively, irregular shapes of the old treetrunk.

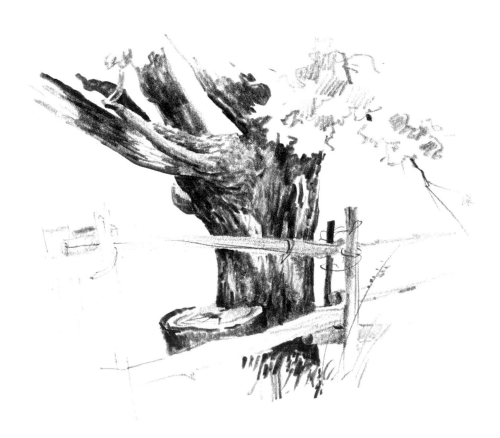

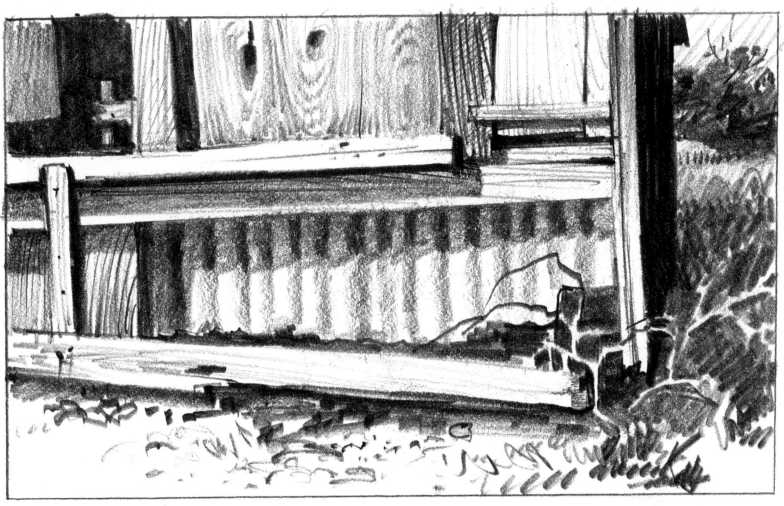

Patched-up Building. I was challenged by the varied textures of old and new wood, corrugated tin, and gravel, enlivened by a few weeds and bare shrubs in the lower right. My pencil sketch attempts to catch the contrast of bright sunlight and deep shadow, giving depth to a subject that would look flat without this strong, natural lighting effect.

The camera will record visual effects that can't be captured in any other way because time is passing too quickly. But the camera must be your slave, not your master. It's nothing more than another reference tool. Simply copying photographs is pointless. The goal is to transform the impersonal, objective photograph into something that's really yours—and fundamentally different from the image on the film.

Most often, I prefer black-and-white Polaroid pictures. The film is so light sensitive that I can take detailed shots in very dim light. Now and then I take Polaroids in color, but the quality of the color is disappointing and the film is expensive. At best, a color Polaroid is a rough reminder of the color of the scene, but I must rely on my memory for the final color effect in the painting.

You can take more perfect pictures with the most modest *35mm single-lens-reflex* camera, which will produce beautiful color slides or prints. I can compose my painting as I look through the bright window of the viewfinder. Exactly what I see in the window will appear in the photo.

When I paint my nature closeups, texture is particularly important. The 35mm SLR has an incredible ability to reproduce textures in clear detail. But the wonderfully sharp definition of the photo can be dangerous. Restraint is essential: what you leave out of a painting is just as important as what you put in. Don't get carried away and record every textural detail that you see in the photo.

After I finish the painting, I find one other important function for my Polaroid camera. I take a black-and-white Polaroid of the finished painting to check my values. The colors in the painting can sometimes fool the artist's eye, but a black-and-white shot instantly reveals the flaws. And sometimes it's helpful to shoot a black-and-white Polaroid while the painting is in progress—if only to confirm that I'm on the right track.

SELECTING AND RECORDING YOUR SUBJECT

Photograph. I took this little photo of a Hawaiian beach to record the values. Hawaii is so flooded with color that a black-and-white snapshot gave me a convenient way to clarify the light and dark shapes.

Pencil Sketch. The pencil study emphasizes the sweeping design of the tire marks in the foreground. You can see the swift strokes of the graphite stick in the surf, the rocky point, and the windblown trees. Since the snapshot would supply the details, the sketch focuses on the dark and light shapes. I've redesigned the foreground and the pattern of the water.

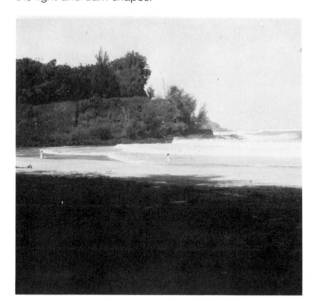

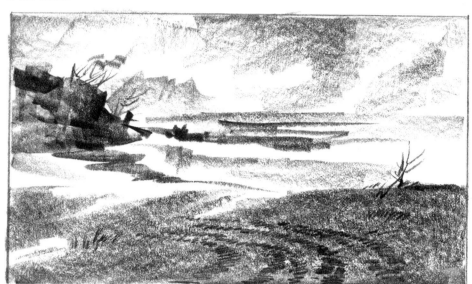

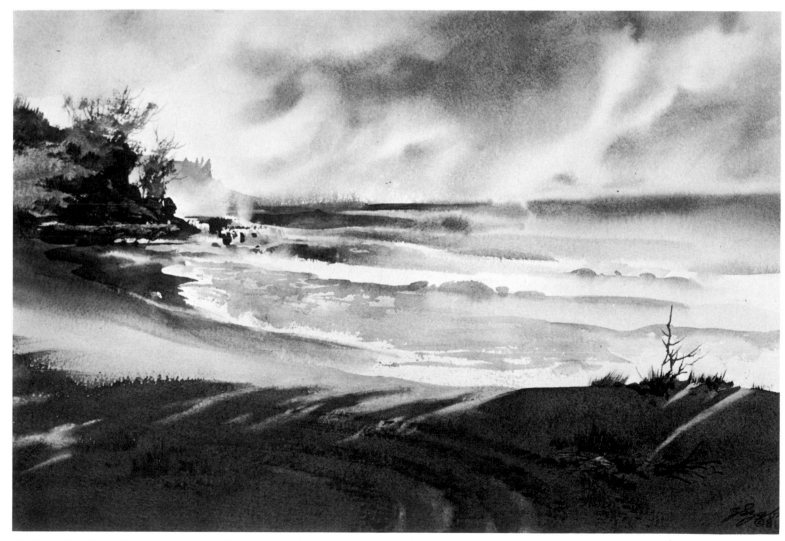

Finished Painting. The closeup view of the foreground creates a frame for the distant sea. The foreground shapes are essential because they lead your eye into the picture. First you read the large shadow and then you see the subtly-textured tire marks in the shaded sand. It should be obvious that the painting is very different from the snapshot. I've introduced more action into the water and I've invented a turbulent sky. *Kauai Shore* is 15″ x 22″ (38x56 cm).

Photograph. The snapshot is swimming in sunlight and casting complicated shadows. There's too much detail in the photo, but I know that I can simplify the subject and eliminate a lot of detail in the finished painting.

Pencil Sketch. Now the shapes are simpler and there's a lot less detail. There's one large shadow shape, and the light on the snow and on the shrub serve to link the picture together. There are fewer darks, carefully located to provide accents. Notice how I've eliminated a lot of foreground detail and also reduced the size of the dark, fallen tree in the upper right.

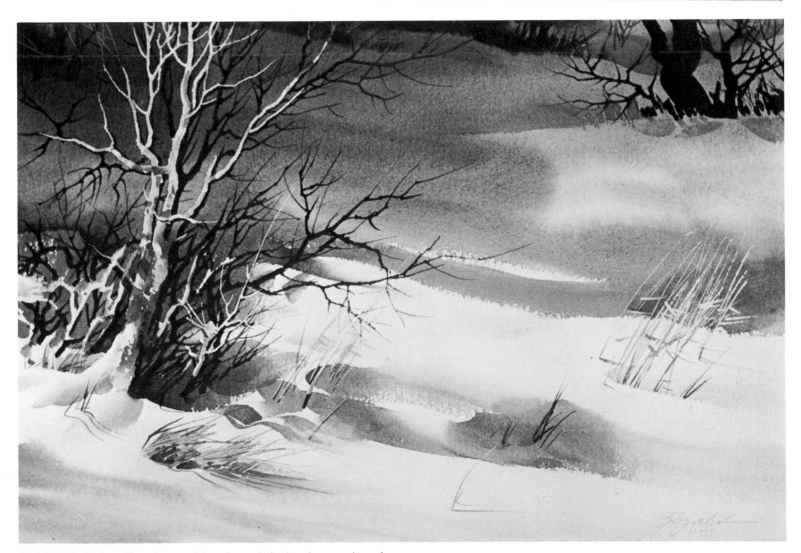

Finished Painting. The drama of the picture is in the closeup view of the brilliant, sunlit shapes of the trunks and branches, contrasting with the shadows at the base of the trees and beyond. I've minimized the darks in the background even more than I did in the pencil sketch. *Integrated Friends* is 15″ x 22″ (38x56 cm).

SELECTING AND RECORDING YOUR SUBJECT

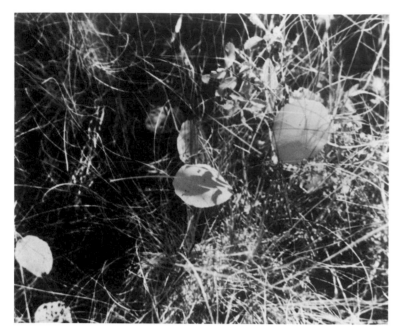

Photograph. I must admit that this is a pretty unpromising photograph. Those few fallen aspen leaves in the grass don't look like much of an idea, but I was struck by the way the sun hit those little jewels. They suggested an autumn picture, rich in color, full of warmth, with a rhythmic, linear design that doesn't really appear in the snapshot—but I felt that I could invent it!

Finished Painting. I didn't make an on-the-spot pencil sketch, but dove straight into the final painting. Except for the shapes of a few leaves, there's practically nothing in the painting that comes directly from the photo. To begin with, I wanted more contrast, so I darkened the entire area around the sunlit leaves. Contrast is drama! I also reduced the complexity of the subject by throwing the entire background into darkness. The medium values are subtle and I've limited them to the grass. Notice how I've darkened the spaces between the blades of grass around the bright leaves, thus emphasizing the center of interest. I've also designed the pattern of the grass so that it leads to the focal point of the picture. *Leprechaun's Gold* is 15″ x 22″ (38x56 cm).

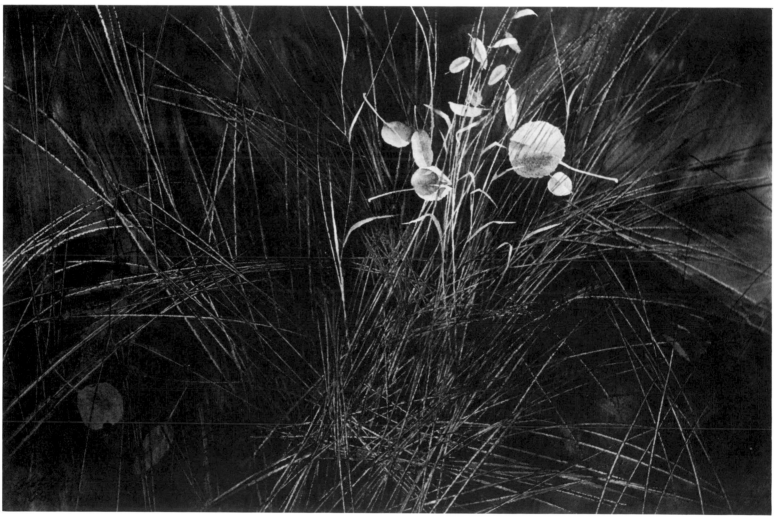

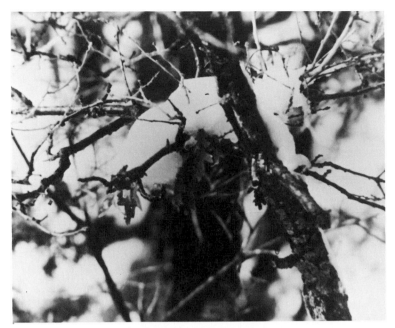

Photograph. Here's another snapshot that looks like a very unpromising subject. However, amid the confusion of crisscrossing branches, I thought I saw a bold, potentially interesting compositional idea through the viewfinder of my camera. The snapshot lacks the large shapes that give readable strength to the painting, but the subject had the right feeling.

Finished Painting. You can see that I've simplified the background, uniting the values and shapes, and allowing them to melt far away into the dreamy distance. I've concentrated all the rich texture and detail on the mossy trunk and branches, and deleted *most* of the branches that appear in the photo. Comparing the painting with the photograph, you can recognize a few shapes, such as the trunk, the main branches, and the mass of snow. But the final painting is successful because I've used the photo as a point of departure, not as something to copy. *Snow Nest* is 15″ x 22″ (38x56 cm).

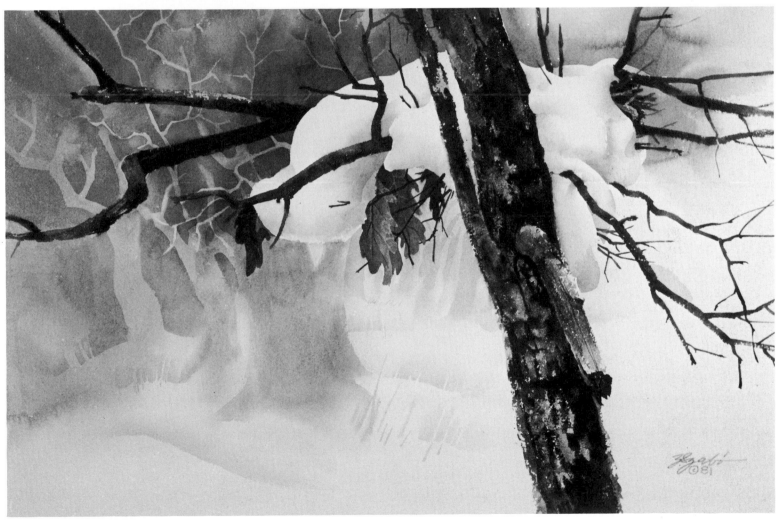

MATERIALS AND EQUIPMENT

Because this is a book for readers who have already done a certain amount of work in watercolor, I think it's reasonable to assume that you already have paints, brushes, and other basic equipment. However, I find that my students are always interested in knowing what materials and equipment I use in my own work. So I'll tell you about these. When you buy additional gear, perhaps you'll want to try some of the tools that I've used for the paintings in this book.

Whatever you buy, the most important consideration is *quality*. Nothing but the best is good enough, and I believe in using the best available materials. Watercolor is such a temperamental medium that it's *always* tricky to control, even with the help of good tools. I realize that many readers will be concerned about their budgets. However, if you must save money, save on quantity, not on quality. Don't buy a whole drawer full of mediocre brushes because you think it's a way of saving money—use that money to buy just a few brushes, but buy the biggest and the best. In the same way, six or eight tubes of top quality color will do a better job for you than two dozen tubes of an inferior brand.

Any good quality rag paper will do the job. My own favorite brand is d'Arches. I find that this French paper is consistently of the highest quality. The surface is tough; it can be scrubbed, knifed, and tortured in all kinds of ways to produce the diverse effects that you see in this book. I prefer a heavy sheet—300 or 400 pound—in the cold pressed surface. (It's called not pressed in Britain.) I usually work on the reverse side of the sheet.

Before I start to paint, I mount the paper on a sheet of hardboard that's slightly larger than my paper. I find that the simplest way to mount the paper is to tape it onto the board with masking tape. Masking tape won't stick to a moist surface, so I tape the dry paper to the board before I touch the surface with my wet brush.

I love my 1″ flat brush in pure sable—my greatest luxury. I also use a 2″ brush that's made of soft white nylon. I also rely on a number of round sables: two big ones, numbers 14 and 12; and a couple of number 6 sables.

Speaking of soft, white nylon, these delicate, springy, manmade fibers can be an excellent, money-saving substitute for natural sable. The Simmons ″White Sable″ and Grumbacher ″Erminette″ are my favorites.

For spontaneous line work, I use a number 3 rigger—a long, narrow, softhair brush. I also use the kind of hog bristle brushes that are normally employed for oil painting. Two of my bris-

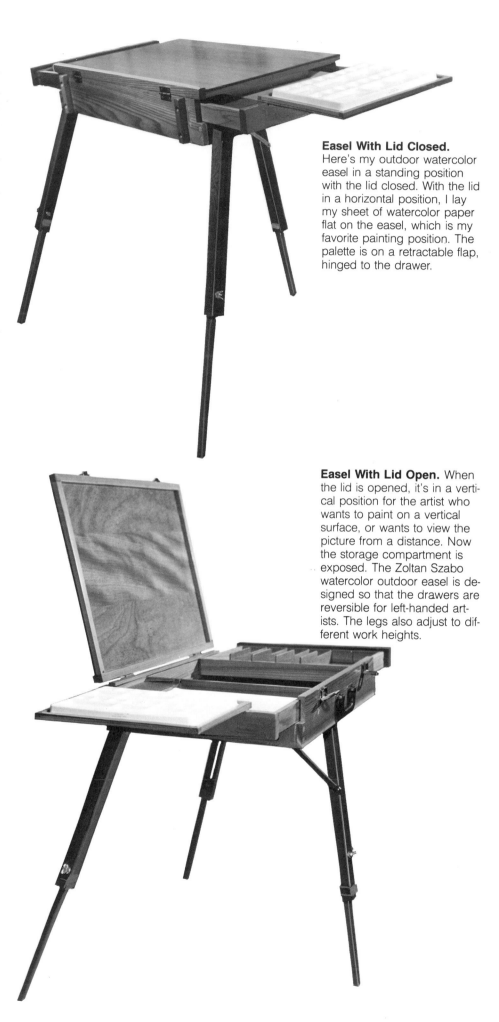

Easel With Lid Closed. Here's my outdoor watercolor easel in a standing position with the lid closed. With the lid in a horizontal position, I lay my sheet of watercolor paper flat on the easel, which is my favorite painting position. The palette is on a retractable flap, hinged to the drawer.

Easel With Lid Open. When the lid is opened, it's in a vertical position for the artist who wants to paint on a vertical surface, or wants to view the picture from a distance. Now the storage compartment is exposed. The Zoltan Szabo watercolor outdoor easel is designed so that the drawers are reversible for left-handed artists. The legs also adjust to different work heights.

tle brushes, one that's 1¹/₂" wide and another that's ³/₄" wide, are for painting. An identical pair, the same two sizes, are used for brushing clear water onto the paper. These are Grumbacher "Gainsborough" brushes, but any good brand will do the job.

I also love to use a palette knife for certain kinds of strokes. I clean the blade with any good household cleanser, or toothpaste, believe it or not. My favorite knife is the Permanent Pigments model number 8.

After experimenting with various palettes designed by a number of manufacturers, I've finally designed my own palette to fit an outdoor easel that's also my own design. (These palettes and easels are produced in modest quantities for my students.) Both the palette and easel are illustrated here.

The palette is white plastic, equipped with sixteen wells for paint and eight larger wells that provide mixing areas. The mixing wells are slanted to pool the color and reduce evaporation. These pools also accommodate the palette knife.

My outdoor watercolor easel (copyright pending) is my pride and joy. Designed strictly for watercolor painters, the easel carries all my supplies, except for water and bulky paper tissues. It's really like a portable studio. The storage drawers and work surfaces are clearly shown in the two photographs that you see here.

You'll find a more detailed description of my painting tools and equipment in my four earlier books, all listed in the bibliography at the end of this volume.

Watercolor Palette. The Zoltan Szabo palette comes with a separate lid that can be used for mixing large washes. I squeeze my tube colors into the rectangular compartments. For mixing different quantities of colors, the palette provides slanted wells of different shapes and sizes. The wash pools at the lower edge of the well.

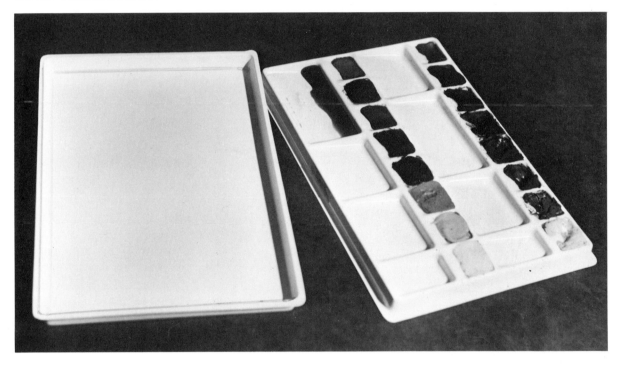

PAINTING LIGHT AND SHADOW

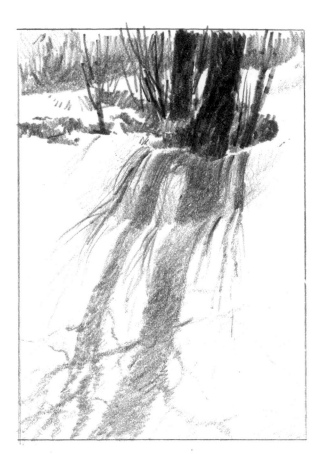

In a closeup, it's light that often transforms the ordinary into the extraordinary. Here are some tips about the behavior of light and shadow—particularly shadow.

Paintings done in early morning or late afternoon are most dramatic because the shadows are strongest. These shadows are dark, cool, and very long. Light areas, exposed to sunlight, are drenched in warm hues. This is the time of day that most landscape painters like best.

In the blinding noonday sun, shadows are rich in detail and full of strong color, but the lights tend to look washed out.

When the sky is covered with clouds, objects are more evenly lit than they are in direct sunlight. The strongest color is in the light. Shadows are very subdued, so the three-dimensional quality of objects must be suggested with subtle tones and soft transitions.

Never treat shadows as if they're solid patches of darkness. Be sure to observe all the subtle value changes that occur within the shadows.

Notice that the edges of cast shadows, where they meet the sunlight, are darker and cooler than the insides of the shadows. Horizontal shadow shapes, on the ground or on a roof, for example, are relatively light because these planes face upward to the light source in the sky. Shadow shapes that turn away from the light source, such as a shadow on a wall or a fence, are a little darker.

Remember that a single light source produces only *one* cast shadow, moving in the opposite direction from the light source. If the light comes from the right side of the tree, the cast shadow is directly to the left. The dark value of a cast shadow must be painted with quick, decisive brushstrokes. One sweep of a rich, dark mixture, and the job is done. Shadows should be colorful despite their dark value. You'll find a single dark wash on white paper is more luminous than one that's built up in several layers.

The color of a shadow is influenced by three combined factors: the color of the sky; the color of the surface that the shadow is cast upon; and the color of any nearby object that may reflect light into the shadow. Thus, a shadow on a beach may combine the influence of the blue sky, the golden gray of the sand, and the reflected color of a red rowboat nearby. Because these color influences can be so diverse, every shadow is a unique phenomenon. There are no rules except that you look before you paint.

This doesn't mean that you've got to paint shadow colors exactly as you see them. When you paint closeups, you can exaggerate shadow colors and values to accentuate the mood. You're also free to improve upon reality by the selective use of colors that may not appear in the subject.

It's also worth remembering that a painting looks more unified and relaxed when there's a single light source. Look for subjects in which there's a strong light coming from one direction. If you find an interesting subject that's complicated by multiple light sources, do your best to simplify the pattern of light and shadow so that the painting has one basic light source, even if it doesn't work that way in nature.

LEFT
Shadow Pattern. In this pencil sketch, the shadow pattern itself is my subject. At the top of the picture, the intricate design of the real branches is cut off to let the shadows dominate. At the base of the tree, the mound of snow becomes slightly darker because the shape rolls away from the sun, although it's still in the light. The curving shadows of the trees follow the curving surface of the snow.

BELOW
Shadows for Composition. In this graphite stick drawing, the shadows are designed to lead your eye to the center of interest. They also create a pattern that's interesting in itself, filled with a variety of rhythmic positive and negative shapes that move over the rolling surface of the snow. The strong touches of darkness contrast with the paler tones of the shadows, which look sun-filled and luminous.

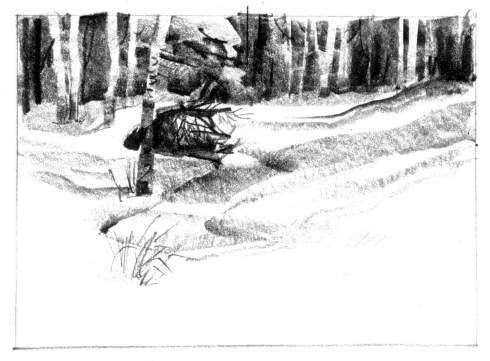

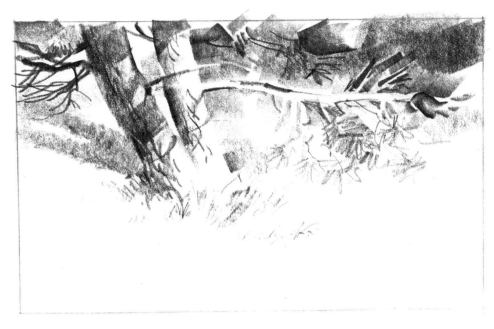

ABOVE
Sunlit Pine Trunk. Most forests are filled with sights like this one, particularly in clearings. I fell in love with the contrast between the sunlit and shaded shapes. What *makes* the composition is the bold contrast of light and shadow, creating interesting positive and negative shapes. To keep the sketch simple and strong, I used a 6B graphite stick.

RIGHT
Stump With Saw Marks. I found this playful conglomeration of textures in a park at the edge of a forest. At first glance, the subject seems common enough, but there's a lively, abstract quality in the dynamic shape and rhythmic pattern. Notice how the upper part of the trunk is broken into round and jagged planes of light and shadow. I was particularly interested in the texture of my subject, which I recorded with a 2B pencil.

Certainly one of the best places to find live stills is the forest, where the density of trees and other plant life forces us to look closely.

Needless to say, leaves occupy the forest in enormous quantities. All species of trees, shrubs, and other growing things bombard us with leaves in a fantastic variety of shapes and colors. Don't ignore these wonderful subjects simply because of their bewildering numbers.

Amid the profusion of detail, you'll find a single leaf or a small group of leaves with some striking quality that's worth painting. Look for some unusual color, shape, or condition—damaged, curled, dried, or rain-soaked. A *single* leaf, in the right surroundings, can be a dramatic subject. You may want to "move" leaves into a new and unusual environment. Imagine or invent a new setting, which you can paint from memory or from sketches. For instance, you may want to isolate that little cluster of leaves by moving it from the forest floor to a patch of snow or a rock formation.

Stumps are well loved by landscape painters—and I'm certainly no exception. The character and strength of stumps come from the texture of the bark, the splintery detail of cut wood, and the moss that grows on the surface. The decaying condition of a stump is particularly lovely to paint.

It's terribly easy to be literal, getting carried away with all that fascinating detail. But you'll make a more personal painting if you simplify and redesign the patterns of the bark and moss. Don't paint every crack and crevice!

Particularly in moist, deciduous forests, there are mushrooms and toadstools in abundance. Sometimes they're colorful, sometimes not. These little clowns of the forest often look bulky and solid when you paint them, and they *can* look corny. Eliminate this danger by surrounding them with other details of the forest floor, so that the mushrooms and fungi look integrated with their surroundings.

Healthy trees produce fruits and other containers for their seeds—often colorful and unusually shaped. Some of these trees release their seeds in little, V-shaped spinners with wings. Others produce nuts (such as acorns), berries, and beautifully varied cones. Paint them as part of their surroundings, integrated with other details of the forest. Don't let them look flat or pasted on.

Parasites like mistletoe, Spanish moss, and other vine-like creatures are terrific painting subjects. Some of the most destructive vines produce marvelous, spooky rhythms as they wind around the unlucky tree. Look for these rhythms; then simplify or redesign them.

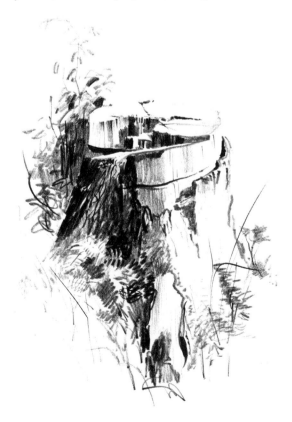

PAINTING CLOSEUPS OF WATER

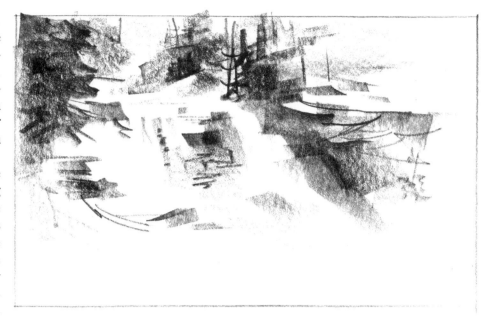

Water appears in an amazing variety of forms. There are painting possibilities in a mere puddle of still water or in the complex patterns of moving water that occur in streams and waterfalls.

A body of water, in any form, is always a reflective surface. Even the smallest dribble on a window contains reflections! The color of water may reflect the sky or any objects near enough to influence the reflecting surface.

Normally, a water closeup includes both the real object and its reflection. The painting makes more sense if the viewer can see the shape next to the water and then see how it's transformed in the mirror-like surface. The closeup is more dramatic if the actual object is only partly visible. Occasionally, you can try placing the actual object out of the compositional area. A well-placed reflection, clearly visualized, can tell the viewer all he needs to know about the object that creates the reflection.

When you paint a puddle, or any patch of still water, you must emphasize the fact that the reflective surface has a texture that's totally different from the dry ground nearby. Puddles stand out best when they're painted with strong value contrasts: pale puddles against dark ground *or* dark puddles against lighter ground.

Painting the colors of still water demands highly trained powers of observation. You'll notice that shallow water is transparent and often pale, but darkens as the water becomes deeper. Looking directly into the puddle from above, you can see its local color, which is usually the color at the bottom of the puddle. But when you look at the water from a normal viewing angle the color contains a variety of reflections that come from the sky and from surrounding ob-

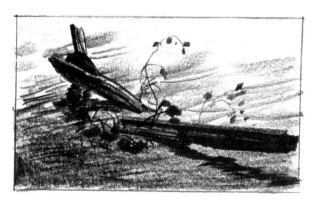

jects like trees, shrubs, rocks, weeds, and grasses.

Churning, moving brooks are generous suppliers of tiny waterfalls, which make lively closeups. When a stream moves along horizontally and then has an abrupt drop in elevation, the water can fall in a smooth film, like a transparent, curving curtain. The illusion of moving water is best captured with a wide, firm brush and quick, light strokes. You often see a highlight at the top edge of the waterfall.

There are also interesting painting possibilities in the turbulent patterns of foam and churning white water at the bottom of the fall. And don't overlook the dynamic pattern of white water, moving over and around submerged rocks.

Beneath the surface of the water—perhaps poking above the surface—are submerged objects that make interesting closeups. Most common are fallen trunks and rocks. You'll discover many interesting painting subjects in the mysterious, half-concealed forms, surrounded by moving or still water, and animated by reflections. Because the submerged objects are wet, they tend to be darker than the same objects would be on the shore. When part of the object is beneath the surface of the water, the dark shape may be broken up by reflecting wavelets, making the painting even more lively and mysterious.

ABOVE
Waterfalls. Working with a 6B graphite stick, I recorded the contrast of positive and negative shapes with broad strokes. Then I indicated the linear details with a 6B pencil. I knew that the closer trees would be painted with sharp, detailed strokes on dry paper, while the more distant trees would be blurred forms, painted wet-in-wet. I stressed the darkness of the shore to dramatize the bright light on the foaming water.

LEFT
Flooded Fence and Vine. I used the graphite stick to record the dark-to-light gradation of the water from the foreground to the background. The dark reflections follow the shapes of the fallen fence, but the reflections are more jagged because of the movement of the water. I add the bouncy, linear shapes of the vines to fill in a space that seemed too empty.

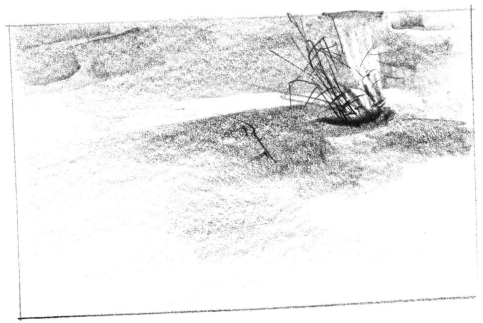

Frosty Grass and Snow.
The pencil sketch reveals the basic strategy of my pictorial design. I wanted to show that 80 percent of the main pictorial area would be covered by a medium value. Only a few delicate, dry weeds are dark. The frost-covered, sunlit weeds were rubbed out with the sharp corner of an eraser. Sunlight flashes across the snow, just behind the weeds, to dramatize the center of interest.

Melting Ice Pattern. My sketch emphasizes the reflective shape of the exposed water in the snow. The dark shape of the water unites in value with the shaded shrubs on the left shore. I've just hinted at the sky and trees at the horizon, minimizing their detail and texture. I was already planning the finished painting in my mind, knowing that I'd paint the distant sky and trees on wet paper to reduce their contrast.

I particularly love to paint winter closeups because the pure, pale surfaces of the snow and ice provide a wonderful setting for the tiniest form. The smallest twig, weed, or leaf looks important. And a few dark forms, surrounded by whiteness, create beautiful positive and negative shapes.

When weeds, shrubs, trees, and other growing things are taller than the snow, they expose only their top parts. To paint these shapes convincingly, remember that they continue beneath the snow, right down to the ground.

Where these growing things emerge from the snow, there are small, protruding drifts that I call *snow pimples*, or hollow, nest-like shapes that I call *snow dimples*. Don't neglect these details. They give the snow a feeling of reality.

At the crotches of branches and heavy limbs, there are often large piles of snow. These pale, round, negative shapes provide a dramatic contrast with the dark, positive calligraphy of the branches. These suspended, snowy islands, like snowdrifts and snow-covered evergreens, must be shaded with light values. You'll find that snowy shapes look more luminous when you place them against dark evergreens or shadowy rocks.

Frozen condensation on an object is called hoarfrost. It looks as if the shape is dressed in a soft, white fur coat. Coated with hoarfrost, the simplest weed, branch, or wire fence has a magical, soft look, even in bright sunlight.

An exciting way to paint hoarfrost is what might be called the negative wet-in-wet technique. You begin by painting the background as a solid, not-too-wet wash. Just as this wash is ready to lose its shine, quickly paint in the frost-covered, linear shapes with clear water, using a small, pointed, half-loaded brush. These strokes of clear water create little backruns that look like frosty lines. The darker you make the background wash, the more contrast you'll create, and the more dramatic the backruns will look.

Painting icicles requires a different approach because their edges must be sharper than hoarfrost and the icicles must glisten. I think that the best way to paint icicles is to mask them out and paint the background tone right over the dried mask. When the mask is peeled away, the bare paper is revealed and you've got the sharp contrast that you need.

The color and texture of ice are particularly subtle. Ice normally has a gently reflective, light blue or green surface. On a stream or lake, ice shows a very light, somewhat blurry reflection. On a frosty window, there's an intriguing texture, but *no* reflection.

Salt, scattered on the drying, but still moist paint, produces that distinctive icy look. The timing of the salt application takes a lot of practice. Try it several times until you get it right.

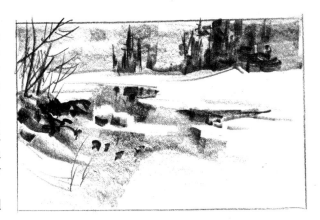

PAINTING CLOSEUPS OF FLOWERS

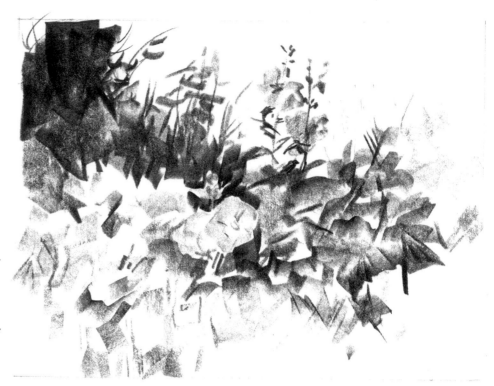

Flowers are too often stereotyped as "sissy subjects." But that stereotype quickly evaporates when you think of the great samurai warriors who were connoisseurs of flowers, as well as connoisseurs of swordsmanship. To paint flowers really *well* is as difficult a task as any assignment that faces an artist. Because the colors of the flowers are so fascinating and overwhelming, composition becomes particularly challenging. Here are some suggestions about some of these problem areas.

These little gifts of nature are commonly, but not always, small. However, their color stands out despite their size. Above all, don't *exaggerate* their color, but aim to capture the delicacy of their hues, which are bright enough.

Wildflowers and flowering weeds are often hiding, so we must look for them. Study their living habits so you know where to find them. If it's natural for them to hide, then be true to their natural personalities when you paint them. That is, paint them in the natural surroundings where they're concealed. The best way to avoid that corny look in a flower painting is to paint the flower in its normal setting, where it won't look like some artificial arrangement from a florist's shop.

If you've ever tried to take home a wildflower, you know that it wilts quickly. You may also know that many wildflowers are protected by law, and it's illegal to take them home. So

the best way to take them home is in a sketch or in a photograph.

When I get back to the studio and start planning my flower painting, I pay particular attention to the problem of integrating the colors of the flowers with the colors of the surrounding vegetation. To create a more unified color scheme, and to integrate the flowers with their background, I like to mix a bit of the dominant color of the wildflowers into the surrounding vegetation.

A mass of apple, plum, peach, or other blossoms is basically a group of light (negative) shapes against a darker background. I usually handle this problem by painting the background *around* the clustered flowers on wet or dry paper, sometimes with, and sometimes without, the help of a mask. Seeding thistles, milkweed pods, dandelion, fireweed, or any other weeds with soft, flying seeds are best captured on wet paper, or with lost edges on a dry surface. Spontaneous, decisive brushstrokes are essential to assure a clean result.

Desert closeups are extremely colorful in the spring because nearly all the cacti and desert plants blossom at about the same time. Tropical flowers are so vivid that the problem, once again, is to avoid that corny, exaggerated look.

The solution is to avoid filling your paper with dazzling colors that fight for dominance. Instead, focus on a few bright shapes and surround them with more subdued shapes, colors, and values.

ABOVE
Large, Shaded Flowers. As I drew this mass of big wildflowers with my 6B graphite stick, I wanted to preserve the white, negative, sunlit shapes. I surrounded these shapes with dark strokes, and then I placed paler strokes within the shapes to indicate the middle values. The finished sketch served to remind me of the immaculate colors of the flowers and their leaves in the sunlight.

LEFT
Upright Hollyhocks. The strongly upright character of the flower suggested a vertical composition. The sketch shows that medium values would dominate the finished painting, complemented by darks and lights. Notice that I've worked around patches of bare paper to suggest the strongest lights. I've also planned the gradation of the background from a darker tone at the left to a paler tone at the right.

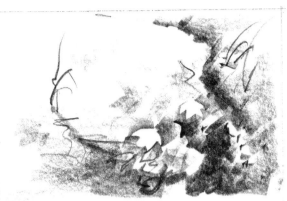

RIGHT
Floating Maple Leaves. Like a lot of nature's abstractions, this subject doesn't reveal itself at first glance. Look closely at the sketch and you'll see that the jagged white shapes, as well as some of the darker ones, are maple leaves floating in a pond punctuated by reeds and their wiggly reflections. The sketch simply records the abstract pattern. In the final painting, I painted the leaves and reeds more realistically.

BELOW
Shaded Log Cabin Door. Weathered architectural details give you the opportunity to paint highly structured, geometic abstractions. This sketch shows the large shapes, dominated by medium and dark values. The dark values strengthen and define the nature of the wood. I made no attempt to record the texture of the weathered wood in the sketch. I saved that for the final painting, where I had a lot of fun drybrushing the wood grain.

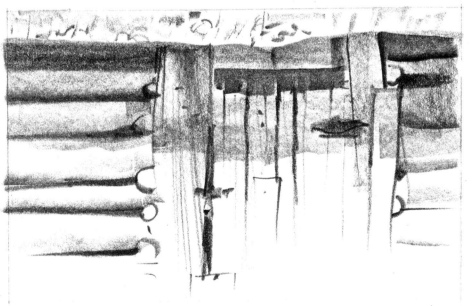

Nature often presents you with shapes, textures, and patterns that have wonderful, abstract visual qualities that are fascinating for their own sake. These subjects are what I call "nature's abstractions."

Some of my own favorites are the amazingly beautiful, delicate patterns of spiderwebs; the glistening light on dewdrops and other water droplets; the textures of wood grain and algae. Look for abstractions that are formed by natural events: the pattern on the ground when trees drop their leaves, rocks roll off a hilltop, and snow cascades off trees. Keep your eye peeled for found objects like feathers left behind by a bird.

Spiderwebs and dewdrops often go together, particularly in the early morning, when droplets hang on the glistening filaments of webs that have been woven on trees, shrubs, and weeds.

Masking fluid is often the best means of capturing these tiny points and lines of light. Learn to use hairline masking tools. The tip of a palette knife will apply the liquid latex very thinly. For dewdrops, you can spatter minute specks of masking liquid. You can apply tiny drops of liquid latex with a small brush or the pointed brush handle.

The sharp corner of a razorblade or the tip of a sharp knife will scratch the lightstruck lines of the spider web out of a dark background, pro-

vided that the paper is bone dry. This sharp tool will also lift highlights out of water droplets.

Algae, mold, lichen, and other small, plantlike growths occur on rocks, trees, cement, and other outdoor surfaces. Rust and other kinds of corrosion occur on metallic surfaces. These all form decorative patterns that are perfect examples of abstraction. To paint these subjects convincingly, you must record the shape, scale, perspective, and foreshortening of the objects on which the patterns rest. The rock or tree gives form to your picture, while these abstract "overcoats" provide the decoration.

Wood grain is one of the most beautiful abstractions that nature creates for us—and provides in great abundance. A single barn wall contains hundreds of painting subjects that we can see if we study the wall from a distance of three or four feet. Each area of the wall can become a painting. Freshly cut wood gives you different patterns than weathered wood. Compare painted wood and raw wood. Look for subjects in the stumps of newly felled trees, the worn floors of old houses and barns, the curving surfaces of old wooden buckets and barrels. Knots and nails, perhaps with a dribble of rust, add variety. So does the sun, which casts dramatic shadow patterns on wood grain.

Drybrush is the most effective technique for painting the infinite variety and unpredictability of wood grain. Try splitting the hairs by pressing the damp brush into the palm of your hand. Just a little twist of the wrist and parallel brush lines will spread and curve to suggest the pattern of the wood surface.

PAINTING CLOSEUPS AROUND THE HOUSE

The ordinary things that we live with and use are really not so ordinary at all. If we look at them with a fresh eye, we discover rich possibilities for painting closeups.

A glass of water isn't just something to drink—it's a transparent form with reflections and distortions that form abstract shapes. That glass contains values and colors picked up from nearby surroundings. Once you're aware of these pictorial possibilities, you'll see them in bottles, pitchers, and every other vessel in your kitchen or dining room. And don't forget the shiny, reflective surfaces of metal containers, often animated by misty condensation and droplets of water.

It's more exciting to paint "around the house" closeups if you don't consciously set up a still life, but paint as you find it. Just leave that half-filled pitcher of water on the kitchen counter, perhaps surrounded by dishes or groceries. Hold on to that unexpected, natural quality.

Changing light conditions, dust, and fading do wonders with old, forgotten furniture. Such objects often look best in the natural light that comes from a nearby window or an open door because strong light, from a single source, tends to dramatize shadows and textures. It's particularly effective to paint these dusty, faded surfaces with the *liftout* technique. Paint a wash, let it dry, then rewet certain areas and lift away the color.

Any abandoned object can have a nostalgic

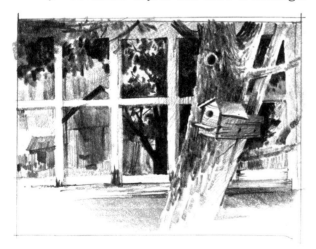

mood, but old clothes and drapery materials are especially promising. It's particularly effective to combine old draperies with forgotten furniture because the soft wrinkles of the fabric provide curving, dynamic shapes that complement the angular, static shapes of the furniture.

It's common for still life painters to make an *arrangement* of food on a table top. But try painting tomatoes and other vegetables as they ripen in the garden. When you bring eggs home from a store, just unpack them at random on your kitchen counter or table; look at them from various angles to try to find a satisfying pictorial design; and then paint them as is. Don't attempt to organize them.

Crumpled forms of paper are endlessly fascinating abstractions. An empty grocery bag, standing on your kitchen table, is a challenging exercise in rendering light and shadow on planes. Have you ever looked at a paper fragment that's been blown against a fence, stopped in its dance in the wind? Look *closely* to see what's on that paper—printing on a shredded newspaper, advertising on a grocery bag—and your painting will tell the story of the little runaway. If the paper is torn, mildewed, or otherwise decayed, then the subject is even more challenging to paint.

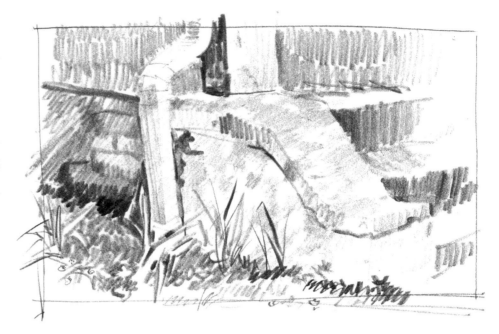

ABOVE
Shaded Trough and Steps.
At the corner of a house, straight (static) and curving (dynamic) shapes come together to make a strong abstract design. The foliage of a big tree, not seen in the picture, casts a large shadow over the entire subject. The sun breaks through the foliage, and the jagged shapes of sunlight and shadow produce a kind of repeated rhythm. But I kept the edges soft so they wouldn't compete with the major shapes.

LEFT
Birdhouse and Reflection.
The straight lines of the windows are played off against the diagonals of the tree in the foreground and the dark reflection of the foliage in the windowpane. When I started the final painting, this sketch also helped me to visualize the generous texture on the bark, the simple shapes of the window frames, and the softly blended reflections in the glass.

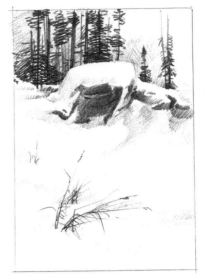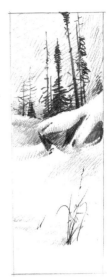

One way to extract the full riches of a subject is to paint a series of pictures, all related to one another. There are at least two ways to do this.

One way is to paint a series of pictures that are complete and satisfying in themselves, but also form one continuous panorama when you butt them together, edge to edge. You can see an example of this in the long, horizontal sketch on this page. It's a long, skinny panorama of a field full of weeds, drawn as a complete unit, and then subdivided into three separate close-ups, each becoming an independent picture.

The lesson you learn from *serial* painting is that nature offers you infinite painting possibilities—wherever you are, you never run out of subject matter. You're also forced to develop your powers of observation, your creativity, and your ability to come up with a variety of design solutions.

To create a feeling of consistency and balance throughout the series, stick with the same palette and techniques. You can also unify the series by the suggestion of movement, carried from one painting to another—blowing snow, flying, soft seeds, a bubbling brook with moving water, waterfalls, flying birds. Repeated rhythms also help—snow humps, ripples in water, tire marks, or architectural details like bricks or a picket fence.

When a shape exits at the edge of one painting and then re-enters at the adjacent edge of the next painting, don't forget that the broken shapes should meet neatly. Value and color should also be continuous from one picture to the next.

The second way to extract the most from a single subject is to paint the same motif again and again, from different vantage points, in different light conditions, and in different compositions.

When you think you've found a promising subject, perhaps a rock formation or a tree that looks good from various angles, walk around it and make a series of sketches. Half-close your eyes until you see nothing but a faint blur and the lightest and darkest shapes. These are the shapes you're after.

Try changing the mood of the subject each time you paint it. As light conditions change, try a new painting. Subjects often change with the seasons. Foliage that's dense and green in the summer will turn yellow or red or mauve in the fall. That same foliage will be less colorful in the winter, but full of bright yellow and green buds in the spring, often with wildly contrasting blossoms.

Learn to work from memory. Don't try to paint the details exactly as they were in nature, but put them down from memory, and place them wherever you think they'll strengthen your composition. Just concentrate on shapes and values in your sketch. When you work from memory, you simplify and abstract your subject, getting down to the essence of its design and mood.

RIGHT
Edge of Forest. These two interlocking pencil sketches show the snowy edge of a rocky pine forest—obviously a single view of the forest, split into two paintings. The two paintings have different shapes to accommodate different compositional strategies. To exaggerate the whiteness of the snow, I've made the dark shapes strong and definitive, while the more delicate tones of the snow are pale and blended. The tones were built up gradually with small strokes made by a 6B pencil.

BELOW
Tall Grass. A panoramic view of a weedy field is split into three separate paintings, all with different shapes. The slender abstract silhouettes of the dark, tall weeds occur in all three paintings, continuing from one segment to another. Yet these abstract shapes are designed differently in each painting. In the painting at the extreme left, a flock of birds suggests movement. See how many pictorial possibilites you can find in a motif as simple as a bunch of weeds!

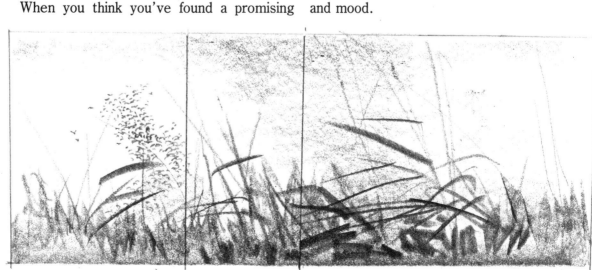

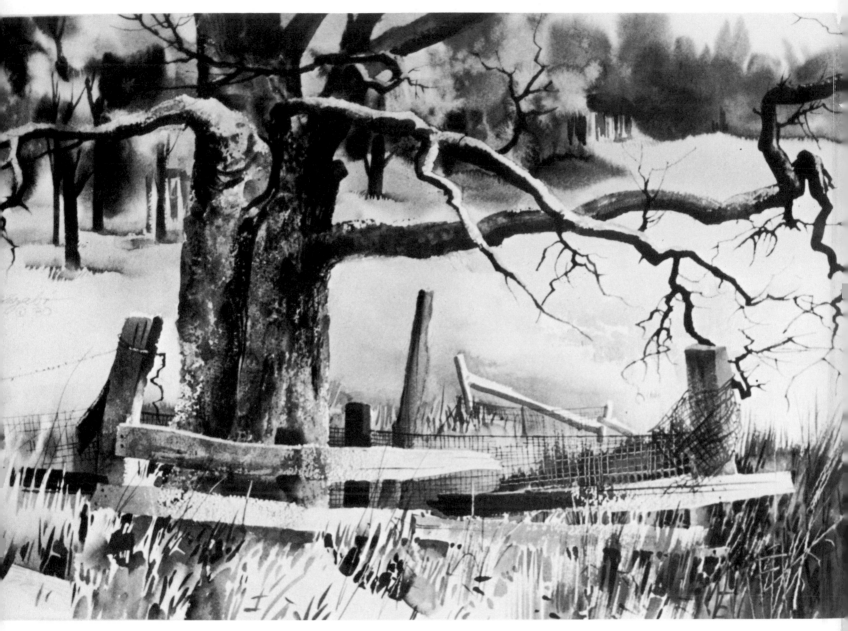

"Old friend." 15″ × 22″ (45 × 66 cm.). Collection of Mrs. Agnes E. Rabon. I particularly enjoyed painting this nostalgic subject. It offered an opportunity to invent a few negative shapes to create the illusion of depth where there was very little distance. Negatives and positives blending smoothly can be an exciting compositional trick, especially on cluttered subjects.

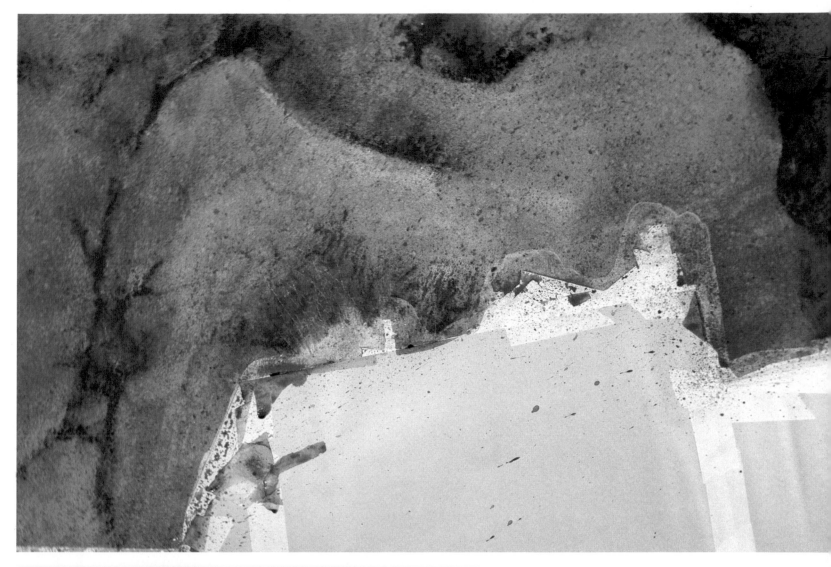

Step 2. When I'm sure that the spattered and dry-brushed passages are absolutely dry, I cover the entire area with a deep, but luminous wash of French ultramarine, cerulean blue, sepia, and burnt sienna. I want to be sure that I won't scrub off too much of the color applied in Step 1, so I use a soft, 2″ brush. I don't mind if the color softens a *little*, but I want to be certain that the *texture* survives. Notice that I darken this cool wash around the edges of the distant rocks in order to give a stronger feeling of three dimensions.

Step 2 (detail). Here's the same rocky shape that you saw in the detail on the previous page. Now it's covered with that wash of sepia and cerulean blue. The original effects of the drybrush and spatter have blurred a bit, but there's still enough suggestion of rocky texture. I like this cool, mysterious, shadowy tone because it pushes the background rocks further into the distance, providing a strong contrast with the sunny rocks that I'm going to work on in the next step.

DEMONSTRATION 2. ROCKS AND WEEDS

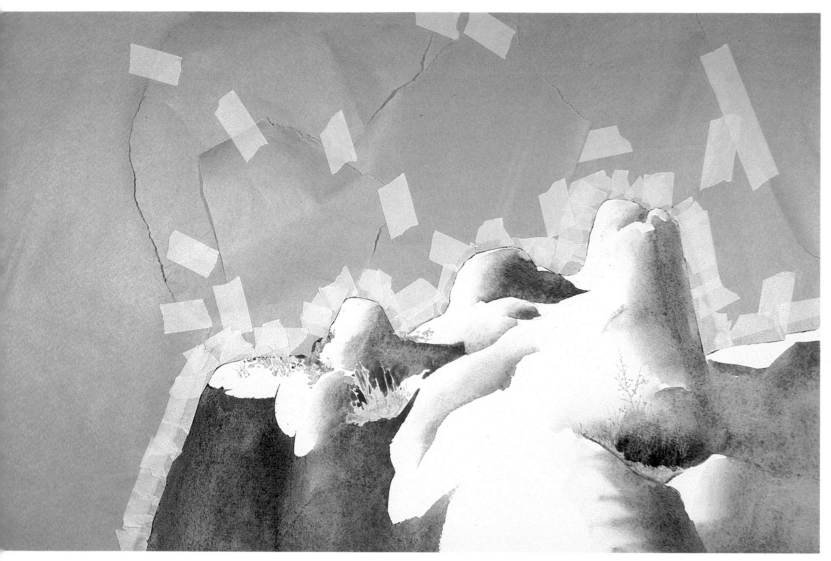

Step 3. Now I strip the protective coat off the foreground rocks and I cover the entire background with scrap paper and tape. (Because it's less sticky than masking tape, drafting tape is preferable—if you can get it.) On the foreground rocks, I paint out a few sunlit clumps of weeds with Maskoid, since I expect to spatter this whole area. Now I paint in the larger shadow shapes on the foreground rocks with burnt sienna and cerulean blue. These two colors tend to separate and dry to a granular texture that looks especially good on rocks. Wherever I need a slightly darker value, I add a little French ultramarine.

Step 3 (detail). You can see how I've trimmed the tape and placed it around the edges of the foreground rocks. I want the silhouette to be exactly right. Within the graded washes that model the rocks, the cerulean blue and burnt sienna have formed that typical granular mixture, so perfect for rendering rocky textures. Because these colors separate, there's also a nice variation from warm to cool within the washes. It's one of those controlled accidents that watercolorists always love.

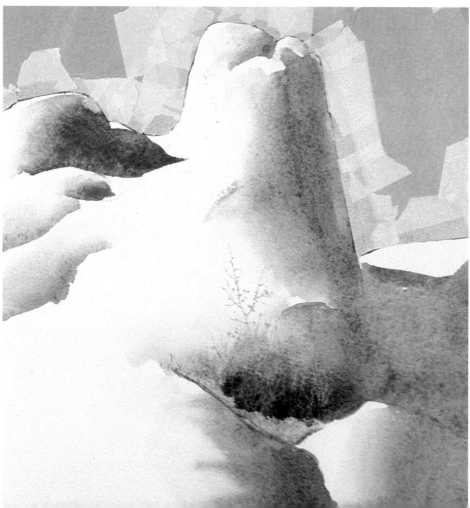

Step 1. I begin by establishing the center of interest with bright, fresh colors. I use new gamboge, burnt sienna, and brown madder for the mushrooms. Then I add a few bright touches of complementary color to suggest some small leaves and weeds; these are mixtures of cerulean blue, French ultramarine, and new gamboge. I also spatter some of this cool mixture on the bare paper, and then use a ragged, drybrush stroke to suggest the texture of moss.

Step 2. The mushrooms are masked out with carefully cut pieces of tape, and I protect those few leaves with liquid latex. Now I can work very freely, painting a bouncy, wet, abstract texture over the background. I work on the dry surface of the paper with a large, soft brush, allowing wet areas to run together, but try to keep some sharp lights and darks. I also spatter lively warm and cool colors over the surface to suggest clutter on the forest floor.

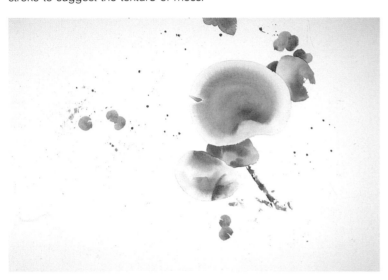

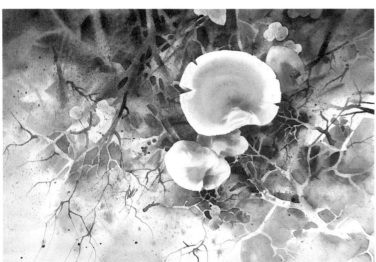

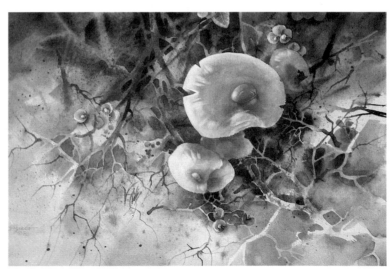

Step 3. Before removing the liquid latex and the tape, I finish the entire background. I glaze dark, but luminous washes over the forest floor. I connect some of the abstract, linear shapes to suggest branch-like forms. I use my palette knife blade to paint a lot of dark twigs. When all this is dry, I remove the protective mask. I look over my value contrasts and strengthen some of the darks.

Step 4. At this final stage, I complete the details of the mushrooms and the small leaves. I'm particularly concerned with the *density* of the color. Thus, I want more color on the mushrooms, so I glaze one more coat of new gamboge and brown madder on the warm shapes, and then wipe off the highlights with a bristle brush. Finally, I lift out the droplets of water and model their shapes with a few darker touches. *Forest Cocktail* is 14¹/₂" x 22" (37x56 cm).

DEMONSTRATION 4. WILD MUSHROOMS

Pencil Sketch. My on-location pencil study is a quickie, as always. But I do record the strong value contrast between the mushrooms and the shadowy forest floor, as well as the suggestion of light in the lower corners. I also suggest the clutter of forest debris, knowing that I'll invent the actual pattern and details when I get back to the studio. I also pay particular attention to the off-center placement of the mushrooms within the rectangle.

Finished Painting. The final painting owes a great deal to the contrast between the big, rounded, very simple shapes of the mushrooms and the wiry, complex pattern of the shadowy forest floor. Many of the twigs around the mushrooms are suggested by dark strokes. To suggest lighter twigs against the darkness, I paint dark patches around them. These branching forms tend to move your eye to the center of interest. The complementary contrast of the warm mushrooms and the cool leaves is accentuated by the fairly neutral color of the background.

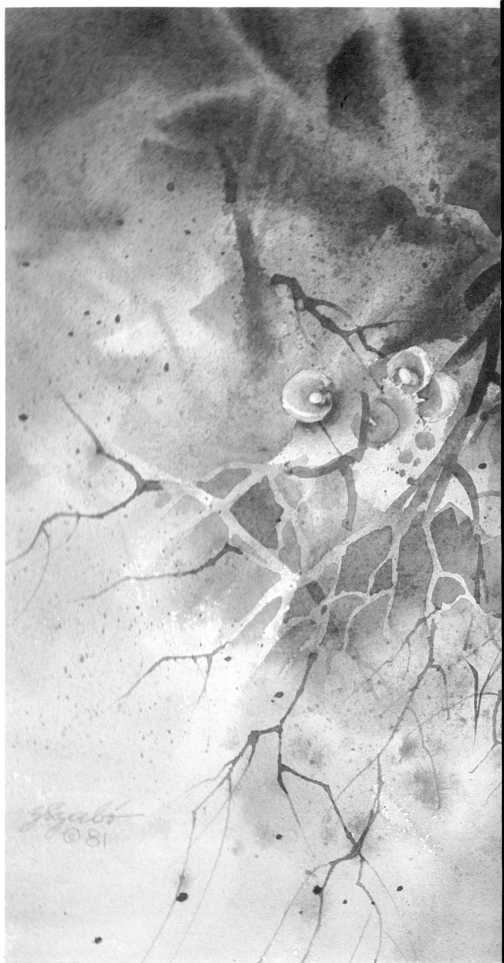

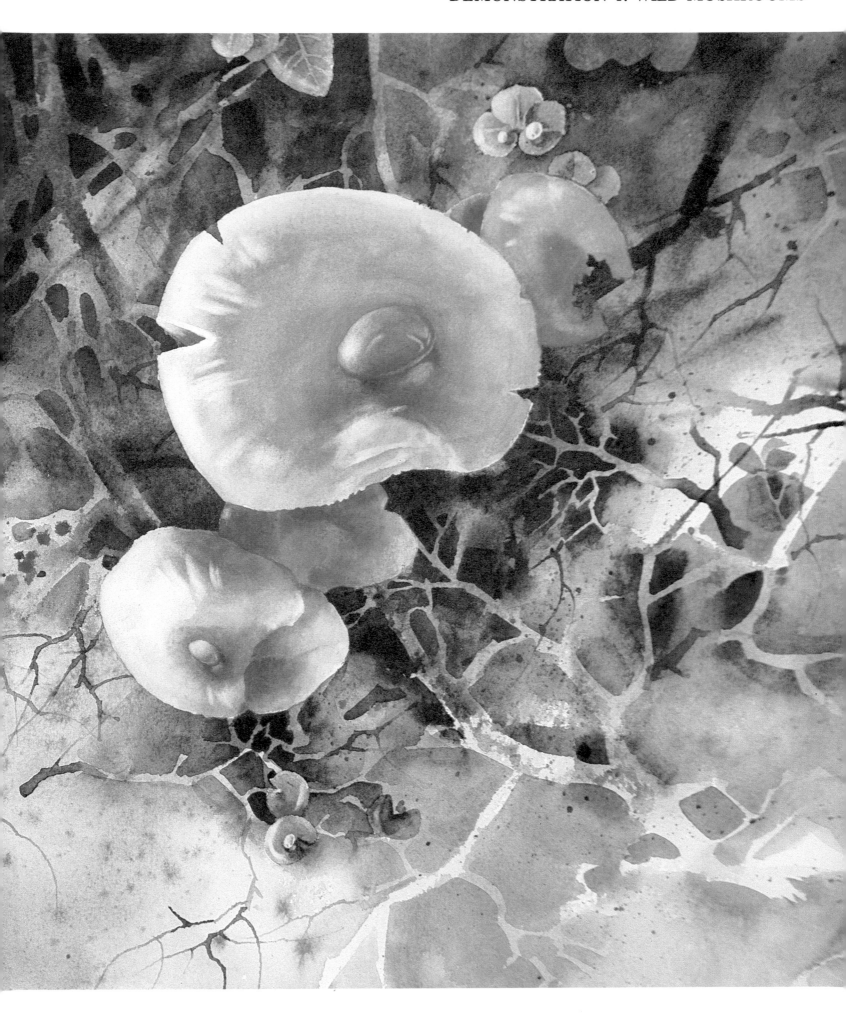

DEMONSTRATION 5. STUMP AND WEEDS

Step 1. This closeup begins with the wet paper technique. I brush clear water over the paper and then I vigorously apply random combinations of raw sienna, burnt sienna, cerulean blue, and Winsor blue. There's just a touch of new gamboge in the brightest greens around the future center of interest: the tree stumps that will appear in the next step. When the wet color has *almost* lost its shine, I knife out a few light weeds from the dark background. And I keep adding color until the values are dark enough to indicate deep, lush weeds throughout the lower half of the sheet.

Step 2. Now I paint the stump, working mainly with drybrush strokes. Lots of small, rough strokes suggest the bark. I add a new shoot of bright maple leaves. To join the knifed-out light shapes of Step 1, I paint more pale weeds at the base of the stump, using the sharp tip of my brush to work the darks around the light shapes. I'm concentrating most of my details near the stump—the painting's center of interest. (To paint pale weeds against a dark background without the help of liquid latex, it often helps to lift some of the dark color, let it dry, and *then* add those small touches of darkness that surround and define the lighter shapes.)

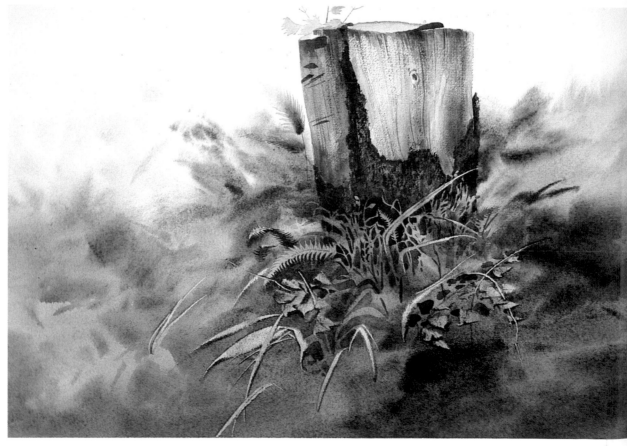

DEMONSTRATION 5. STUMP AND WEEDS

Step 4 (detail). Now you can examine that same section of the finished painting, with all the final details and colors. The intricate pattern of the weeds and ferns in the foreground is complete, at last. Visualizing each shape as precisely as possible, I add hundreds of dark touches that move around the pale silhouettes, sometimes indicating shadows between weeds, and other times becoming dark weeds and ferns. And speaking of ferns, look at the details that now appear at the left-hand side of the treestump, where I worked over the blurs of Step 2 to add just enough detail to suggest ferns emerging from the fog. You can also see the lights that I lift from the ax marks on the stump, and the dark touches of modeling on the maple leaves at the top. With all the darks and details of the foreground in their final places, I add delicate glazes of cool and warm color to bring the foliage to life. *Leaving Early* is 14½" x 22" (37x56 cm).

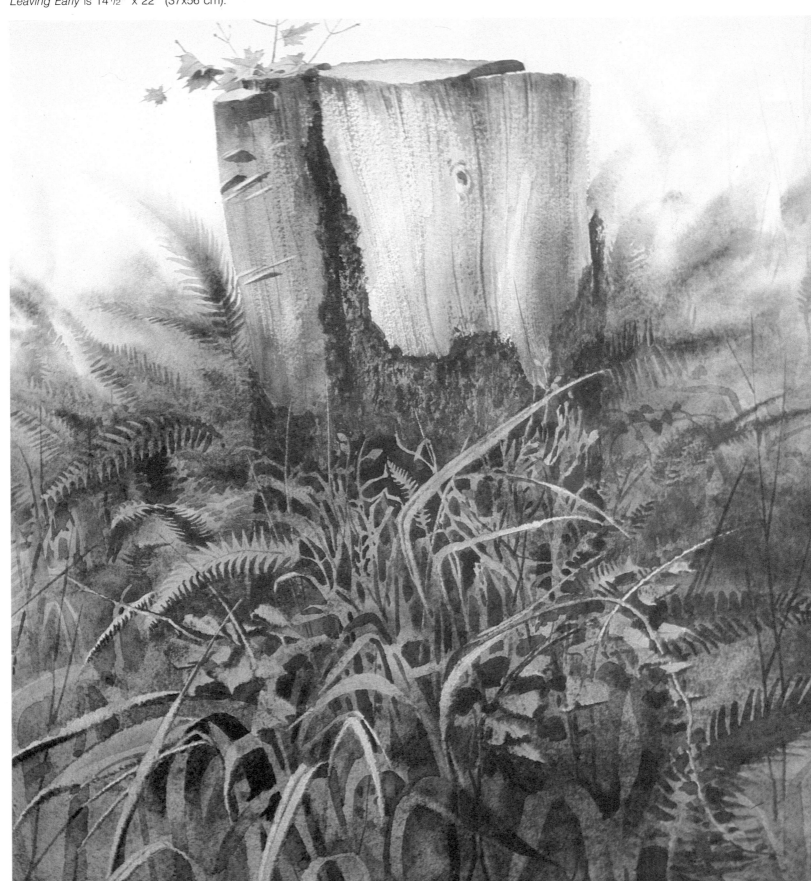

DEMONSTRATION 6. COBWEB AND WEEDS

Step 1. Wetting the paper with pure water, I brush on a bright, rich wash of new gamboge, mixed with brown madder, to establish the sunlit area. For the darker, cooler background, I brush on various mixtures of these two colors, plus burnt sienna, manganese blue, Winsor blue, and French ultramarine. These colors represent my full palette for this painting. I apply these washes rapidly, while the paper is still wet, with a 2″ soft nylon brush. The brush contains only enough water to dissolve the pigment, since the wet paper contributes all the extra water I need for blending. I maintain a soft, but distinct line where the cool, shadowy background ends and the warm, sunlit foreground begins.

Step 2. When Step 1 is bone dry, I use paper stencils to lift off the color for a few leaves. (This is particularly obvious where pale leaf shapes now appear in the dark background.) I also begin to define the edge of the cobweb with carefully placed darks. And I begin to glaze the leaf shapes with transparent colors, both warm and cool. Where the design demands them, I retain sharp edges on the forms, but I often lose the other sides of the forms with soft, wet transitions. Observe this in many of the leaves, which may be hard-edged at one end, but melt softly away at the other end.

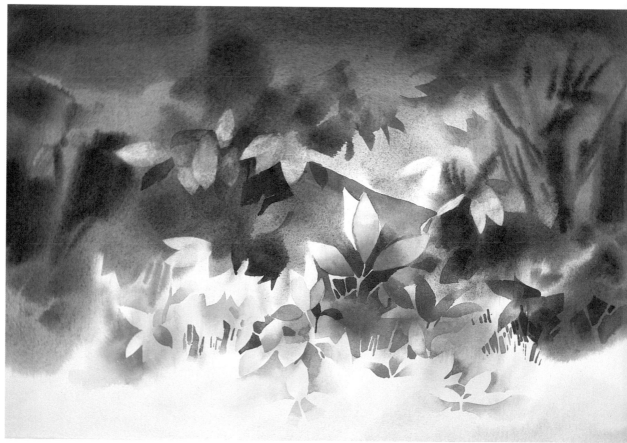

Step 3. I continue to develop the weeds in the sunny foreground, isolating and defining the pale shapes with small, dark touches. I continue to build up the colors of the leaves with bright, transparent glazes. At this stage, I'm also working on the details within the leafy forms, as well as the patches of shadow cast by one leaf upon another. Just a little more detail is added to the blurred background, but not enough to distract attention from the foreground.

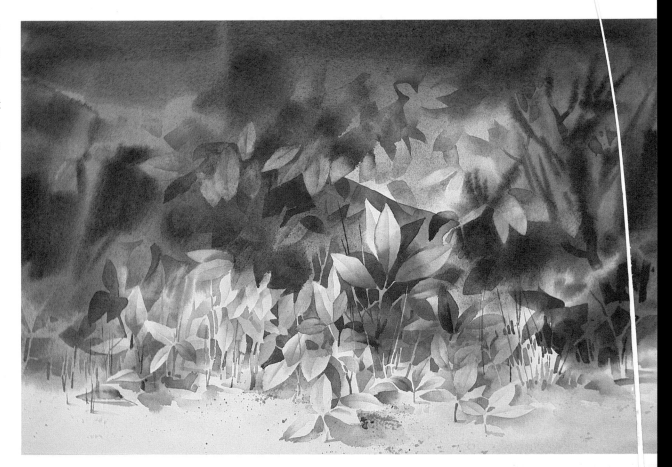

Step 4. I feel that I've lost a bit of contrast, which I regain by adding more darks, particularly in the background. Now I carefully wet and blot out the large, negative shape of the cobweb. When this area is dry, I paint the breaks in the web with dark touches, suggesting background shapes peaking through. The thin threads are first executed by painting darks right up to them, and then scraping out a few crisp lines with the corner of a razor blade. Notice that I don't reduce the web down to pure white, but allow some of the underlying color to remain, so you have the feeling that you can see the shadowy background through the web. *Housing Shortage* is 14 1/2" x 22" (37x56 cm).

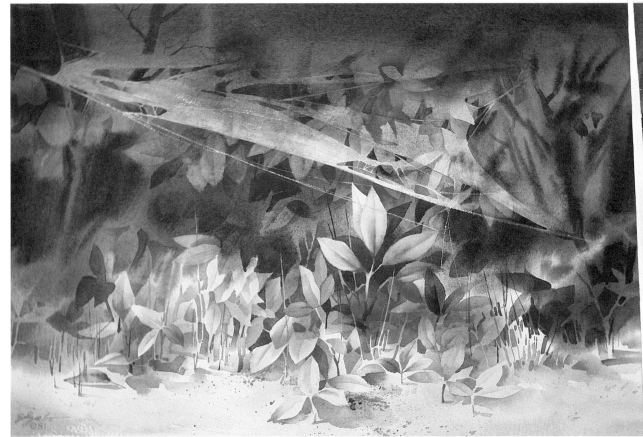

DEMONSTRATION 6. COBWEB AND WEEDS

Photograph. My snapshot serves to remind me of the general distribution of light and shadow, particularly the contrast of the dark background and the sunny foreground. The snapshot also records the shapes of the leaves and the angle of the cobweb. But compare the snapshot with the painting and you can see that the leaves and the cobweb have been completely redesigned.

Pencil Sketch. I define the idea more strongly in the sketch, emphasizing the cobweb and condensing the shape of the sunlit weeds. The values of the sketch are a bit closer to the painting, but most of the painting is still done from memory and imagination.

Finished Painting. Tones that have been lifted off, leaving just a hint of the original color, always have a wonderful delicacy, particularly when they've been glazed with additional washes of transparent color. You can see this in the luminous hues of the sunlit weeds in the foreground. This liftoff technique also accounts for the mysterious, veil-like tone of the cobweb. It's interesting to observe that the cobweb is *surrounded* by detail, where the background shapes peek through the breaks in the web, but there's virtually no detail *within* the big, misty, diagonal shape. You can't see any individual filaments, except for a few scratches that connect the web to the weeds.

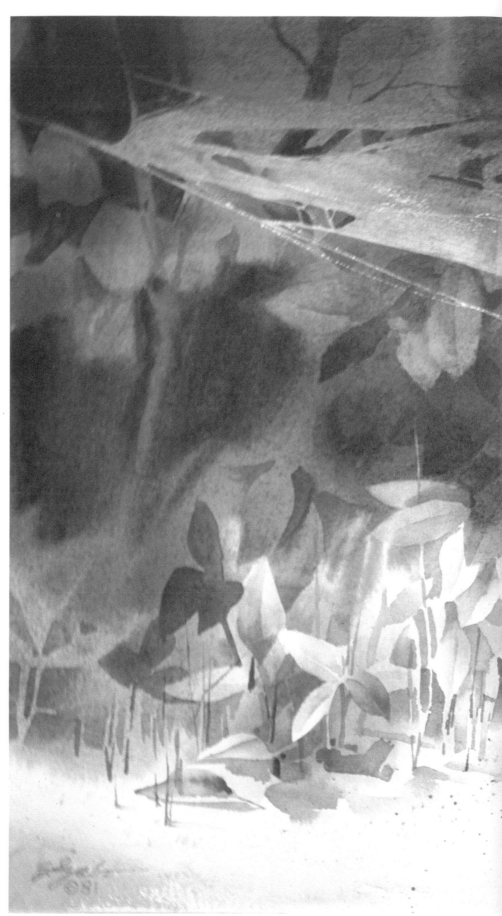

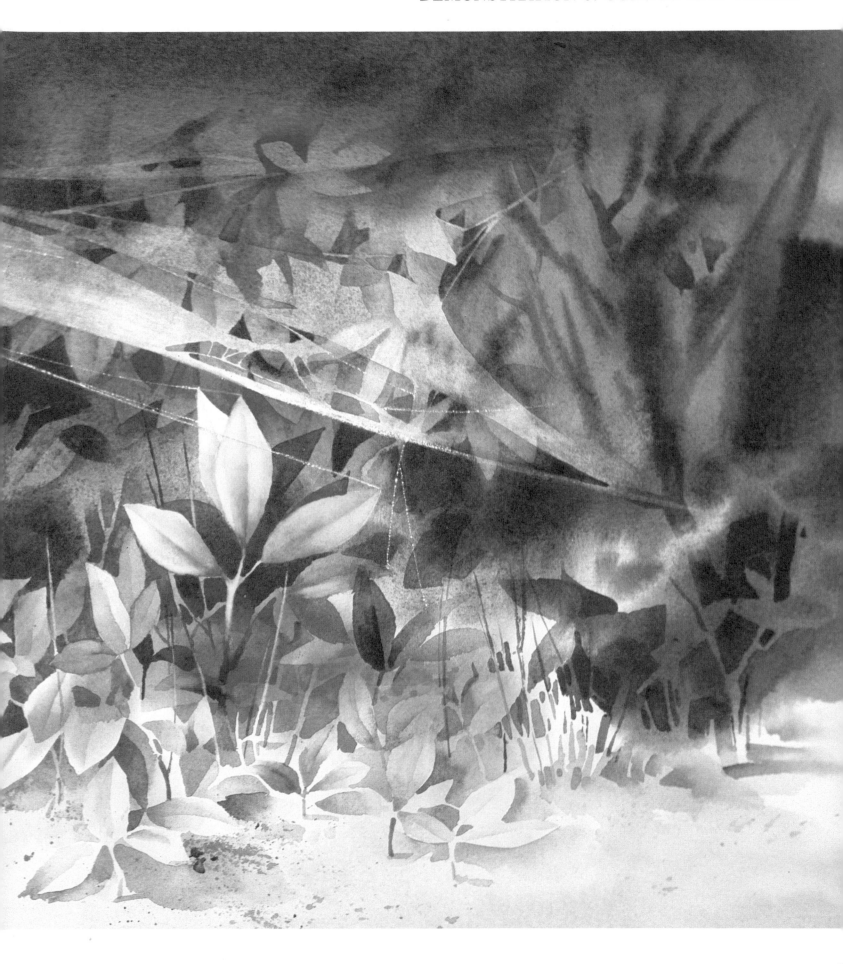

DEMONSTRATION 7. TREETRUNK WITH SPIDERWEBS

Step 1. I'm doing another painting of a web to show you the contrast between the liftout technique (Demonstration 6) and the technique of reserving the lights (Demonstration 7). The composition is divided into two shapes: the vertical trunk on the left and the sky (with a few horizontal branches) on the right, which I paint in two separate operations, both on damp paper. I begin with the light and medium values, saving the darks for later steps. I paint around the bare paper, leaving soft, wet edges on these reserved lights so that I can go back to them and paint the webs. The webs create a bridge that links the shapes of the trunk and background, unifying a picture that would otherwise be badly divided.

Step 2. When Step 1 is dry, I bring medium values up to the edges of the webs to define their shapes. I begin to paint the dark details of the trunk, working around the pale lines of the twigs that grow around the cobweb, or are caught in it. I also begin to add dark branches that grow outward to the right. I'm working with six colors: new gamboge, raw sienna, burnt sienna, sepia, Antwerp blue, and French ultramarine. The warm darks are blue-brown mixtures, while the cooler, lighter tones are mainly blue-yellow mixtures with touches of the browns.

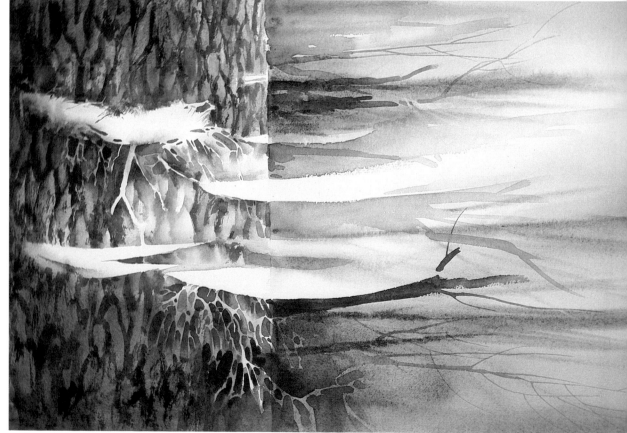

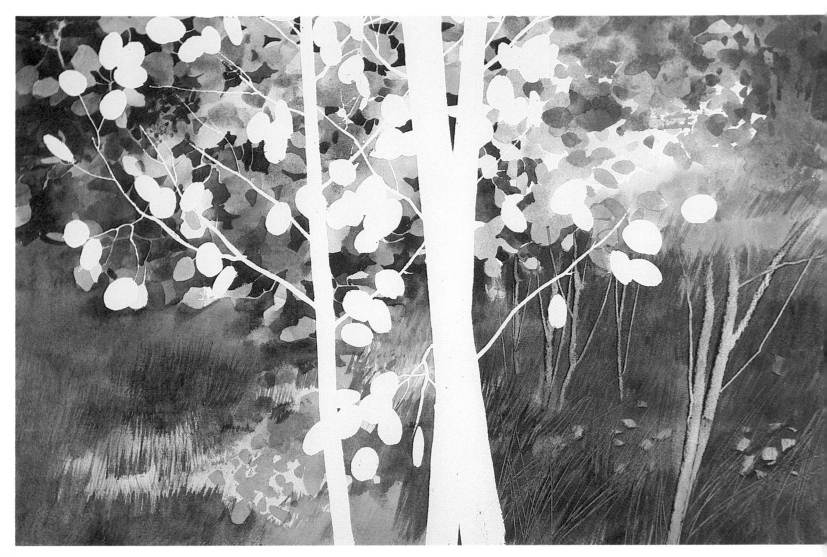

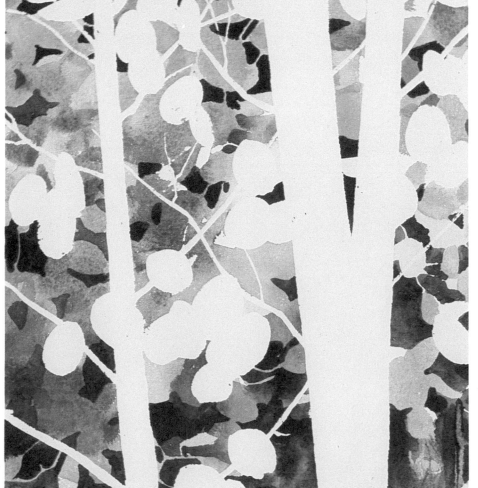

Step 2. When Step 1 is dry, I deepen the values of the dark forest behind and between the leaves. Then I paint the broad tones of the undergrowth, in the lower half of the picture, with a bristle brush. In the lower right, I knife out the trunks of the younger trees. Then I lift out the light lines of the grass with the handle of a nail clipper. (All this is done while the color on the paper is still damp.) These dark tones are all mixtures of Antwerp blue, burnt sienna, and new gamboge. When the colors of Step 2 are dry, I peel off the Maskoid by sticking masking tape on top of it and pulling it away gently. Now the trunks and the brightest leaves are pure, white paper once again.

Step 2 (detail). Compare this detail of Step 2 with the detail of Step 1 on the facing page. You can see how I've gone back into the warm tones of the leaves with sharp touches of cooler, darker color. Thus, the loose, fairly indistinct shapes of Step 1 are neatly broken up into more precise, leafy shapes at this second stage.

DEMONSTRATION 8. SUNLIT LEAVES

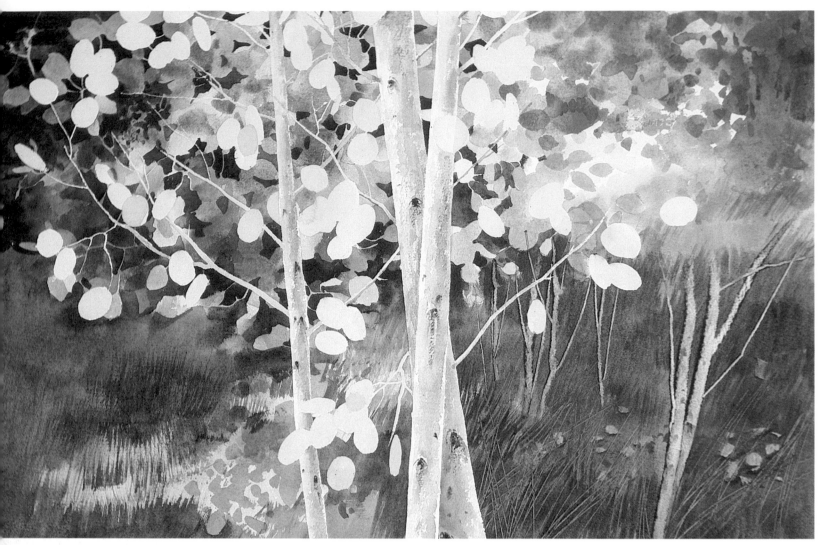

Step 3. With pale, transparent washes, dominated by new gamboge, I glaze the round shapes to look like the leaves on young aspens. For the trunks and limbs, I mix burnt sienna, Antwerp blue, and sepia in varied combinations. To suggest the texture as well as the color of the trunks, I work with loose, scrubby strokes, followed by drybrush touches. In the lower right, you can see bright dabs of color that suggest wildflowers. To relieve the density of the leafy detail, I allow a bit of pale sky to show through at the right of the trunks.

Step 3 (detail). The painting is close to its final stage, but the dense, colorful leaves are essentially a pattern of lights, middletones, and darks, *without* any detail within the leafy shapes. This pattern, carefully planned and executed, tells the story without any need for detail. Each tiny shape has been carefully designed. Study the darks and you'll see that no two dark shapes are exactly alike. Each has been designed and placed so that it reveals the edges of the surrounding leaves.

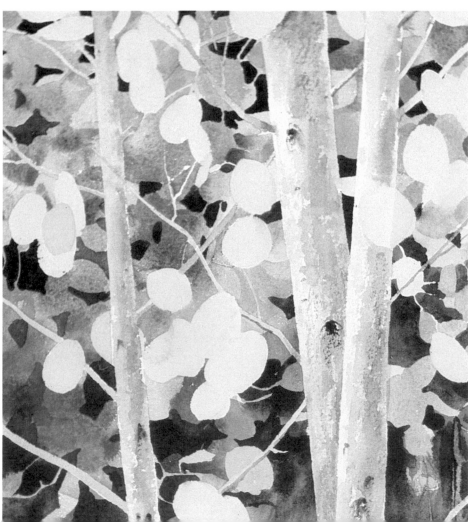

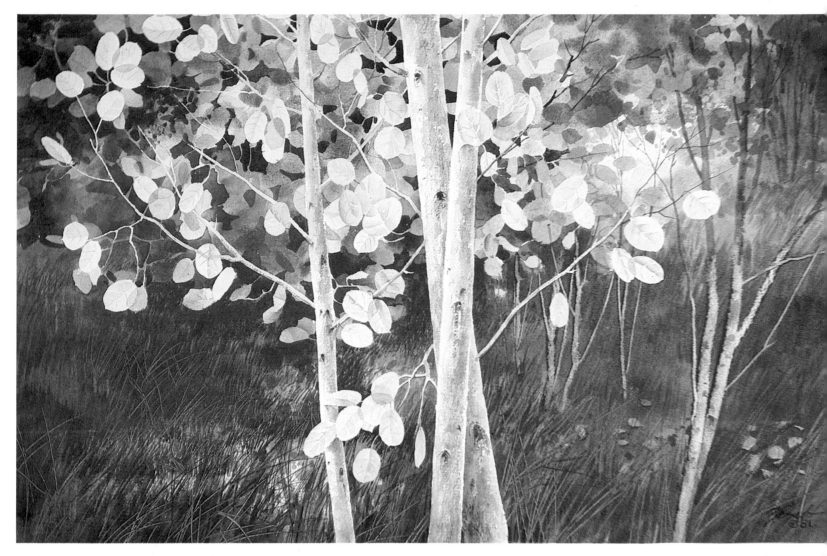

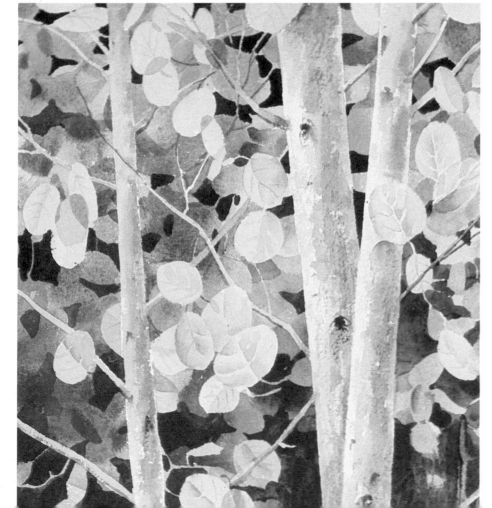

Step 4. At last, I develop the internal details of the leafy shapes at the top of the picture, suggesting veins within the leaves, as well as subtle planes of light and shadow, both within the leaves and where the shapes overlap one another. The grass and weeds come to life as I add dark, slender strokes, and then scratch away the lighter lines. I add more dark trees in the upper right-hand corner. And I darken the upper branches of the slender trees at the right, so that their shapes start out as negative lights and then change to positive darks. Notice how drybrush strokes blend the grass softly into the ground cover. In the lower left, the shadowy grass is darkened to dramatize and balance the lights that dominate the upper part of the picture.

Step 4 (detail). Now the flat shapes at the top of the picture are transformed into realistic leaves by selective touches of detail. I don't paint every vein on every leaf, but just add details to a *handful* of leaves. To create a more three-dimensional feeling, I also add shadow shapes where leaves overlap. Within individual leaves, I suggest tiny planes of light and shade. *Recycled Gold* is 15″ x 22″ (38x56 cm).

DEMONSTRATION 9. SHRUB ON FOREST FLOOR

Step 1. The major shapes of the picture are established with rich, luminous colors, painted wet-in-wet. The result is a kind of abstraction, which already begins to communicate the feeling of the subject, although there are no precise shapes or details. The strongest contrasts are placed around the center of interest, which will eventually turn out to be a shrub. My palette is new gamboge, sap green, burnt sienna, brown madder, Winsor blue, French ultramarine, and sepia. Beneath the dark brown of the trunk, next to the bright leaves, there's a stain of sap green. This color will be useful later, when I want to lift out a few leaves, exposing the green underneath.

Step 2. Scrubbing with a wet brush, I lift out some leaves. Inside these leafy shapes, you see the sap green, which sticks to the paper because it's a strong stain. To gain sharp edges, I paint some shadows around a few leaf clusters. Turning my attention to the forest floor, I apply a tacky mixture of raw sienna, sepia, and a little burnt sienna, and I immediately squeeze out the needles on the ground with the tip of my knife. I also 't some detail from the lighted : de of the trunk. The forest f. or isn't finished yet, but th re's a more distinct shape to ach flash of light that mc es diagonally across the for t floor.

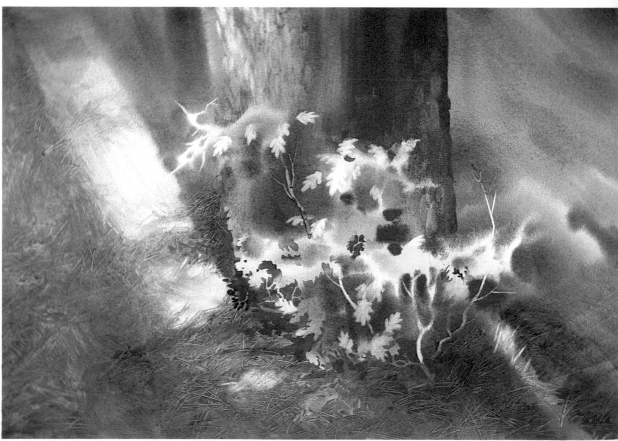

DEMONSTRATION 9. SHRUB ON FOREST FLOOR

Step 4 (detail). It's important to know just how far to carry texture and detail in the final stage of a picture. You can see that I move carefully around the shapes of the leaves with dark strokes to define the edges. I don't define every single leaf, but allow some of their shapes to be lost in the shadows. I'm also very selective about adding detail within the leaves, adding just a few veins and stems. The drybrush texture on the trunk is mainly on the lighted, left-hand side. The pine needles on the forest floor are indicated with loose, irregular scrapes that *suggest* more detail than you can actually see. To avoid monotony, there's less texture in the lighted areas. The leaves are full of magical light-to-dark transitions, which are the result of the wet-in-wet treatment in Step 1. *Daily Miracles* is 15″ x 22″ (38x56 cm).

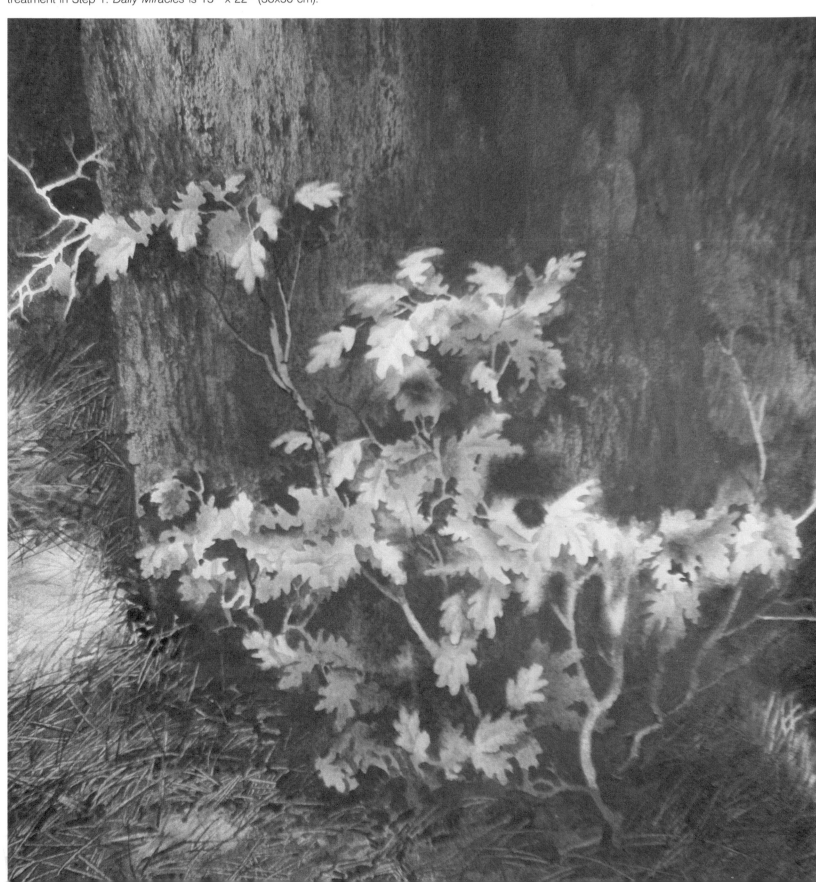

DEMONSTRATION 10. FALLEN LEAVES

Step 1. I start with the colorful focal point, concentrating on the leaves at this early stage because I want to get their shapes, placement, size, and relationship exactly right. I also know that my colors will be cleanest if I work on pure, white paper, before any other colors are applied. The leaves are painted with the simplest watercolor technique: a series of clear, transparent washes, gradually building up color and detail from light to dark.

Step 2. To protect the bright leaves from further brushwork, I cover them with Maskoid. That's why they look so dark here. Now I can work freely, brushing in the weeds with various mixtures of Antwerp blue, raw sienna, and French ultramarine. The drybrushed clumps are done with a flat 1″ bristle brush. Notice the *negative painting* in the foreground, where I paint the darks *around* the bright shapes of the weeds. Bare paper at either side suggests the fact that the ground is covered with snow.

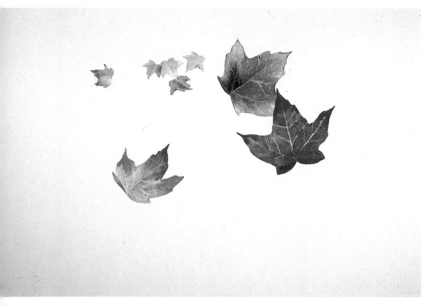

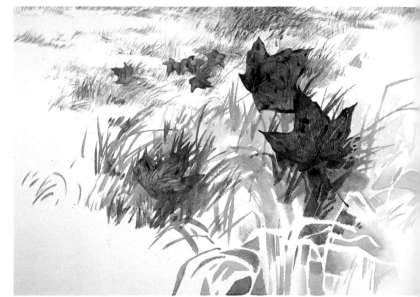

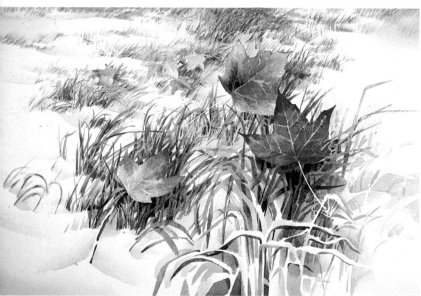

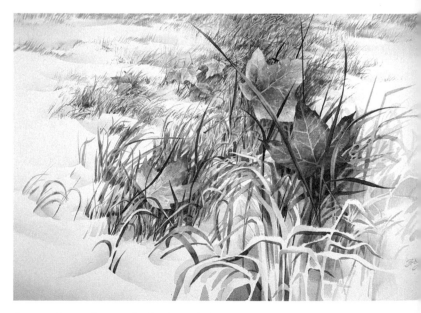

Step 3. Now I continue to develop the detail of the weeds by adding more dark strokes, particularly around the bigger, brighter leaves in the foreground. These strokes indicate the shadowy undersides of the graceful, snow-covered weeds at the very bottom of the painting. Now I strip off the liquid latex because I want to be sure that I can judge the values of the leaves and weeds more accurately. From this point on, I'll have to be more careful as I work around the leaves.

Step 4. I establish the final value relationships, adding dark touches throughout the weeds for more contrast with the leaves. I carry dark strokes over the leaves to suggest additional weeds. I also carry the dark patch at the top of the picture down to the edge of the topmost leaf to emphasize the light silhouette. In Steps 3 and 4, I've been working on the subtle modeling of the snow that surrounds the weeds and leaves, so that the negative spaces of the bare paper are converted into snowdrifts with hints of shadow.

Step 4 (detail). The dark details of the weeds are carefully woven around, and sometimes across, the leaves in order to frame the warm, bright colors. I plan each stroke before I touch the paper, so that all the strokes have a gentle, rhythmic feeling. Within the darks and middletones of the weeds, I leave lots of bare paper for negative shapes that suggest snow lying on top of the blades, as well as on the ground beyond. It's important not to overdo this kind of detail, so I concentrate all this intricate brushwork at the center of the picture, merely suggesting the distant weeds with drybrush touches and a bit of scraping. I leave plenty of blank paper at either side of the center of interest. *Late Visitors* is 14½″ x 22″ (37x56 cm).

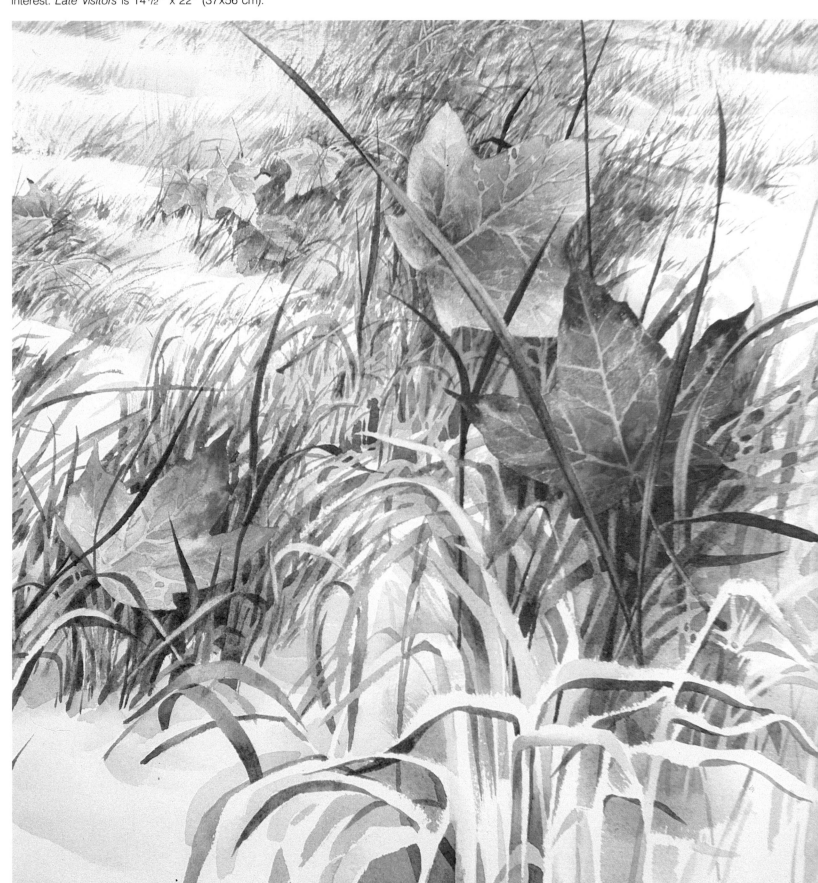

DEMONSTRATION 11. REFLECTIONS

Step 1. Although the subject of this painting is a landscape rather than a small detail of nature, it's a closeup in the sense that it's a study of a body of water that contains interesting reflections. It's usually best to begin by painting the object that will be reflected, as I do here with the trees and the band of sky. The trees are essentially a flat wash covered with darker strokes of drybrush. The band of sky gradates from dark to light. And the band of shadow on the snow is a single, broad stroke on wet paper. I use new gamboge, burnt sienna, and Antwerp blue on the trees, adding a little French ultramarine for the sky and the snow shadow.

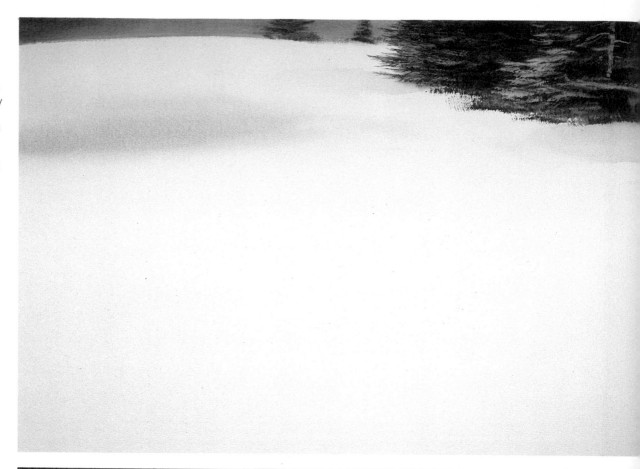

Step 2. Moving into the jagged patch of water, I paint the darkest values of the reflection on damp paper to create soft edges. The reflection contains the same colors as the trees above, but with more blue and burnt sienna. The ground cover, just beneath the trees, is painted with drybrush touches of new gamboge, burnt sienna, raw sienna, and Antwerp blue, with bright notes of new gamboge for the early flowers. For the pebbly ground, my colors are burnt sienna, brown madder, and French ultramarine. To indicate scale, and also to provide some relief from the bare, harsh snow, I paint a few trees at the far edge of the water.

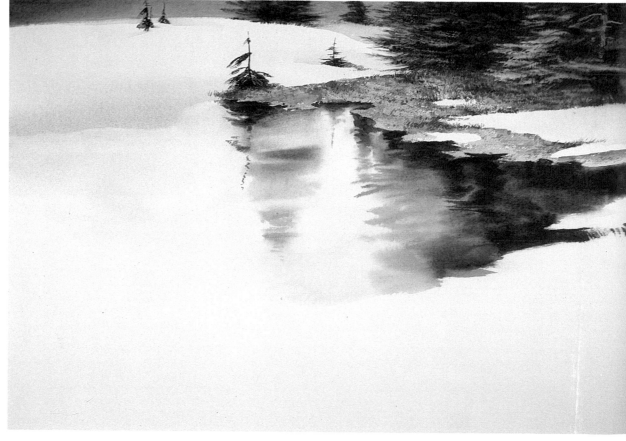

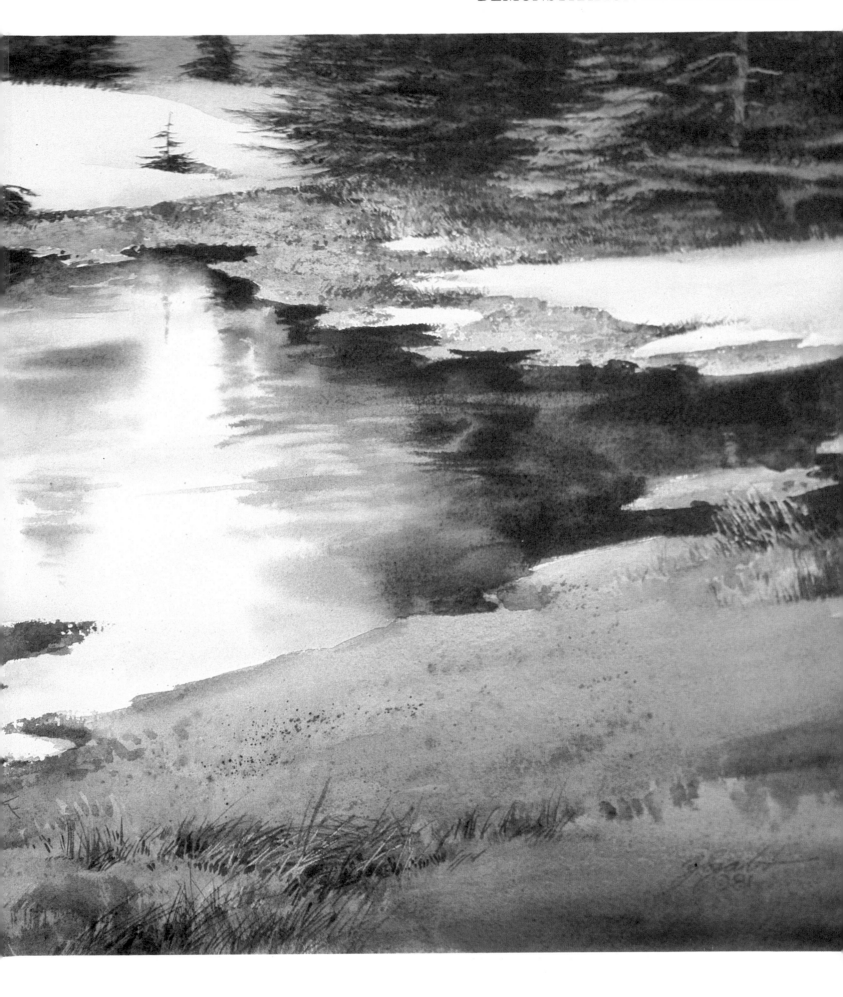

DEMONSTRATION 12. PUDDLE

Step 1. This is probably the most offbeat closeup in the book—two puddles at my feet on a muddy road. The shapes have to be exactly right, particularly the big puddle, which will mirror the pure colors of the sky in the finished painting. So I brush the two puddles with a coat of liquid latex. Study this first step closely, realizing that you're looking at a negative image. In the finished painting, what's dark in Step 1 will turn out light, and vice versa. Every line and droplet of the mask will play some role in the painting. That's why this kind of mask takes planning, and mustn't be applied casually.

Step 1 (detail). Here's a *lifesize* view of that mask. The big, dark blobs will be the puddles. The very slender strokes, running from top to bottom, will be glistening lines of water in the tire tracks in the muddy road at my feet. And the tiny droplets of liquid latex will be a few bright, scattered leaves that punctuate the darks of the road.

Step 2. Over the dry latex, I brush a rough, abstract impression of the muddy tire tracks. I use 2″ and 1″ soft brushes with lots of wet pigment. The dark colors are various mixtures of Antwerp blue, burnt sienna, and sepia. There's a fair amount of drybrushing over the broad strokes, some spatters, and some precise touches in the form of angular dots that indicate the imprint of the tires. I paint the grass at the side of the road with Antwerp blue, raw sienna, and burnt sienna, squeezing away the lighter blades of grass with the tip of my nail clipper.

Step 2 (detail). I've gone right over the edges of the puddle and temporarily obliterated the smaller puddle at the left. But these shapes will return when the mask is peeled away. The brushwork isn't as casual as it looks. The strokes are slightly tilted to suggest diminishing perspective. The dotted tire tracks are placed with inconspicuous precision among the drybrush strokes. The pale lines made with the nail clipper—scraped out of the wet color of the grass—curve gently away from the edge of the road.

DEMONSTRATION 12. PUDDLE

Step 3. I press tape against the dried latex and peel off all the masks, revealing the puddles and all the delicate brushwork around them. Now I develop the details of the muddy tracks with a new series of dark, slender strokes, working around the puddles and preserving the strips of white. The tire tracks become more distinct and the texture is stronger. Over the tiny flecks of white paper above the puddles and to the left, I glaze warm tones and sharpen up the contours to suggest small, fallen leaves. I convert some of those spatters into pebbles. The two puddles remain white paper.

Step 3 (detail). Examine the buildup of dark strokes that convey the detail and texture of the muddy road. The brush moves freely, so the strokes *look* spontaneous, but they still maintain the right amount of precision. Some strokes are made with a wet brush, so that they're fluid and juicy, while others are made with a damp brush, so they resemble drybrush strokes. Just enough of those regularly spaced dots express the mechanical pattern of the tire marks—but not so much as to become monotonous.

Step 3. Now I concentrate my attention around the center of interest. I remove the liquid latex on the fallen tree and then model the tree with halftones and shadows. Moving around the tree, I paint the cool ripples in the distant water and the warm ripples in the foreground water. I put more darks in the upper right to define more branches. I then add more branches (both dark and light) in the upper left, surrounding the warm shape that will soon be transformed into foliage. In Steps 2 and 3, I gradually lift out the light in the water and build up the detail to suggest foam.

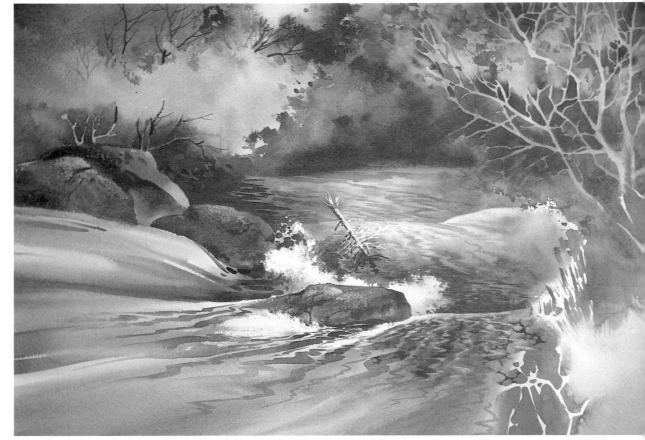

Step 4. The intricate foreground detail is saved for the last stage, as usual. Many touches of warm color—mainly burnt sienna, sepia, new gamboge, and some ultramarine blue—represent the foliage and branches of the low shrub. I bring these colors up into the big tree at the upper right to suggest clusters of foliage, and I move across the picture to add these colors to the lightstruck foliage in the upper left. I warm and darken the upper left with another glaze of burnt sienna, adding more dark branches. Finally I use a wet bristle brush to lift off a few highlights on the ripples in the foreground and middleground.

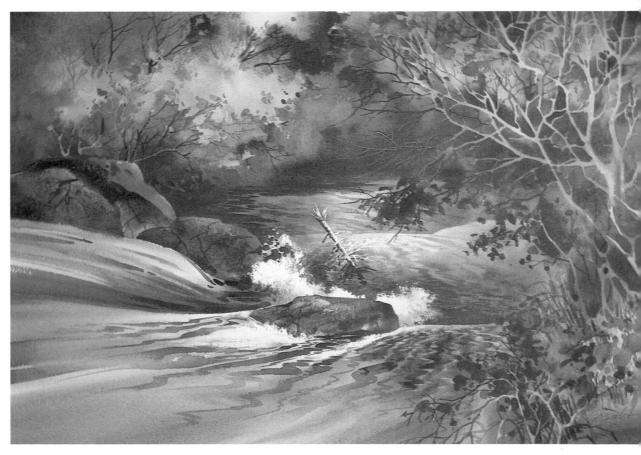

DEMONSTRATION 13. STREAM

Step 2 (detail). At this stage, most of the painting still consists of broad areas of color that flow into one another. There's barely any suggestion of detail. Everything is painted very loosely, except for the hard-edged darks that have been placed in the tree to define the light shapes of the branches. If you're going to paint a tree in this way, you've got to be sure that your background color is light enough, so that the branches will look light when you add the darks around them. If the background is too dark, you'll have to lift the light shapes of the branches with a wet brush, perhaps with the aid of a paper stencil: a sturdy sheet of stiff paper out of which you cut the shapes of the branches with a sharp razor blade. (Paint and hardware stores often carry an adhesive-backed plastic sheet called Contact, which makes an excellent stencil.) You can also scratch out the branches with the corner of a blade, provided that you do this at the final stage of the painting, and don't darken the scratches with wet color.

Step 4 (detail). The finished painting shows the complex pattern of the light branches in the upper right, amplified by some darker branches in the background and toward the left, plus some slender branches that have been scratched out by the corner of a blade against the darkness. A few clumps of foliage have been added with warm strokes. In the lower right, you can see an even more elaborate buildup of detail, where dark strokes of warm color define the edges of the lighter branches, and also create the pattern of dark branches and foliage. The warm, dark foliage pattern merges with the zigzag pattern of the ripples in the stream. In the cool water, notice how the ripples have soft edges because they've been painted on damp paper. They've also been softened as I've lifted out the lights with a wet bristle brush. Thus, there's an interesting contrast between the sharply drawn ripples on the warm bed of the stream and the softer ripples in the cool water beyond. *Riding Downstream* is 15″ x 22″ (38x56 cm).

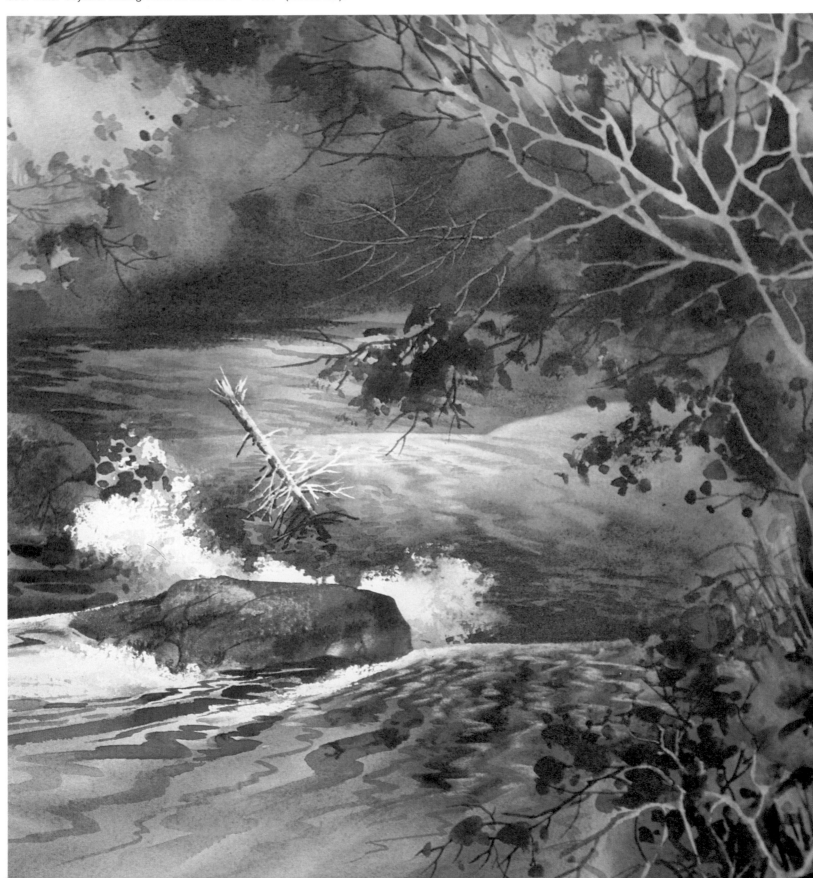

DEMONSTRATION 14. TIDE POOL

Step 1. This is a study of the abstract shape of a tide pool. I wet all but the left center portion of the paper, where I want a few sharp edges to survive. Then I brush the wet surface with raw sienna, burnt sienna, sepia, and French ultramarine. These pigments tend to separate, producing a sandy texture. I leave bare paper for the bright reflections. The distant strip of landscape at the top is mainly raw sienna and ultramarine blue, out of which I knife some bleached-out driftwood.

Step 2. The dark edges of the pool emerge as I paint the reflections with a 1″ flat sable brush that carries burnt sienna and French ultramarine. While this wash is wet, I darken the value drastically with a firm bristle brush, richly loaded with sepia, Antwerp blue, and burnt sienna. At the center of the dark reflection, vertical strokes are interrupted by horizontal strokes that represent ripples. With a small sable brush, I add contrast and detail to the distant driftwood.

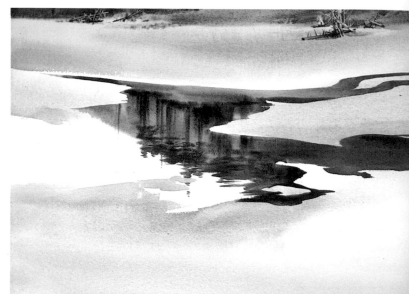
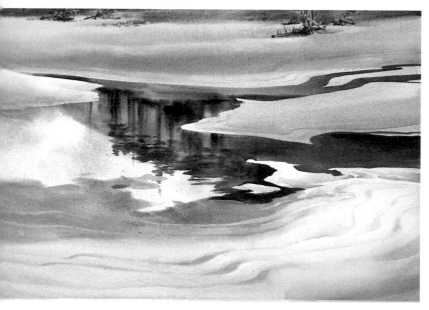
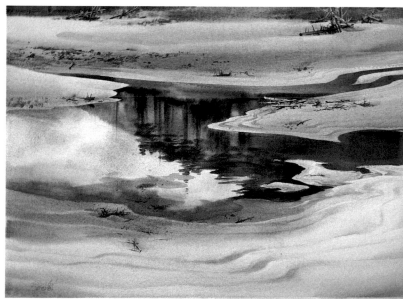

Step 3. With long, curving strokes, I paint the rippling design on the foreground sand, letting these strokes blur slightly into one another. I darken the edge of the pool. On the sand beyond the pool, I add soft shadows with dark strokes, blurring the edges with a damp brush. Wetting the pool with clear water, I drop in a few blue touches to suggest the reflected color of the sky. When Step 3 is dry, I go over the painting to scrub out some lights among the sand and to brighten the cloud reflections in the pool.

Step 4. To add textural contrast, I paint some shoreline debris with small, dark, casual touches. I go around the edges of the pool with slightly darker washes to accentuate the contrasts. At the forward edge, I paint a light wash of Antwerp blue and sepia where the sand is dark and wet. I strengthen the cool tones of the sky reflections in the pool. Finally, I add a few inconspicuous darks in the lower left-hand corner and the strip of shadow just below the grass at the top of the painting.

Step 4 (detail). In this section of the finished painting, reproduced close to lifesize, you can study the varied brushwork more closely. In the immediate foreground, you can see the soft, curving strokes that suggest the rippling pattern in the sand, created by alternating strokes of dark and pale color that blend softly together, with the lights lifted out. You can also see how the dark reflection in the pool has started as a wash of medium value into which I've brushed darker strokes: long verticals that are interrupted by short horizontals that indicate the movement of the water rippled by the wind. The curving shapes of the sand are modeled very much the way I'd model snow, with graded washes and soft tones, finally strengthening the lights by lifting off color when the initial washes are dry. *Tidal Mirage* is 15″ × 22″ (38x56 cm).

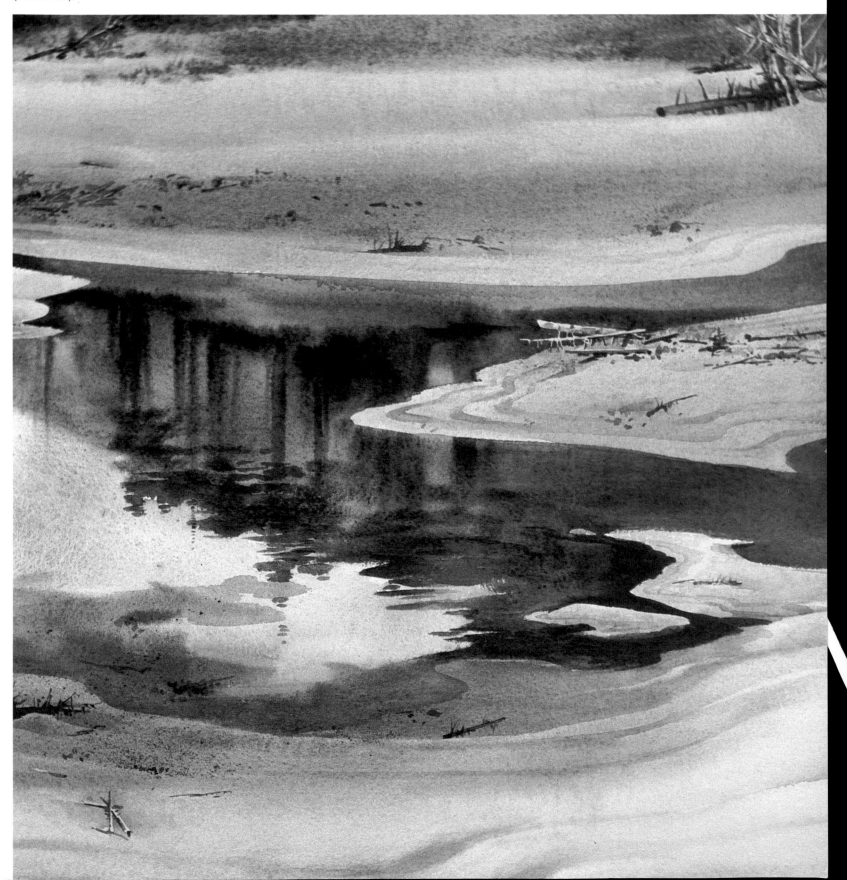

DEMONSTRATION 15. WHITE WATER

Step 1. One of the hardest things to paint is the pattern of white water, where a stream moves over rocks. I begin by wetting the paper and using a 2″ soft, flat brush to establish a loose, abstract base for the composition. I'm working with a six color palette: cadmium orange, brown madder, new gamboge, sepia, cobalt blue, and Winsor blue. All but sepia appear in this first step, which is dominated by cerulean blue to unify all the other colors. The first strokes blend softly on the wet paper. As the paper becomes somewhat drier—although it's still wet—I use more paint and less water in my brush to get sharper definition. You can see these more distinct strokes in the upper right and left corners.

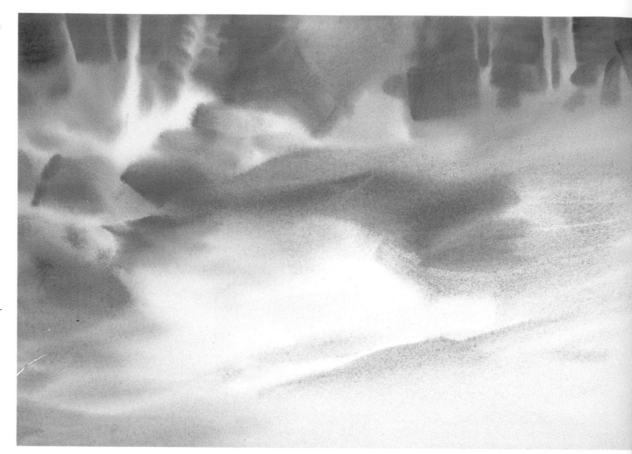

Step 2. In the upper left-hand corner, I build up a combination of positive and negative shapes, carefully designing my darker strokes to reveal the lighter shapes. I keep my darks transparent and many of the shapes have lost edges where the wet strokes fade away. The light areas are filled with the soft, blurred color of Step 1, strengthened by new touches of warm and cool color on the trunks and rocks. The dark shapes are painted with Winsor blue, brown madder, and a touch of new gamboge. The color that looks like burnt sienna is really new gamboge and brown madder. In the upper right, I add a few cool, dark strokes that anchor the negative shapes of the trees to the ground.

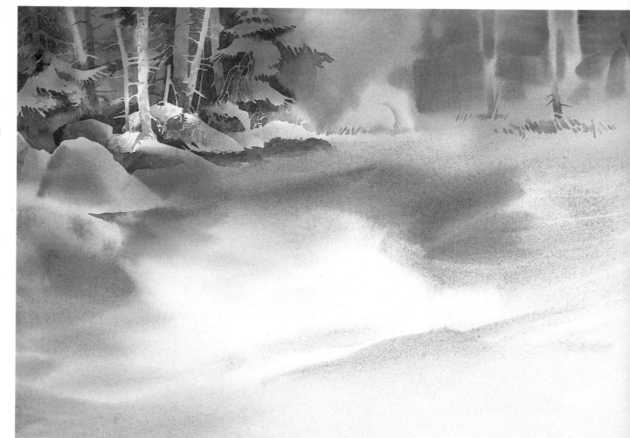

Step 3. Moving down from the background trees, I work on the reflections in the water. The ripples, reflecting the darker values of the shoreline, are Winsor blue, cerulean blue, and new gamboge. I work these darks around the rocks, sharpening their edges. I bring the tone of the water further down to suggest the texture and detail that surround the foam, which now has a more distinct shape. I preserve the glowing color on the dry part of the rocks, but darken the submerged portions so that they look wet. The texture on the rocks is a combination of casual drybrush and spatter.

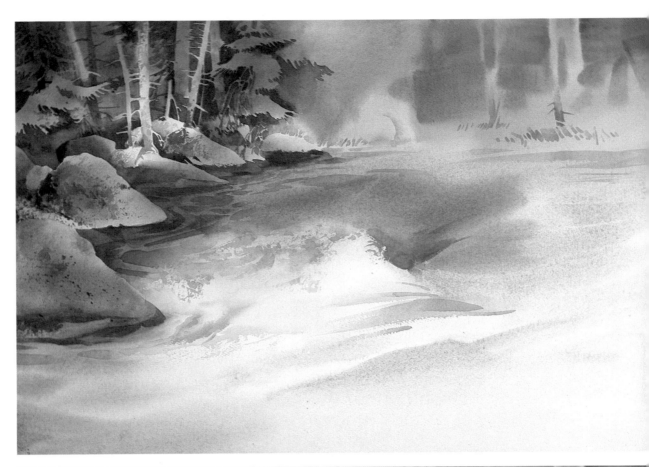

Step 4. Now I mix sepia and Winsor blue for the wet darks of the submerged rocks. I lift out a few lights in the water by scrubbing gently and blotting. A few more trees appear in the background, where you also see a pale, rather ghostly rock that I've isolated by surrounding it with a darker wash. Next to the splashing wave, I place some stronger darks for greater contrast. Last come the cracks in the rocks, some drybrushed and spattered texture, and a bit more modeling to strengthen the shadows.

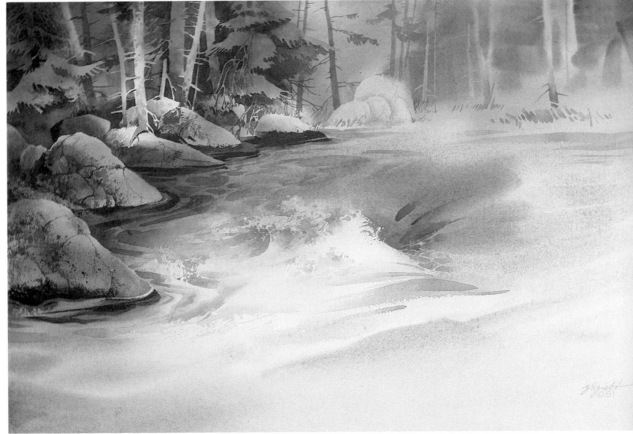

DEMONSTRATION 15. WHITE WATER

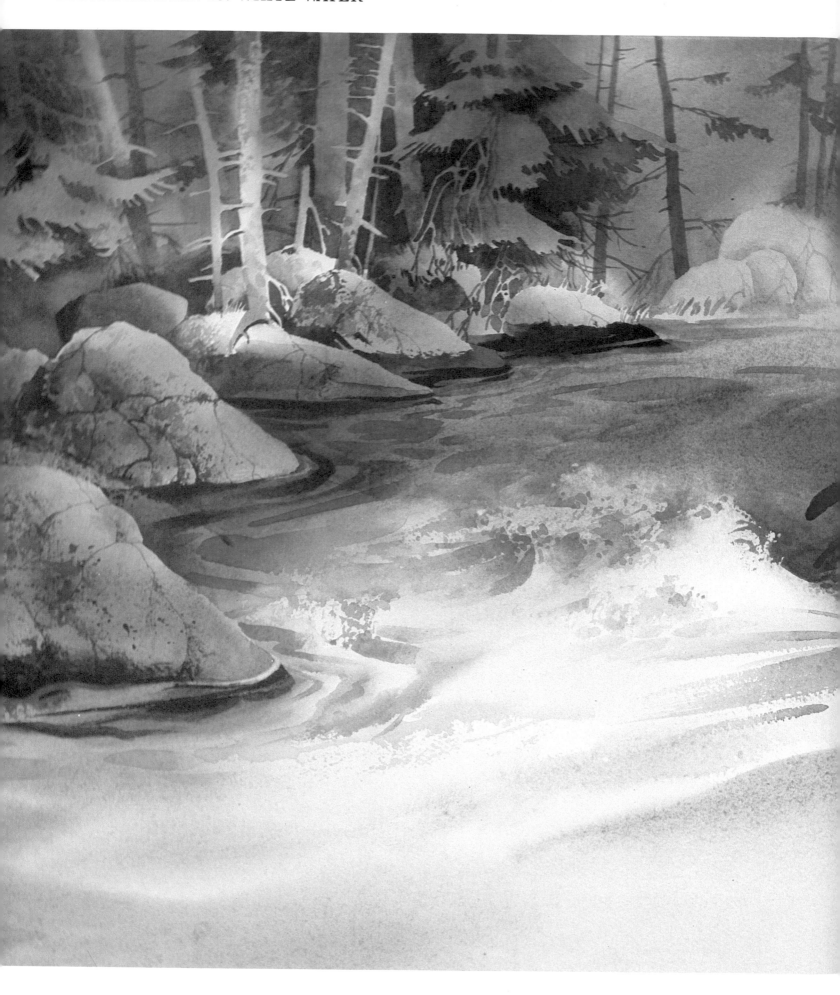

DEMONSTRATION 15. WHITE WATER

Photograph. This snapshot reminds me of the general feeling of the subject, and records some helpful details, particularly the action of the water. When water is moving this fast, a photograph freezes the action.

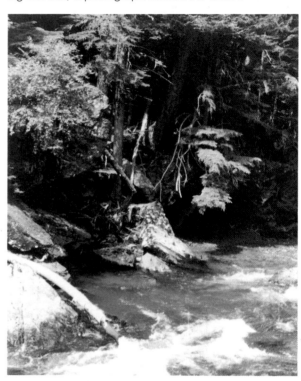

Pencil Sketch. The function of the sketch is to work out the basic composition and the distribution of values. I've determined the location of the main shapes and the most important lights and darks.

Finished Painting. To dramatize the white water, I've surrounded it with the darks of the trees and rocks, as well as the dark reflections. The movement of the water is expressed by smooth, transparent strokes with lost edges, and rough, drybrush strokes. Where the water moves quickly, my strokes are painted quickly. Where the beads of water seem to stop in midair, I apply drybrush very gently. Because there's very little variation in the color of the water, this area of the painting depends upon lively brushwork and control of values. At first glance, the water may seem to consist mainly of white paper, but there are just a few pure whites; most of the water is covered with delicate tones. *Dancing Blues* is 15″ x 22″ (38x56 cm).

DEMONSTRATION 16. FOOTPRINTS IN SNOW

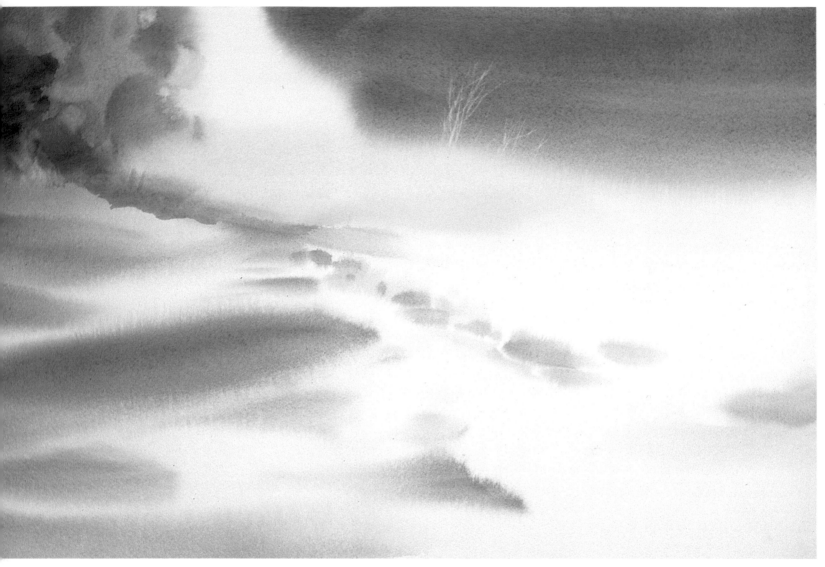

Step 1. The design of this painting is essentially a lot of white space punctuated by darker notes that must be well-balanced and lead the eye through the landscape. The purpose of this first step is to locate the major light and dark shapes. Wetting the entire surface of the paper, I brush on a mixture of brown madder, cerulean blue, and Antwerp blue to model the snow. To stengthen the darks, I use the same mixture, plus French ultramarine and a touch of burnt sienna. As the surface begins to dry, I apply the darker, more distinct strokes in the upper left-hand corner, and I brush in the pale, frosty trees at the horizon with strokes of clear water.

Step 1 (detail). In the upper left-hand corner, I start to model the snow-covered trees with their big chunks of snow. Right now, all you can see are rough, irregular strokes on the shadow sides of the trees, plus a shadowy ditch for the path that leads across the snow into the trees. Notice that this ditch has a soft (lost) edge above, and a hard (found) edge below.

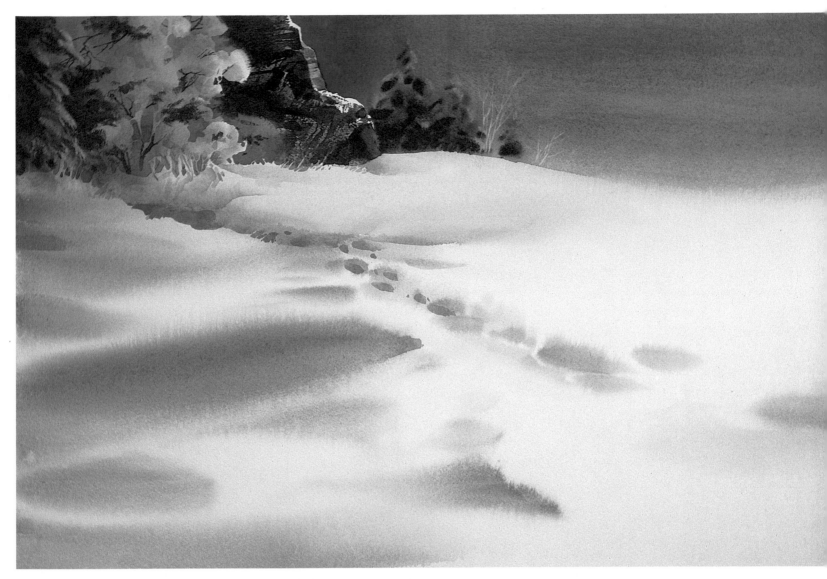

Step 2. The forms of the snow-laden trees emerge as I add strong darks to indicate trunks, branches, and masses of foliage. I paint middletones around the pale, frosty trunks close to the ground. The warm rocks start out with a wash of raw sienna, new gamboge, and a hint of French ultramarine, followed by darker brush-strokes and knifestrokes of blue-brown mixtures for the shadows and the texture. The slightly blurred strokes of the tree at the center of the horizon can be painted by rewetting that part of the paper, or while the paper is still damp toward the end of Step 1. I'm beginning to sharpen the foreground darks with small, distinct strokes along the path.

Step 2 (detail). Along the hard, lower edge of the path, I add darker touches to deepen the shadow tone and make the path more distinct. The strong darks in the trees are raw sienna, brown madder, and French ultramarine. Notice the lost and found edges that model the snowy shapes and give a three-dimensional feeling. The modeling on the warm rock formation starts with thick, moist, drybrush strokes, followed by some knifed-out texture to pick out the lights.

DEMONSTRATION 16. FOOTPRINTS IN SNOW

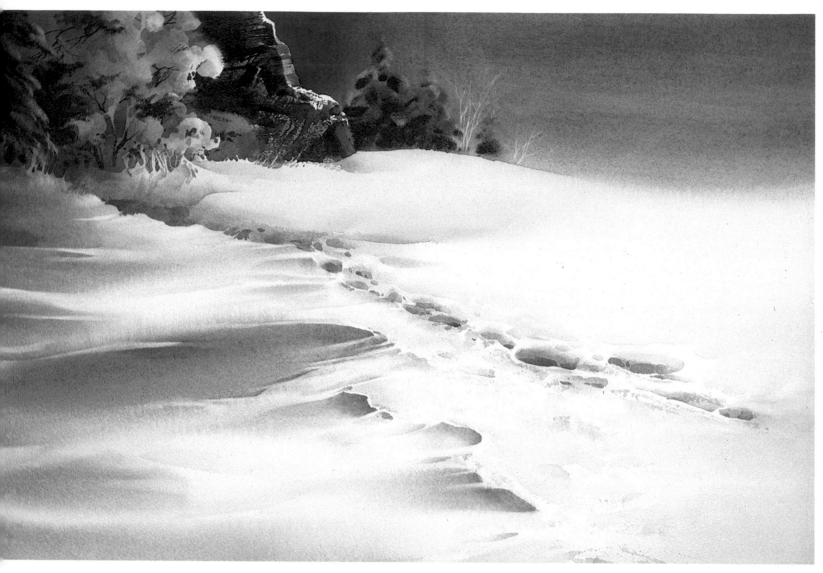

Step 3. Now I work on the modeling of the drifting snow and the footprints. I warm the blue with brown madder to suggest warm sunlight. I brush this mixture over the soft shapes of Step 1, strengthening some edges—but not all of them—and heightening the contrast of light and shadow. Small touches of this darker shadow tone appear among the footprints. A damp, thirsty brush pulls white streaks out of the shadows. To suggest highlights along the edges of the snowdrifts, I paint pale washes to the right of each shape, leaving a bright edge of untouched paper at the high point of the drift. I enliven the distant shrubs with touches of warm color for leaves.

Step 3 (detail). Study the modeling on the drifts. The shadow shapes are darkest and have the hardest edges at the high points of the drifts. Just to the right of this hard, dark edge, you see a slender, white rim, where the sunlight hits the high point of each drift. Then, on the other side of this white rim, you see an almost invisible wash where the drift tapers downward, away from the highlight. Deep pools of shadow have been placed in some of the footprints, but not all of them.

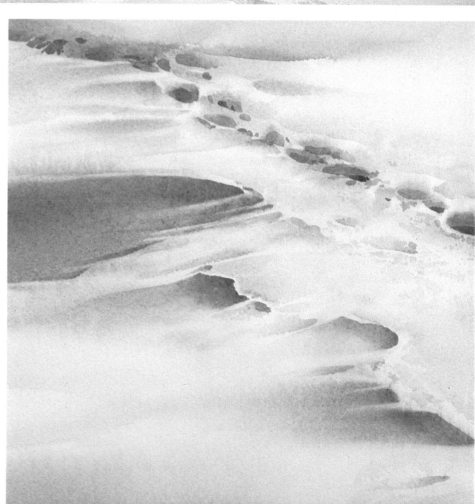

Step 4 (detail). The shadows of the trees are darkest where the shadow meets the trunk, gradually growing paler as each shadow moves away. I brighten the snow selectively by scrubbing that easy-to-lift manganese blue with a wet bristle brush and then blotting away the wet color with a tissue. There's actually very little detail in the painting, and most of that detail is concentrated in the foreground. That's where you can see the light weeds that I knife out of the damp color, and the darker weeds that I brush up over the icy edges of the snowbank. Where the snow meets the water, there's a slightly darker strip to indicate ice. The shadows on the snow are kept soft and atmospheric— it's important to avoid the temptation to exaggerate shadow contrasts on snow. *Mountain Chemistry* is 15″ x 22″ (38x56 cm).

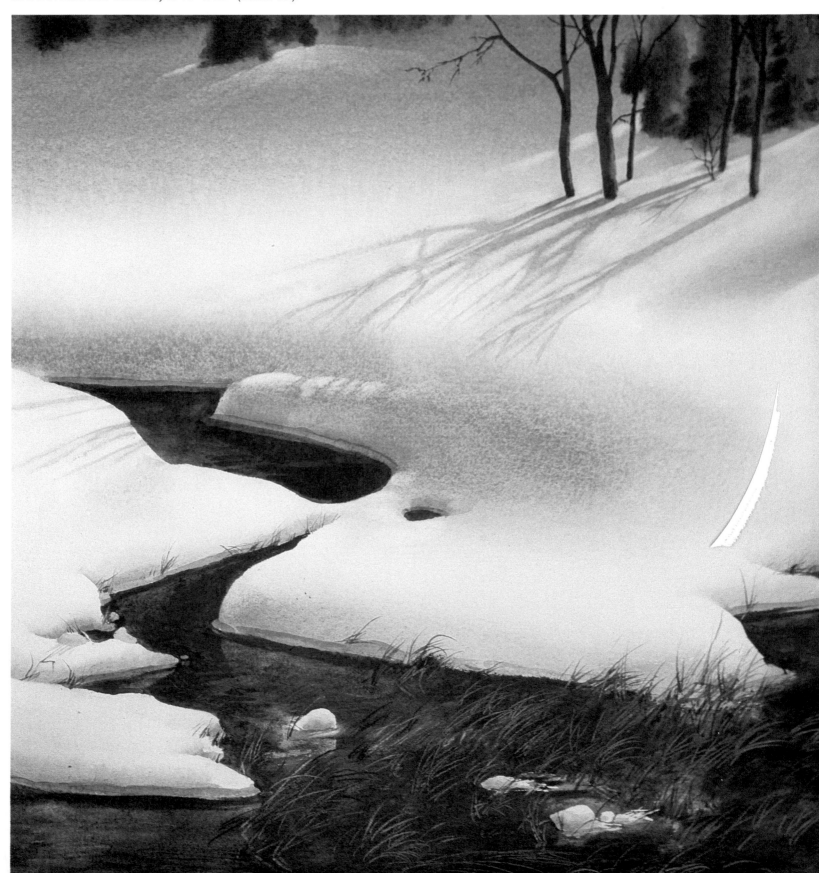

DEMONSTRATION 18. SNOW-COVERED TREE

Step 1. The grandeur of the Grand Canyon is the background for this closeup. I play down those colossal shapes and colors by simplifying them. Once again, the first step is painted on wet paper: cool colors in the sky and warm colors in the layered rocks of the canyon. The rocky colors are streaky to suggest the horizontal layers. I pay particular attention to the degree of moisture in my brush, making sure that the brush holds *less* moisture than the paper, thus avoiding unexpected backruns with ugly, hard edges. Notice how the sky is gradated from dark to light.

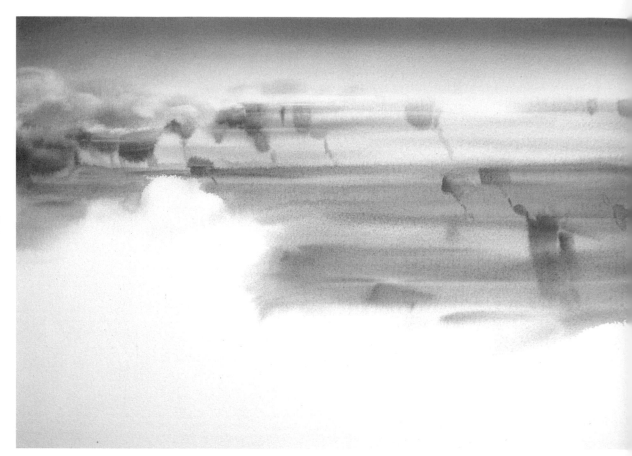

Step 2. While the paper is still slightly damp, I paint the deep shadow of the gorge with Winsor blue, ultramarine blue, a little alizarin crimson, and a hint of burnt sienna. Then, with varied combinations of Winsor blue, French ultramarine, and a little burnt sienna, I paint the masses of the snow in the foreground, as well as the disembodied masses of snow that are silhouetted against the sky, where they'll hang from the branches of the tree. The tops of these shapes have sharp edges, while the lower edges are lost. For the shadows on the snow, I add a hint of alizarin crimson to this mixture. Right now, the snowy masses look more like clouds than snow. But watch what happens in Step 3.

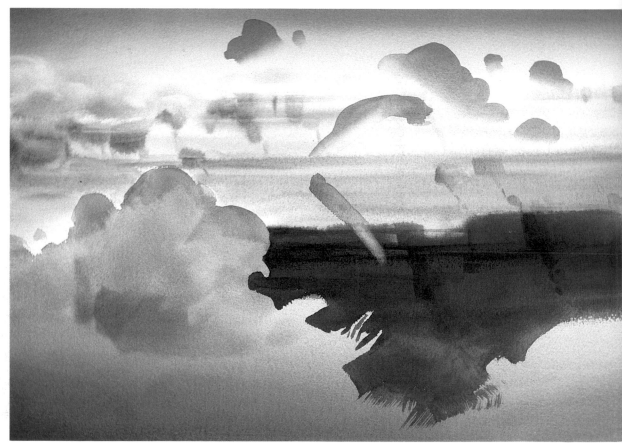

Step 3. Now I link up those clumps of snow by painting my center of interest—the big, old, weatherbeaten tree—with various mixtures of burnt sienna, new gamboge, alizarin crimson, and French ultramarine. I indicate the foliage beneath the snow with small, scrubby strokes of burnt sienna and ultramarine blue, working with a damp brush so that the hairs will divide. I work around those pale spots where the snow hides the dark limbs. Many of these snowy patches look too flat right now, but I'll model them in the next step. Those snowy shapes do have a nice glow of reflected light.

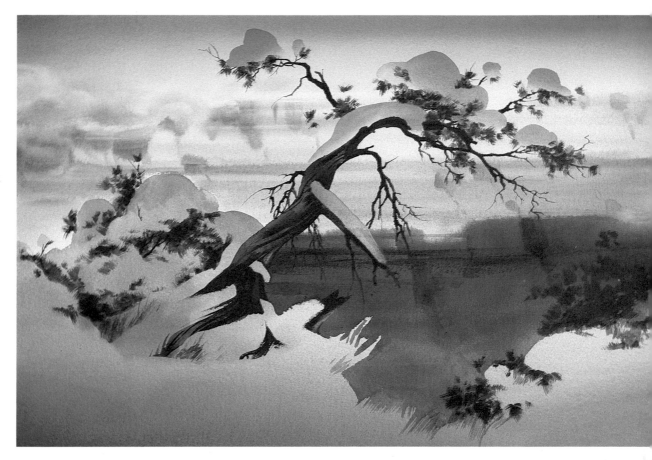

Step 4. Now I finish modeling the clumps of snow with very soft, graded washes that have lost-and-found edges. Throughout the painting, I've used a lot of Winsor blue, which stains the paper and won't come off when I scrub and lift away color to strengthen the lights as I do here. I also lift out the frosty weeds at the bottom of the painting, brushing in a few dark weeds (with their shadows) here and there. For greater luminosity, I lift some color off the treetrunk. And I add some more dark twigs to complete the tree. *Show Stopper* is 15″ x 22″ (38x56 cm).

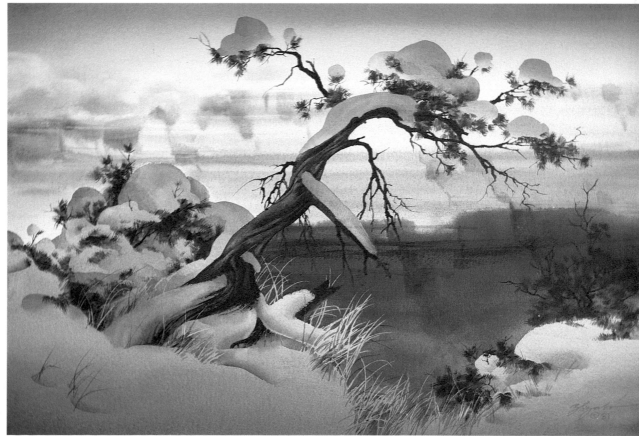

DEMONSTRATION 19. SNOW, WEEDS, AND ICICLES

Step 1. Just before sunset, the sunlight is very warm, and the snow picks up this warm light, which bounces over every surface. I paint this glow of direct and re-flected light with a 2″ flat, soft brush, richly loaded with new gamboge, alizarin crimson, Winsor blue, and French ultramarine in various combinations. I apply these colors on wet paper, allowing them to blend where the strokes touch. Thus, the first step is an ab-stract impression of warm and cool contrasts. Even the lightest areas of the paper contain a hint of color. I don't leave pure white anywhere.

Step 1 (detail). At first, this section of the painting is just a big, sunny mass of color, reflecting the rosy hues of the sun as it approaches the horizon. Because the strokes are painted on wet paper, all the edges are soft and the colors tend to flow together. However, the ef-fect isn't as accidental as it looks. As you'll see when you look at Step 2, this shape has been precisely planned, and the colors are placed exactly where I want them, creating a solid, three-dimensional form with a highlight in the center.

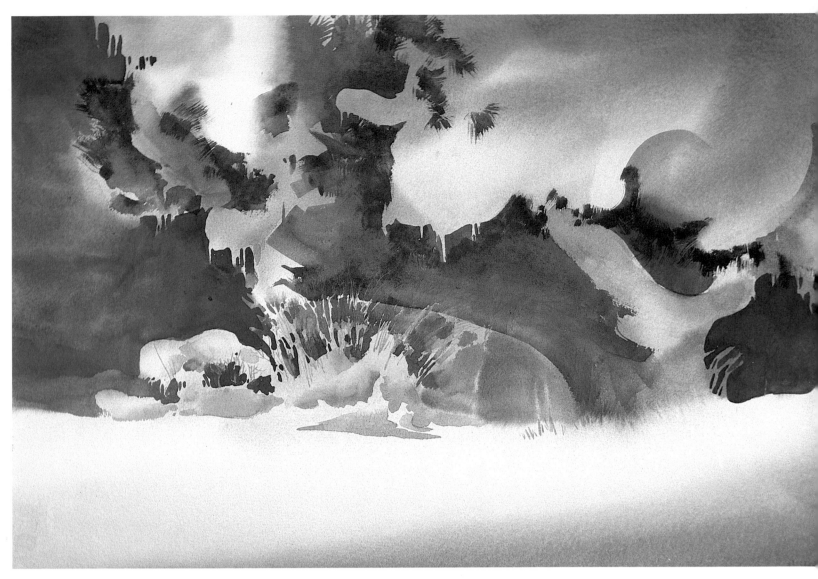

Step 2. When Step 1 is dry, I mask out the fine, slender weeds in the bright light to permit me to brush the background color freely over them. I paint the cool background tone (Winsor blue, French ultramarine, and alizarin crimson) around the silhouette of the trunk with its big masses of snow, defining the horizon line at the same time. I work around and over the weeds with smaller strokes of the same mixture. With burnt sienna and Winsor blue, I rough in the shape of the treetrunk and the silhouettes of some branches. These two dark tones, one cool and one warm, define a lot of the pale, negative shapes, such as the snow clumps, weeds, and icicles.

Step 2 (detail). Working around that rosy, cloudlike shape in the upper left, I add the warm darks of the pine branches. In many places, I work with a split brush to suggest clusters of pine needles. Thus, the amorphous shape in Step 1 begins to look solid, with strong contrasts of light and dark. The brushwork is still broad and rough, but you begin to see a clump of snow hanging amid the pine branches.

DEMONSTRATION 19. SNOW, WEEDS, AND ICICLES

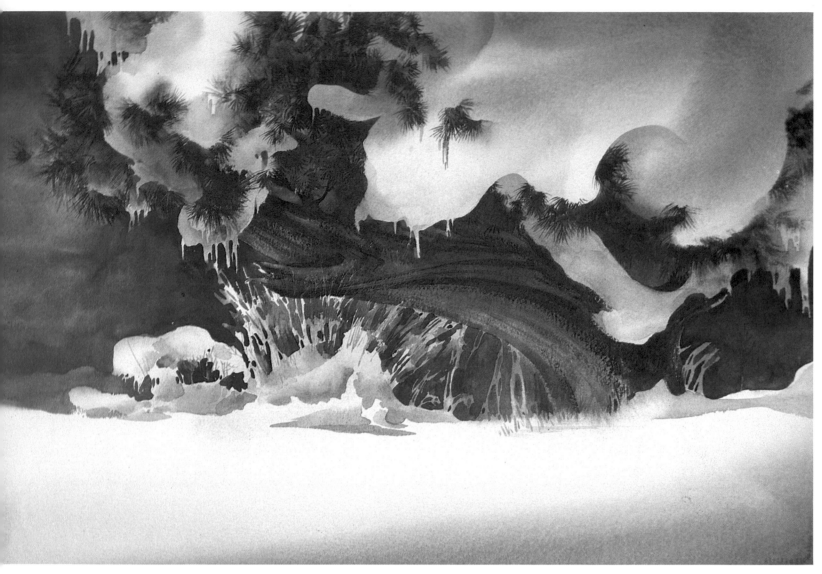

Step 3. With sharp, tiny strokes, I develop the detail of the foliage, defining many more pine needles. This is particularly evident in the upper left, but you can also see these details beneath the big clump of snow to the right. Working mainly with drybrush, I add texture to the thick trunk. Beneath the trunk, I add more darks to define additional weeds—sharpening the lower edge of the old juniper at the same time. I place a few cast shadows on the ground to the right. And I add more modeling to the hanging clusters of icicles to make them look more solid and less like cutouts.

Step 3 (detail). In this section of Step 3, you can see where I add more detail to the needles at the top. Dark drybrush strokes, following the curve of the tree shape, suggest the texture of the bark. I place more darks among the weeds to suggest still more detail.

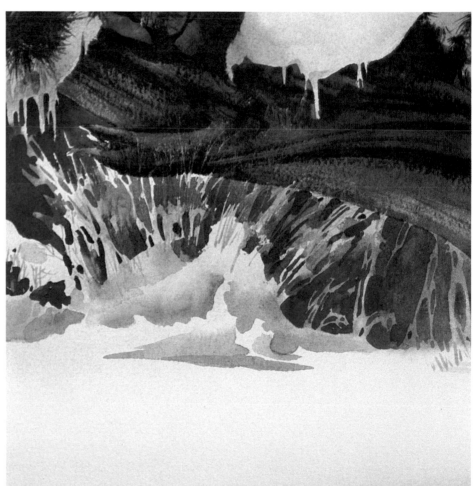

DEMONSTRATION 19. SNOW, WEEDS, AND ICICLES

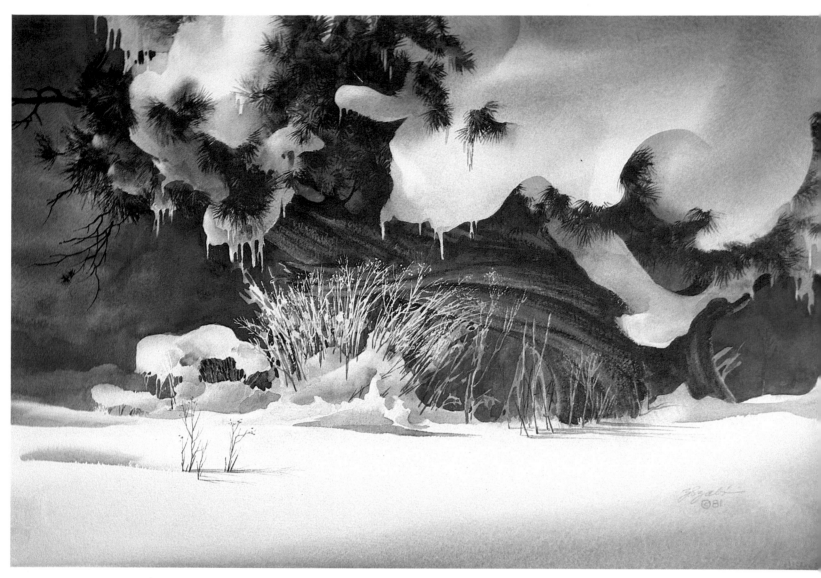

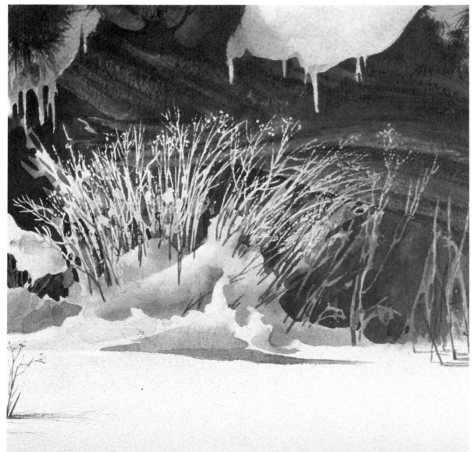

Step 4. I alter the light on the trunk by scrubbing off dark color along the lower edge. This brightens the shape with reflected light bouncing off the snow. Lifting off the Maskoid to expose the light weeds, I add dark weeds, thus anchoring the entire clump to the snow. (The warm tone of the pale weeds remains untouched as I painted it in Step 1.) Since the tree needs to rest more firmly on the ground, I widen the base, adding more darks, and scratching out pale weeds. I brighten the lights on the snow by scrubbing and blotting. I paint dark, slim branches with sepia and Winsor blue. The foreground needs more action, so I add more weeds and their tiny cast shadows.

Step 4 (detail). With the latex peeled away, the frozen weeds reveal an extraordinary amount of detail. The original color, painted in Step 1, shines through. Dark weeds mingle with the lighter ones. You can see where I've scrubbed away the dark underside of the trunk to suggest reflective light, and where I've drybrushed the bark. *Frozen Delight* is 15″ x 22″ (38x56 cm).

DEMONSTRATION 20. SNOW PATTERNS

Step 1. At first glance, this painting appears similar to Demonstration 19, but there's an important difference in technique. I start out by painting on wet paper. But, as the color begins to dry, I add fresh washes of pale color to create backruns on the insides of the trunk. These loosely-defined, negative shapes create the first suggestion of snow piled up on the trunks. The dominant color in the trunks is brown madder, which dries quickly and makes it easier to produce backruns if my timing is right. The strokes follow the diagonal movement of the trunks. In contrast, the foliage between the trunks is indicated with short, quick dabs of color.

Step 2. When Step 1 is dry, I texture the trunks with a soft flat, 3/4″ white nylon brush. The brush holds very little water, so the damp color is perfect for drybrush. First, I brush on the sunlit color, a mixture of new gamboge and brown madder. Then, for the dark textures, I continue with French ultramarine, cerulean blue, raw sienna, and an occasional hint of Winsor blue. I blend these colors with swift strokes while the paint is quite moist. But I allow some drybrush strokes to survive. The big, cool shadows on the snow are brown madder mixed with French ultramarine, cerulean blue, and just a touch of Winsor blue. The backruns of Step 1 have become interesting snow shapes.

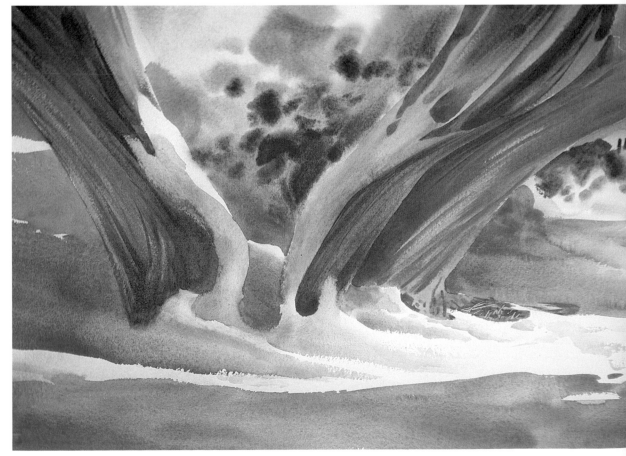

Step 3. I finish rendering the texture on the tree with a dark mixture of Winsor blue and brown madder. These dark strokes define the edges of the snowy shapes on the trunks. With a damp bristle brush, I wipe away some soft light on the snow that covers the ground. How much blue I can lift depends upon how much Winsor blue is on the paper. Because Winsor blue stains the paper so tenaciously, I use this color very sparingly if I want to lift away highlights. I build up the warm color in the trunks with new gamboge, brown madder, and a little raw sienna.

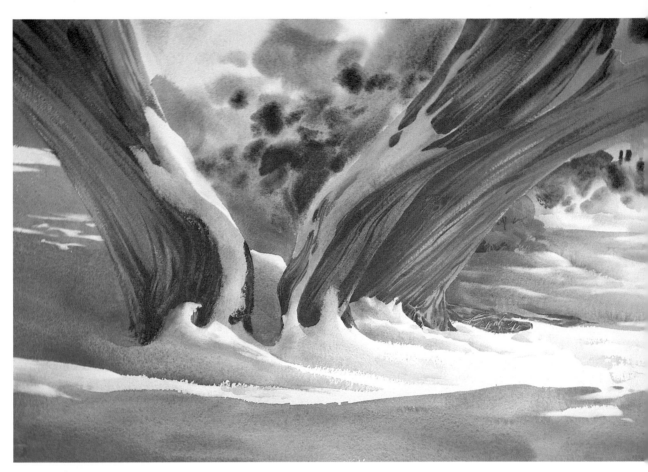

Step 4. Now I strengthen the sky tones at the top of the picture (between the two trunks) and define the shapes of the distant trees more clearly at the same time. I very selectively add more darks, as well as the details of trunks and branches, to the distant trees. This gives the painting a stronger sense of scale and perspective. A few weeds in the foreground snow also strengthen the scale as the tiny weeds make the big tree look even bigger. Like all successful closeups, the finished painting is really a study of shapes: the lively pattern of lights and shadows on the snow framing the powerful V-shape of the sunlit tree. *Survival Test* is 15" x 22" (38x 56 cm).

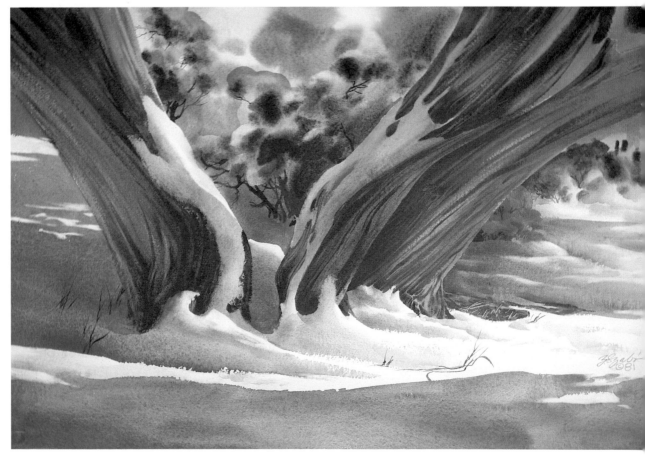

88

DEMONSTRATION 21. GRASSES IN WINTER

Step 1. This closeup will consist mainly of negative space (bare snow) with just a few dark details placed against the whiteness. Every touch of the brush must be carefully planned, and that whiteness must be preserved. First, I mask out the big fence post. Then I paint the dark background with Antwerp blue, French ultramarine, and burnt sienna, leaving a pale, ghostly tone for the soft value of the drooping spruce. When this dark band is dry, I wet the rest of the paper and brush in an almost invisible, neutral wash of French ultramarine and burnt sienna over the entire area, adding darker strokes of the same mixture for the shadows of the snowdrifts.

Step 2. Warming the snow mixture with a bit more burnt sienna, I model the humps of snow with lost and found edges. I use a bristle brush to drybrush the stiff, dead blades of grass and the patches of exposed dirt with a mixture of raw sienna, burnt sienna, and French ultramarine. While these shapes are still damp, I use my nail clipper to scratch in some texture. Notice how the loose drybrush strokes break up the solid darks, which are placed to lead the eye upward toward the fence post.

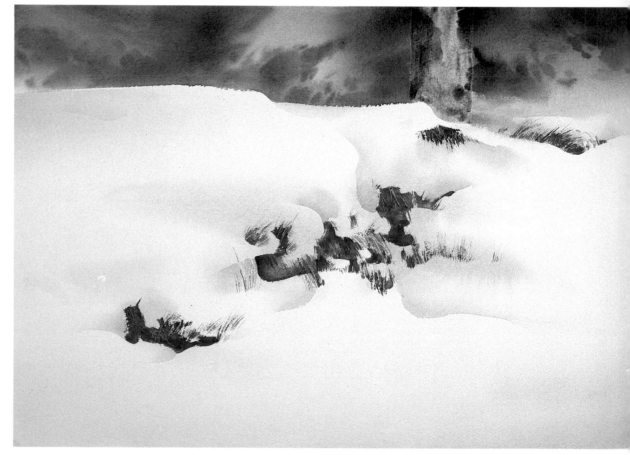

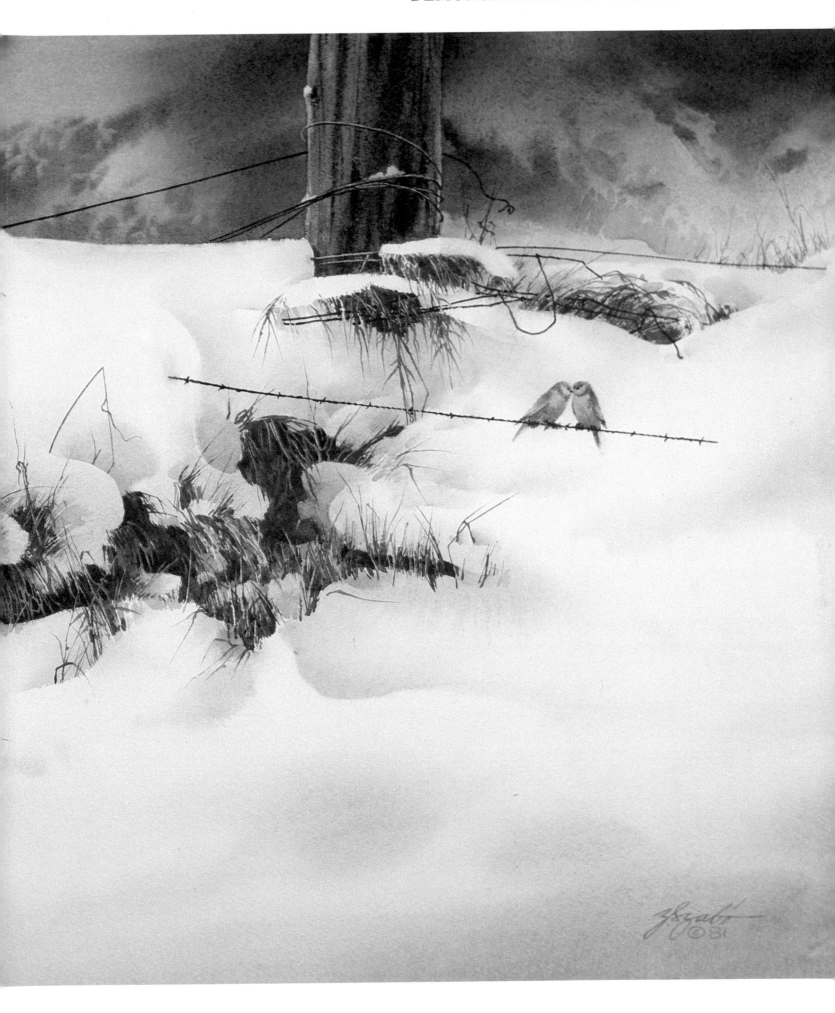

DEMONSTRATION 22. FROST AND ICE

Step 1. Frost-covered trees at the edge of a frozen pond are one of the most magical of all closeup subjects. I wet the paper thoroughly with clear water. With a firm, 2″ bristle brush, I paint the large background shapes with French ultramarine, cerulean blue, and a little raw sienna. I mix each brushful of paint separately so that the colors become gradually cooler toward the bottom, where they're dominated by cerulean blue. For the ice at the lower edge of the painting, I use raw sienna and cerulean blue. As my background is beginning to dry—and is losing its shine—I paint in the frosty branches with a number 5 round sable and clear water. I work very swiftly to prevent the water from gushing out of control.

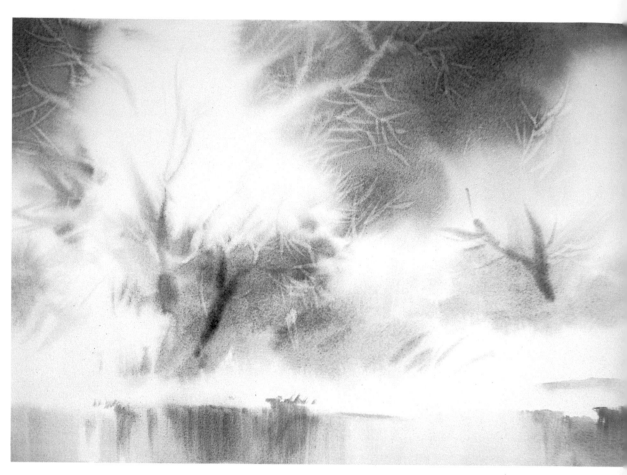

Step 2. When Step 1 is completely dry, I work along the shoreline with sharp strokes and hard-edged washes to suggest a lot more frosty foliage. I darken some of the pale tones, like the shape in the upper right, with delicate washes, softly blended at the edges to avoid hardening the shapes of the trees. I'm still working with the same colors that I've used in Step 1, but I sneak some greener mixtures (with more raw sienna) into the trees and weeds. Now they echo the color of the ice, which would otherwise be isolated from the rest of the painting.

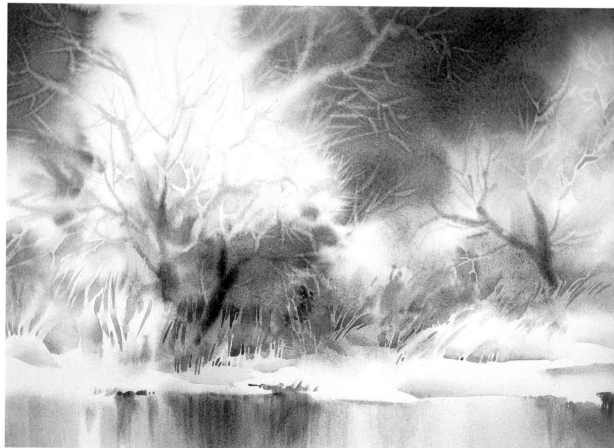

Step 3. Working with warm darks, I concentrate on the center of interest, strengthening the lower portions of the larger tree. This mixture is sepia with cerulean blue and a little burnt sienna. I continue to add more darks along the shoreline to suggest weeds and shrubs. Notice how a few bluish weeds curve under the weight of the frost. To lift out more frosty branches, I use a wet bristle brush, scrubbing and then blotting the dark background wash. Slender, dark branches begin to appear amid the upper foliage, but I keep them inconspicuous so they won't conflict with the focal point of the picture.

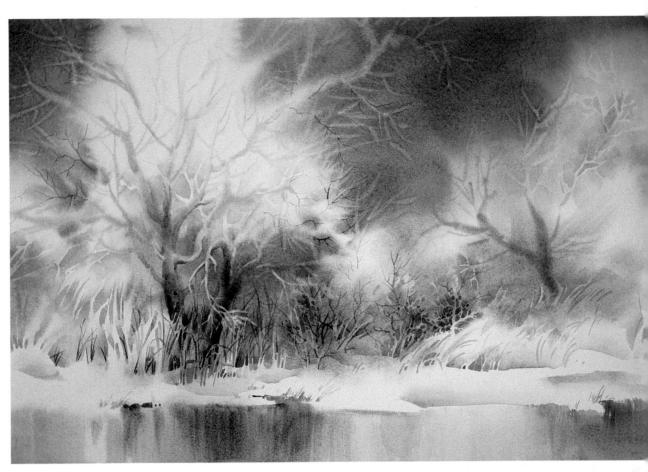

Step 4. I finish the painting by adding just a few more refinements, such as the lacy twigs, painted with a small rigger brush loaded with sepia and cerulean blue. For just a suggestion of color contrast, I sprinkle the warm tones of some leftover leaves onto the bigger tree, and on the snow and ice. In Steps 1, 2, and 3, I've painted the ice with *vertical* strokes. Now I lift out some light *horizontal* lines that cross the vertical strokes. Study the finished painting and you'll see that there's very little detail. The sharply defined brushwork is all concentrated along the shoreline at the center of interest. The rest of the picture consists almost entirely of large, soft-edged shapes.

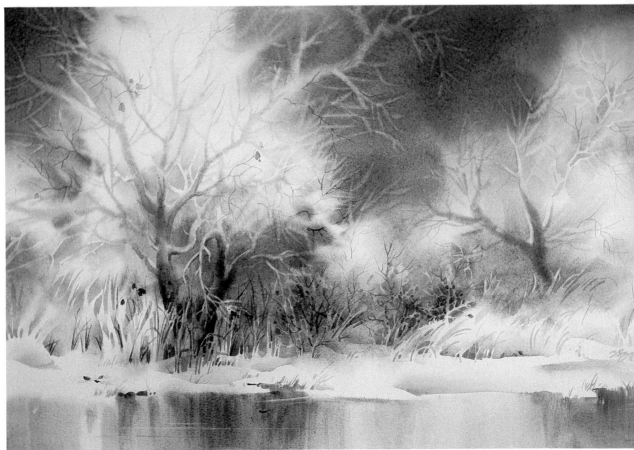

DEMONSTRATION 23. THISTLE

Step 1. A single thistle, placed against the right background, shows how much you can do with a very simple subject. After wetting the paper, I brush in the background with a wide, flat brush that carries various mixtures of raw sienna, burnt sienna, Winsor blue, and cerulean blue. As this wash begins to lose its shine, I apply strokes of clear water with a small, finely pointed, number 5 sable. The clear water produces delicate backruns that read as three pale shapes against the darkness.

Step 2. To help me judge the values more accurately, I remove the Maskoid, revealing the white shape of the thistle. Working carefully around the thistle, I strengthen the contrasts with dark glazes of the original background mixture, but now I add a little French ultramarine. I exaggerate the cool color because, later on, I intend to paint a glaze of yellow on top of everything. You can now see much more detail in the background, where I've placed a variety of strokes on the dry paper.

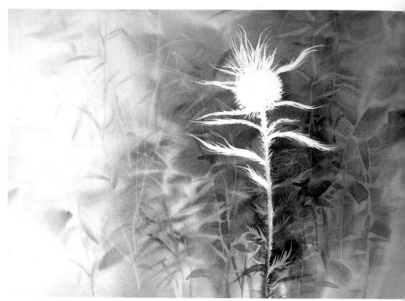

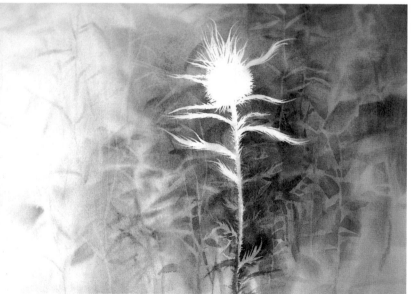

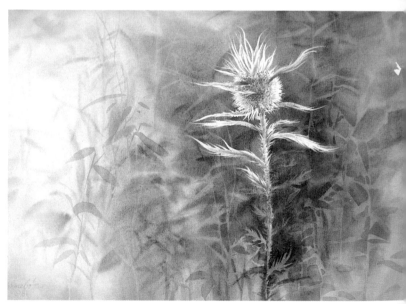

Step 3. Making certain that Step 2 is absolutely dry, I give the whole painting a pale wash of new gamboge, using a soft, wide, 2″ brush. (I choose new gamboge because it's very transparent.) I don't want to disturb the cool, dry colors, so I move very gently over the paper, barely touching the surface. I start this wash from the white thistle, working outward so that the brush touches the thistle first, before the warm wash becomes slightly tinted by contact with the cool background.

Step 4. I finish the details of the thistle with raw sienna, burnt sienna, and French ultramarine. I model the form so that it feels round and three-dimensional, working with a small, sharply pointed number 3 sable. Working with this same brush, I go into the background again to add more stems and leaves, sharpen some of the background shapes, adjust values, and enrich the colors with stronger, darker accents.

Step 4 (detail). As I add color and detail within the thistle, I work with very small strokes, generally keeping the darker colors away from the sunlit edges of the shapes. Thus, the thistle (as well as its leaves and upper stem) seems to glow with light on all sides. I try to be selective about the amount of detail that I build up. The greatest amount of detail is in the center of the thistle, while the leaves and stem are modeled very simply, with just a few touches of shadow. To emphasize the sunlit shape of the thistle, I build up my background darks around the center of interest, allowing the background to grow gradually lighter as it moves away from the focal point of the picture. The background shapes are most sharply defined at the center of interest, where my strokes have hard, distinct edges. But most of the background shapes are soft and blurred, as they appeared when I first painted them on wet paper.

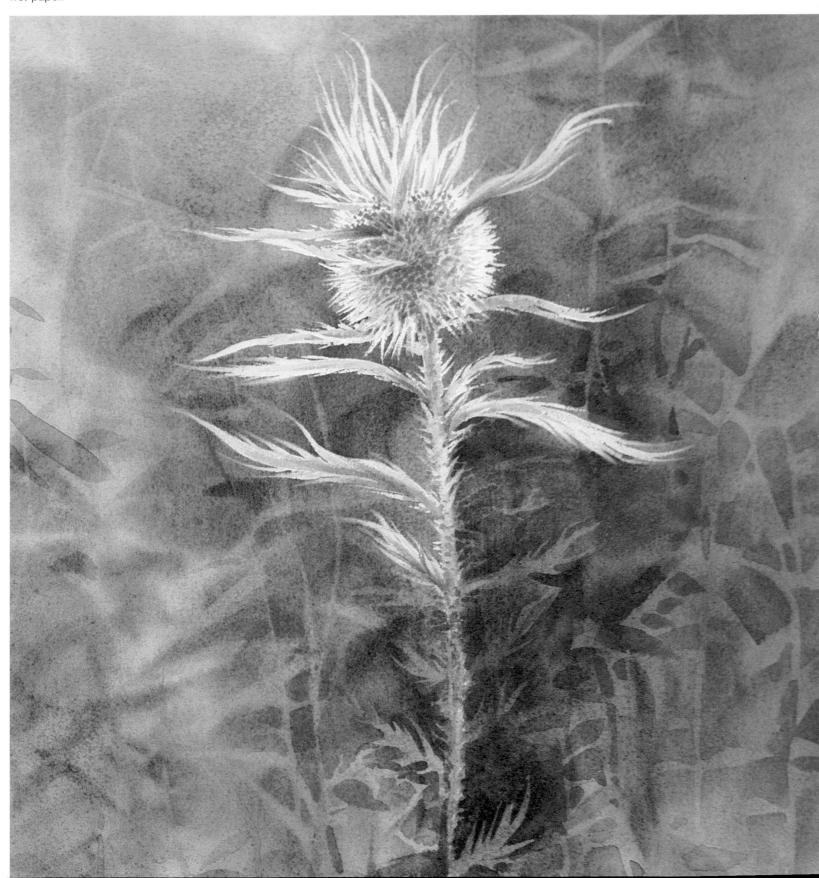

DEMONSTRATION 24. FLOWERING TREE BRANCH

Step 1. After wetting the paper thoroughly, I paint the subdued background tone at the top of the picture with a mixture of cobalt blue and burnt sienna. Then I visualize the slightly shaded lower half of the flower cluster, and I paint this across the center of the picture with cobalt blue, alizarin crimson, and an occasional touch of Antwerp blue. The green shapes of the leaves are burnt sienna and Antwerp blue. As these washes start to lose their shine, I introduce touches of clear water. These last touches (the green leaves and the strokes of clear water) produce interesting backruns.

Step 1 (detail). The pale backruns, which are made with clear water as the undertone starts to lose its shine, suggest blossoms. The darker backruns suggest leaves. Sometimes called *fans,* such backruns are often dreaded by watercolorists, who consider them mistakes. But when they're properly controlled (and not overdone) I think they add vitality and spontaneity. And I think this is a wonderful technique for placing soft, light shapes, with exciting edges against a dark background.

DEMONSTRATION 24. FLOWERING TREE BRANCH

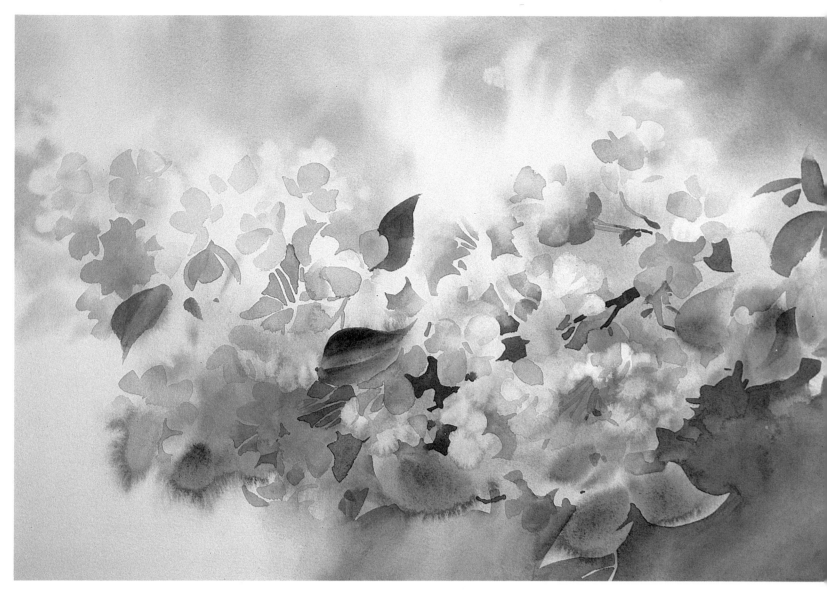

Step 2. Although I'm guided by a pencil sketch, I don't follow it slavishly. I'm inventing the shapes of the blossoms and leaves, which just seem to happen, one by one. The sharp (found) edges carry the design, while the soft (lost) edges blend and lock the shapes into a unified whole. Cobalt blue is the color that appears most often in these mixtures, combined with burnt sienna and/or new gamboge for the leaves, and blended with alizarin crimson and burnt sienna for the flowers. The darkest touches are a combination of the two mixtures, plus Antwerp blue. I make sure that there are plenty of spots of clean paper showing through to communicate the freshness of the subject.

Step 2 (detail). Blossoms and leaves, now painted with hard edges, are placed among the soft-edged shapes of Step 1. Thus, there's a delightful interplay of sharply defined shapes, out-of-focus shapes, and the backruns (or fans)—most evident at the bottom of the picture. Thus, the brushwork is full of variety and surprises, conveying the freshness and profusion of the blossoms on the branch.

DEMONSTRATION 24. FLOWERING TREE BRANCH

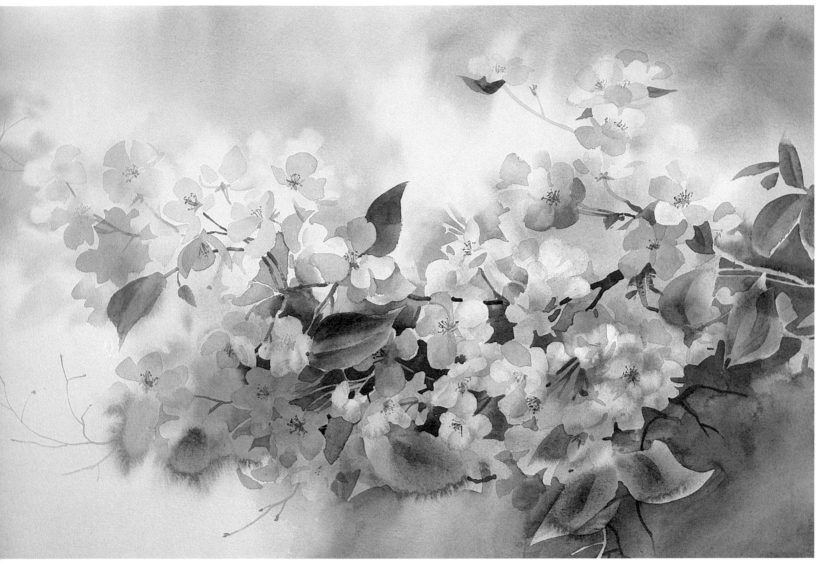

Step 3. With the same mixtures that appeared in Step 2, I continue to clarify the shapes of the flowers and the background. Now you can see more petals and the small details at the .centers of the blossoms. I also add more touches of darkness to indicate background tones behind the flowers. Small branches begin to appear between the clusters of flowers, giving inner structure to the design, which might otherwise look like a vague mass of flowers, unrelated to the tree. I add more modeling to the leaves, suggesting the gradation of light and shadow, but I avoid adding distracting detail that might compete with the blossoms.

Step 3 (detail). I'm working mainly with three values: light, middletone, and dark. The lights are the patches of paper that carry the delicate, wet-in-wet tones of Step 1. The middletones are slightly darker mixtures that suggest the shadows on the blossoms. The darks suggest the shadowy background behind the flowers; I add these touches very sparingly, just for variety and to make the flowers come forward in space.

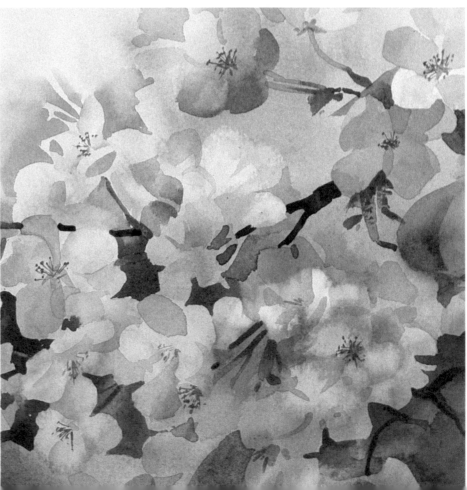

DEMONSTRATION 24. FLOWERING TREE BRANCH

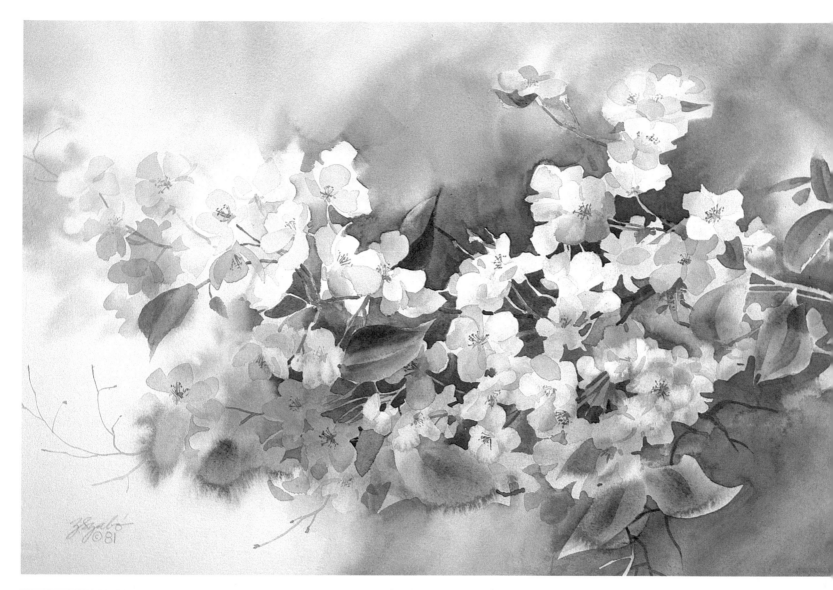

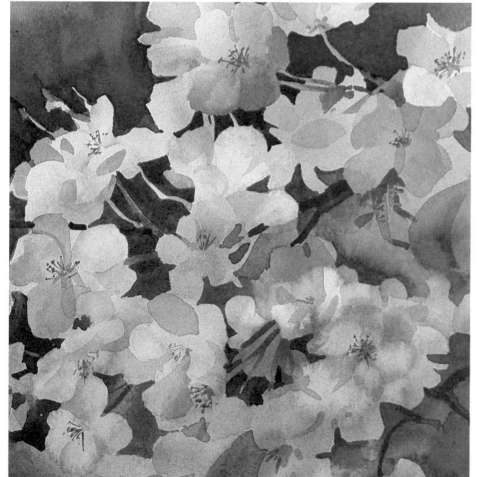

Step 4. I want to dramatize the blossoms by adding more contrast, so I paint a dark background above them. This background mixture is darkest near the flowers and gradually lightens as my brush moves toward the top of the painting. Because of this contrast, the flowers look lighter, brighter, and more luminous. And the entire painting looks more three-dimensional because the flowers seem to move forward while the background tone melts away into the distance. I carry some of this dark background mixture down into the gaps between the blossoms, defining the edges of some individual flowers. I also do a bit more work on the flowers themselves, defining a few of them more precisely.

Step 4 (detail). As that dark background tone moves down between the blossoms, their edges seem to be spotlit by a clear, cool light. The viewer's attention goes to the center of interest, where the contrast is strongest. I introduce just enough darks among the flowers to heighten the contrast and define a few shapes more precisely, but I don't let the darks take over. The mass of blossoms is still dominated by lights and middle-tones. *New Apples* is 15″ x 22″ (38x56 cm).

DEMONSTRATION 25. WILDFLOWERS IN MEADOW

Step 1. Sometimes the right strategy is to reverse the usual painting procedure. That's what I do here, beginning by painting the flowers first, and saving the background for later on. The dominant color in the flowers is alizarin crimson, of course, with cobalt blue and Antwerp blue. For the cool colors of the leaves, I mix raw sienna with these two blues. The flowers are painted with crisp touches of transparent color, overlapping at times to suggest shadows where the flowers overlap. I'm working on pure, white paper, letting the bright surface of the paper shine through to insure the freshness of my washes.

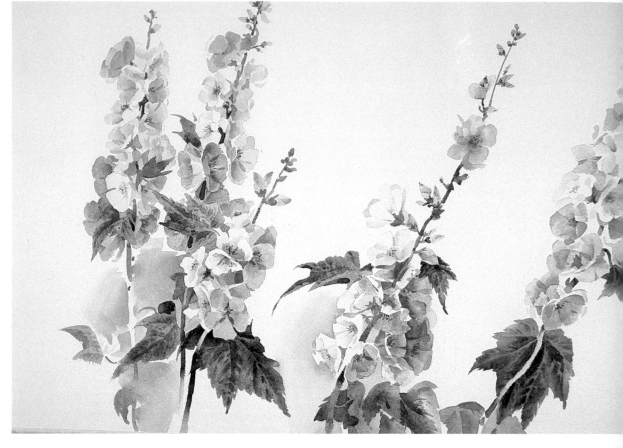

Step 2. The shapes of these flowers are so complex that there's no way I can mask them out before I paint the background. So I paint them first, and *now* I cover the completed blossoms with liquid latex wherever those blossoms will interact with the dark background. Then I wet the paper and apply rich background mixtures of Antwerp blue, cobalt blue, burnt sienna, raw sienna, and alizarin crimson. The lower third of the painting remains unmasked, since the background tone doesn't go down that far. I begin to add more weeds, grasses, and leaves along the lower edge of the painting.

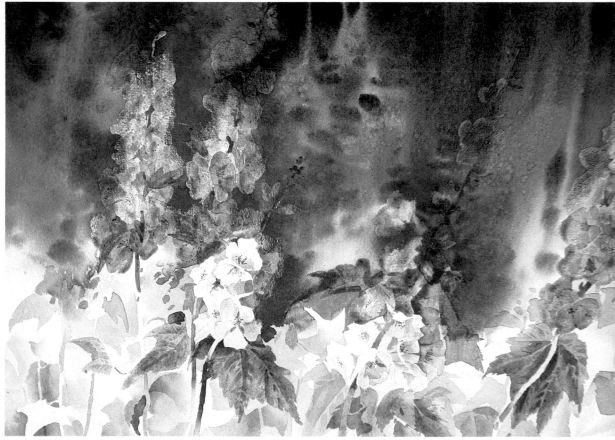

Step 3. When I remove the Maskoid, the flowers seem to be bathed in bright sunshine as they reappear against the shadowy background. This contrast also makes the flowers look paler and more delicate than they seemed in Step 1. Now I can see the values more clearly, so I go back into the flowers to make subtle value changes among the blossoms and to introduce small background darks among the clusters of petals. The background tone still contains a variety of strokes that never completely disappeared on the wet surface of the paper, thus suggesting the presence of other growing things in the shadowy distance.

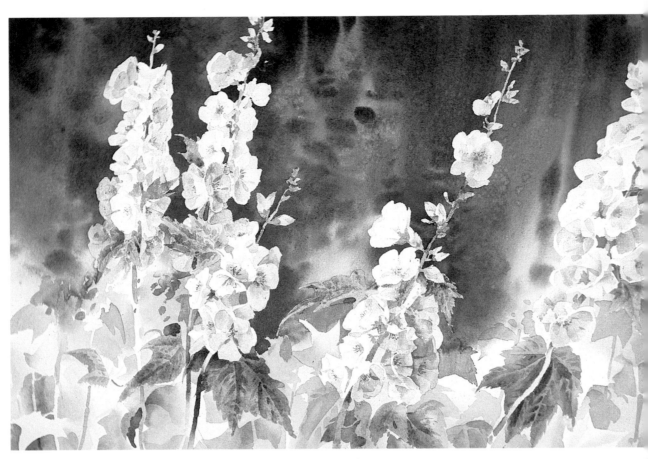

Step 4. Working over the soft, blurred shapes of the background, I develop more detail among the shadows with Winsor blue, burnt sienna, and alizarin crimson. You can see lost-and-found edges; dark touches that define shapes or suggest individual stems; and places where I lifted away the dark color. I also do some lifting in the foreground to cleanse and brighten some of the leaves and flowers. The finished painting has a strong sense of three dimensions and a feeling of realistic space because there are clearly defined lights, middletones, and darks. *Forest Renegades* is 15″ x 22″ (38x56 cm).

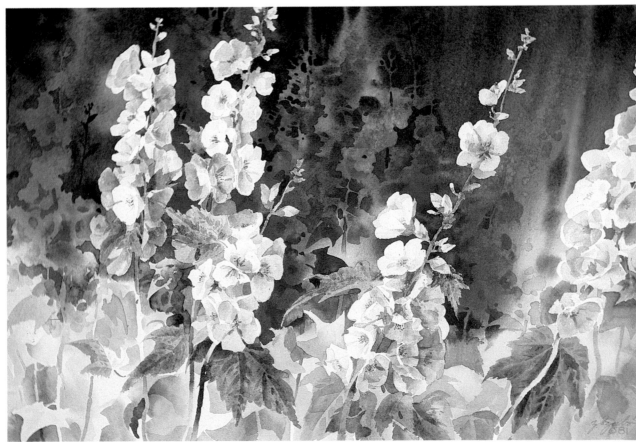

DEMONSTRATION 25. WILDFLOWERS IN MEADOW

Step 3 (detail). Here you can see how the background and flowers look when I peel away the liquid latex that I've applied in Step 2. At this stage, the dark background tone consists entirely of soft, blurred shapes that have diffused on the wet paper. But the background contains darker and lighter areas, as well as warm and cool notes, that will be transformed into weeds, grasses, and flowers in the final stage of the painting. The dark background dramatizes the pale colors of the sunlit flowers in the foreground. They seem to radiate light. But now I can spot some problems that weren't evident when I first painted the flowers in Step 1. Some of those blossoms look *too* light and seem to pop out of the picture.

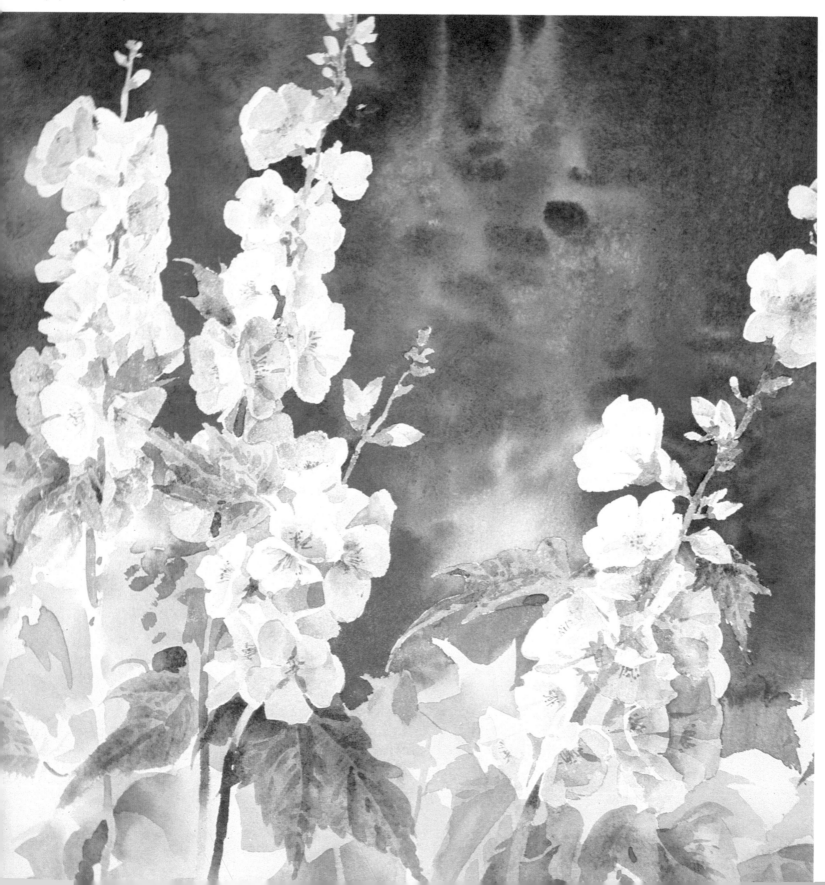

Step 4 (detail). I make subtle value adjustments by adding slightly more tone to those flowers that look too much like paper cutouts, threatening to pop out of the picture. You can see these adjustments most clearly in the big blossom in the upper right-hand corner, although similar changes appear in several other blossoms. Now these flowers hold their places more firmly in the picture. Working into and around the blurry background shapes, I convert them into *slightly* more distinct forms that suggest clusters of wildflowers in the shadowy distance. I keep detail to a minimum and I also avoid any strong value contrasts in the background, so the distant flowers don't conflict with those in the foreground. The finished painting has a strong sense of three-dimensional space because there's a clear break between the pale, sharply defined shapes of the foreground and the dark, loosely painted shapes of the background. Covered by a kind of cool, dark haze, the background shapes seem to step back from the luminous details of the foreground.

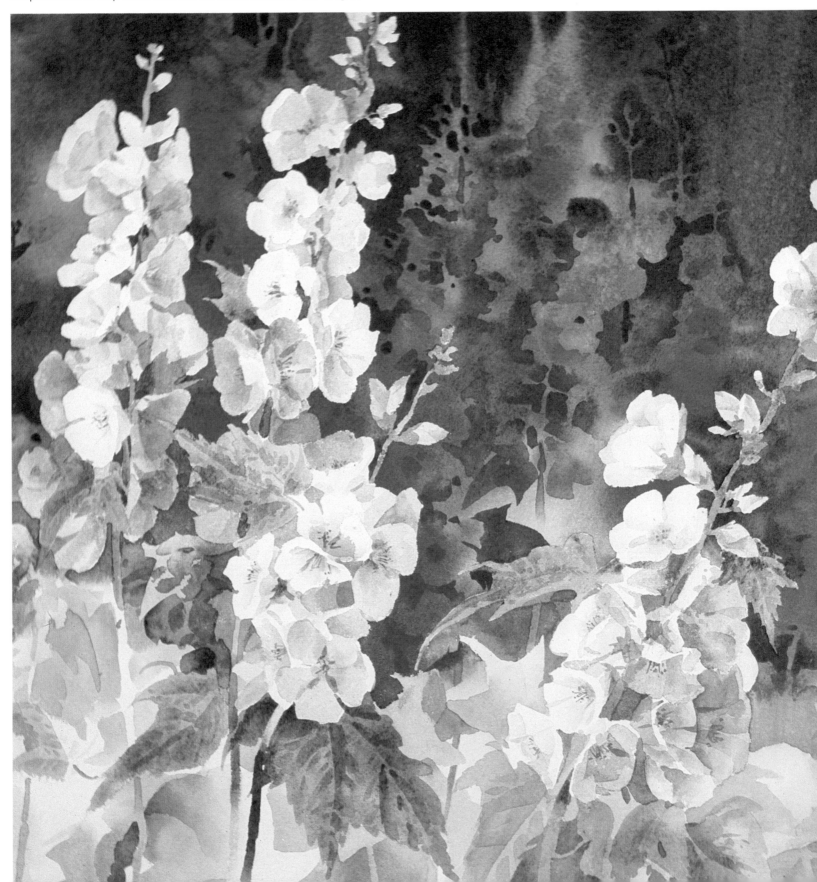

DEMONSTRATION 26. FLOWERS AND LEAVES

Step 1. The simplest way to protect a large mass of flowers is to paint the background *around* them. I wet the paper *partially,* leaving a dry area where the lilacs will appear. I paint the background with French ultramarine and burnt sienna, holding my flat nylon brush with its tip away from the edges of the flowers so there's a loose, drybrushed feeling around them. The background foliage is painted on the wet paper with new gamboge, burnt sienna, and French ultramarine.

Step 2. On the dry paper, I paint the basic colors of the lilac clusters with French ultramarine and alizarin crimson. I drag the side of the brush over the paper to get a lacy feeling that matches the ragged edges of the shapes. Then I strengthen the foliage with a darker mixture of French ultramarine, new gamboge, and some raw sienna. I add more background tones around the flowers to increase contrast and to suggest light branches against the darkness.

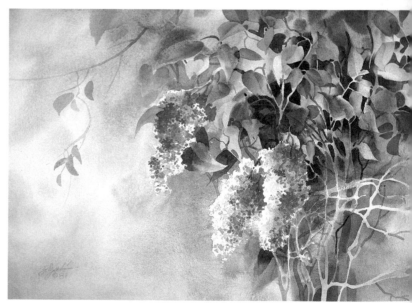

Step 3. With Winsor blue, alizarin crimson, and burnt sienna, I introduce more dark shapes, particularly in the background between the leaves. I also darken the value of that area by adding darker leaves, a mixture of Winsor blue and burnt sienna. There's an exciting variety in the foliage, created by the interplay of negative and positive shapes, cool and warm color, and light and dark values.

Step 4. Now I add dark modeling to the lilacs to define individual flowers. I connect leaves and branches with dark strokes, and I also place dark strokes among the lights to define the edges of pale branches. I darken the lower left corner with a soft, subdued mixture of alizarin crimson, burnt sienna, and French ultramarine. As I move this wash upward, I "lose" it by adding more water. To complete the painting, I touch up some of the branches with burnt sienna.

Step 3. I need more value contrast to draw attention to the flowers and grass. With the sharp point of a small sable brush, I build up the darks behind the flowers. Then I work upward into the grass itself, strengthening the darks and adding detail at the same time. Notice the very painstaking *negative painting* around the pale blades of grass above the flowers.

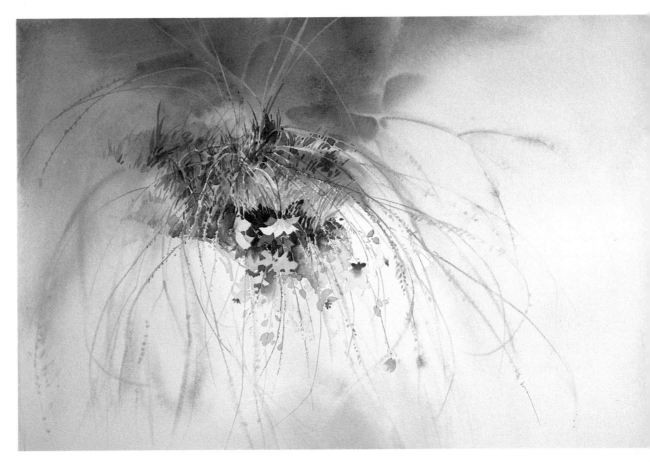

Step 4. Rewetting the lower right and lower left portions of the paper, I spatter touches of blue-gray on the moist surface, and then I connect these spatters to a few more stems. These stems are painted on the moist paper, so the lines are slightly softened. These last touches are subtle, but important, because they allow my composition to fill the entire sheet, reaching out to all four sides. I don't want the cluster of flowers and grasses to become an isolated vignette, nestling in one corner of the sheet. Rather, I want to create a pictorial design that uses the entire rectangle.

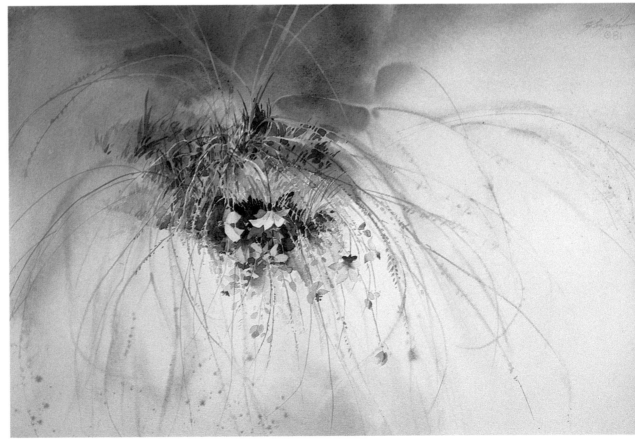

DEMONSTRATION 27. FLOWERS AND GRASS

Step 2 (detail). At this point, I establish the basic design at the center of interest. The flowers are still flat, poster-like shapes, without any detail. Above the flowers, the clump of grass is painted with broad strokes, allowing some gaps for the light stems that trail downward. In the dark background area above the grass, you can see the pale lines that I lifted away in Step 1. Radiating downward are the slim lines of the hanging stems, some painted on wet paper in Step 1, and some painted on dry paper in Step 2.

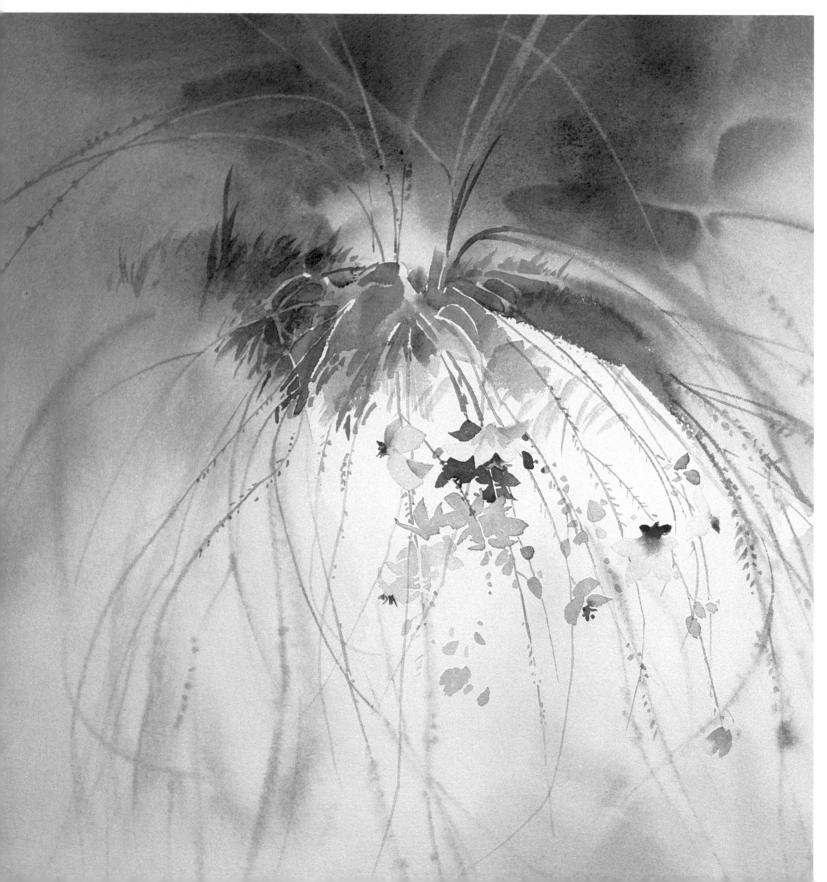

DEMONSTRATION 27. FLOWERS AND GRASS

Step 4 (detail). Small, dark strokes add just enough detail to make the grass look realistic—but not *so* much detail that it looks like a pincushion! I place that important patch of darkness behind the hanging flowers. Now their bright silhouettes stand out more clearly. Within the shapes of the flowers, I add planes of shadow. I also add hotter colors that suggest the center of each blossom. At the very bottom, you can see those final spatters of color, dropped on the wet sheet. *Tropical Tears* is 15″ x 22″ (38x56 cm).

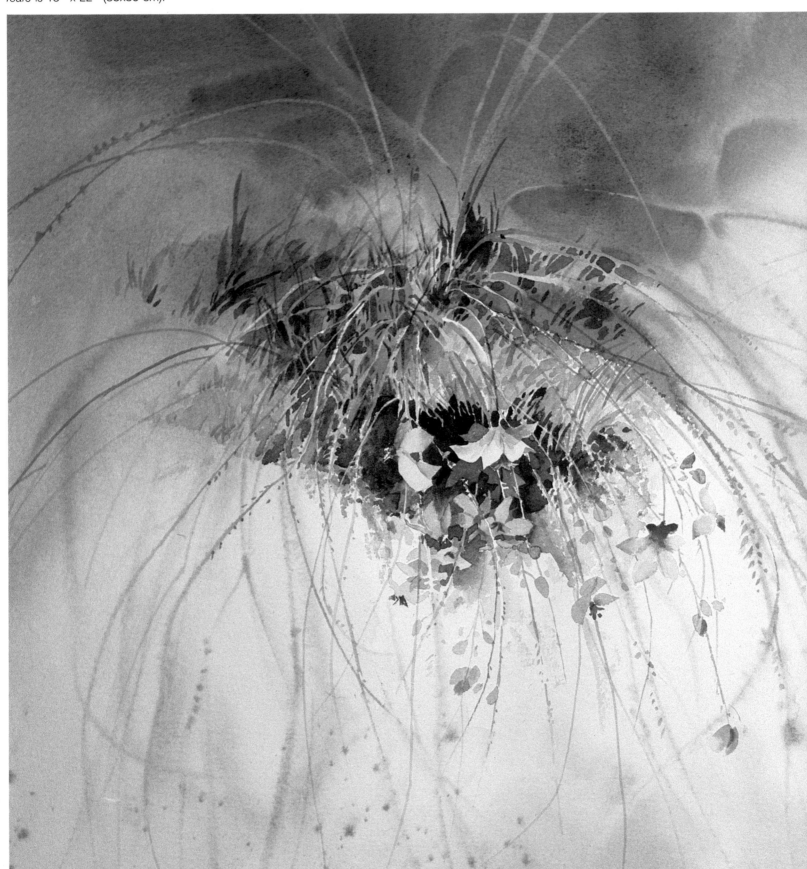

DEMONSTRATION 28. WILDFLOWERS AMONG ROCKS

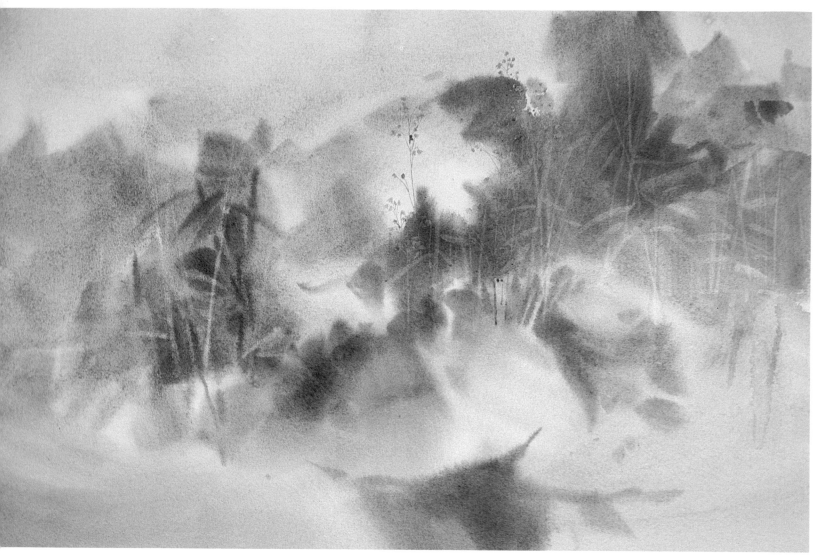

Step 1. There's no way to paint around the tiny flowers, so I mask out the thin stems, applying the liquid latex with the tip of my palette knife and moving the edge of the blade along the paper. Then, wetting the paper, I paint the large shapes with mixtures of cerulean blue, new gamboge, burnt sienna, and a little Winsor blue. Cerulean blue dominates the foliage, while the rocks are mainly new gamboge and burnt sienna. When the washes start to lose their shine, I paint the light weeds and their leaves with clear water. These vertical strokes form a bridge between the lower and upper parts of the picture.

Step 1 (detail). The rocks blur slightly on the wet paper, but they have a fairly distinct silhouette because I pay special attention to the timing of the dark strokes that surround the rocks. I wait for the water to soak in a little and then paint on *damp* paper. The soft, weedy strokes, springing upward from the rocks, also depend upon exact timing. It takes practice to know when the paper is beginning to lose its shine and is just damp enough to create those little backruns with strokes of clear water.

DEMONSTRATION 28. WILDFLOWERS AMONG ROCKS

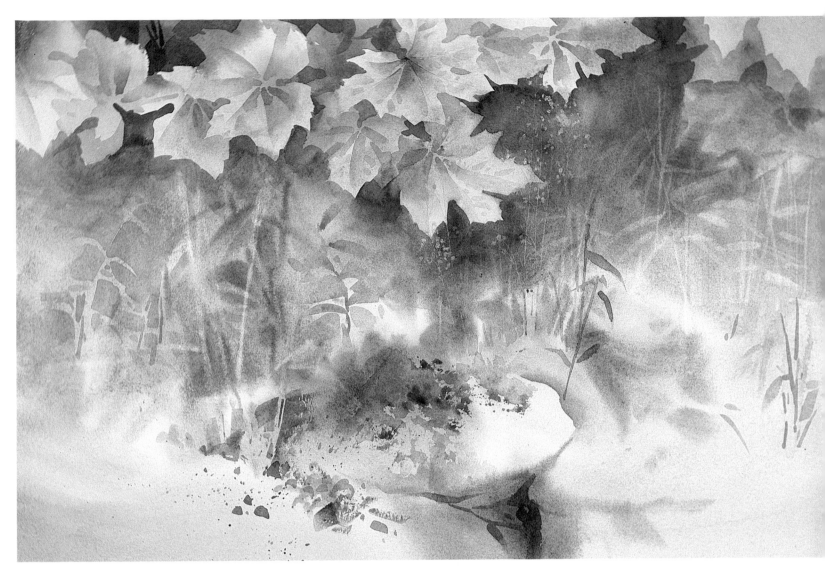

Step 2. I paint in the large, overhanging leaves, which are an important design element because they emphasize the tiny scale of the little flowers that will soon appear in Step 3. (The liquid latex still covers those white flowers.) I introduce a few dark weeds, and then I create some paler weeds at the left with negative painting. With spatter and a few touches of drybrush, I suggest moss on the rocks. Some more spatters and small drybrush strokes are placed in the foreground, where they'll become pebbles later. Just a few dark touches sharpen the edges of the foreground rocks.

Step 2 (detail). Now the flat, soft-edged shape of the rock in Step 1 is transformed into a more distinct shape. A few darks along the edges do the job, along with a pool of darkness for the deep crack underneath the rock. The moss on the rock and the pebbles on the foreground are just the beginning; more of this texture and detail will appear in the finished painting. In the upper left, I place a few strokes of middle value around some light patches to make them look like the leaves on a small weed.

DEMONSTRATION 28. WILDFLOWERS AMONG ROCKS

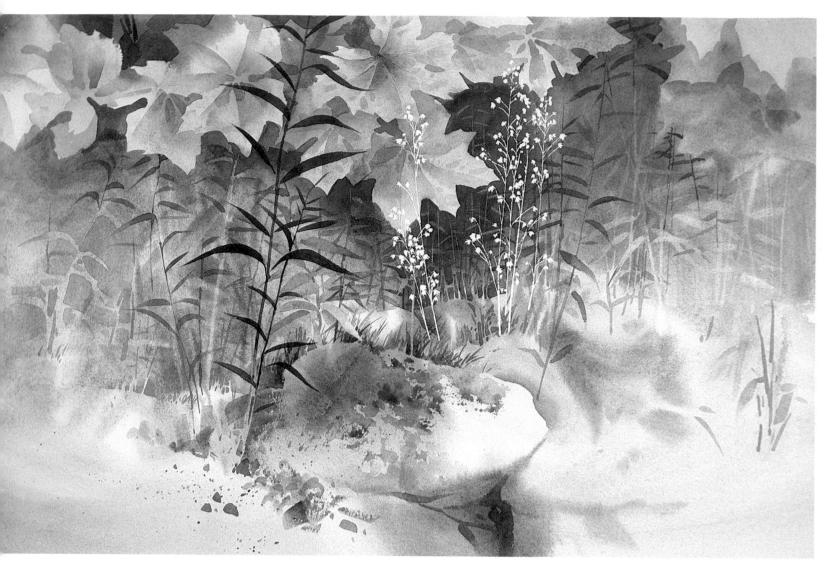

Step 3. Before I remove the mask from the tiny flowers, I build up the background darks around the leaves, and I add more dark strokes for weeds beneath the leaves. Very dark weeds overlap lighter ones to increase the illusion of depth. Now, before I go any further, I remove the mask. The white lace of the fragile flowers is now exposed, and I can judge my values more accurately. To strengthen the contrasts at the center of interest, I build up more darks around and between the little flowers.

Step 3 (detail). With the Maskoid removed, the lacy flowers are the only notes of pure white against the darks and middletones of the weedy background. Thus, despite their tiny size, the flowers command attention as if they're in a spotlight. The entire background plane behind the white flowers is in shadow, but that shadow is deepest behind the two clumps of flowers, and on either side. That's where I've placed a dense cluster of dark weeds that blend in the viewer's eye to create a shadowy frame for the wildflowers.

Step 3. Now I paint the strong, dark shadow under the wood, and I carry this darkness over the sand and beneath the bigger shells. The dark wood is executed with flowing, horizontal strokes, while the darks on the sand are drybrush strokes. This darkness brings the wood and the sand together, uniting the shells at the same time. (The color mixture is sepia, burnt sienna, and French ultramarine.) I also strengthen the value contrasts and the modeling within the shells, making them look more three-dimensional and also commanding more attention to the center of interest.

Step 4. Now I can concentrate on those small, final details that always add authenticity to a painting. I paint in the rusty nail and add some little blades of grass with a mixture of raw sienna and Antwerp blue. The nail and the grass are particularly important because they give the viewer a sense of scale. I find all those little barnacles distracting, so I tone them down with a subdued wash. On the small, white patches and the knife-strokes just beneath the big shells, I add a few dark touches to suggest smaller shells and pebbles. *Adoption Agency* is 11″ x 14½″ (28x37 cm).

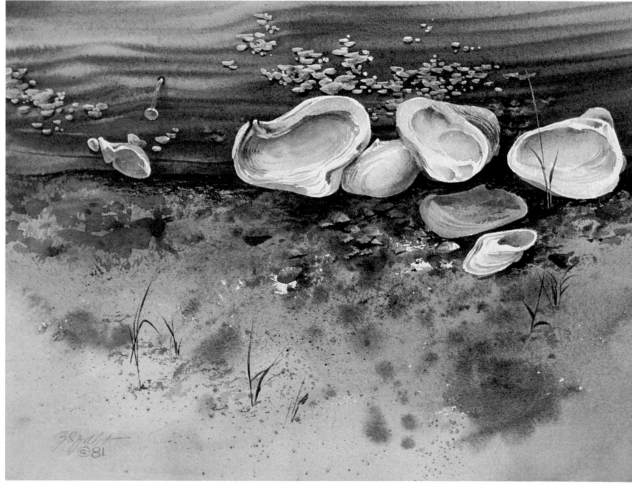

DEMONSTRATION 30. WEATHERED WOOD

Step 1. As I said earlier, weathered wood, heightened by dramatic lights and shadows, is a marvelous source of nature's abstractions. I use liquid latex to mask out the dry twigs at the lower edge of the wall, and then I mask the ends of the boards with a vertical strip of tape. To protect the Maskoid from the tape, I place a piece of brown wrapping paper between them. Now I go straight to work on the texture of the wood, drybrushing the boards with pure sepia containing very little water.

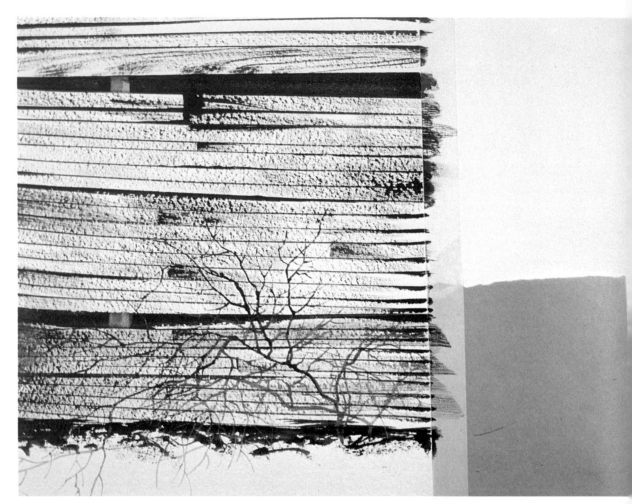

Step 2. Before I start on the door and its windows, I peel off the drafting tape and wrapping paper. (The latex is still intact on the dry twigs.) Now I finish drybrushing the texture of the wooden door, working with horizontal strokes for the horizontal boards, and vertical strokes for the upright frame. On the battered windowpanes, I drybrush both vertical and horizontal strokes. The ground is still bare paper, although there's a ragged shadow at the lower edge of the bottom board.

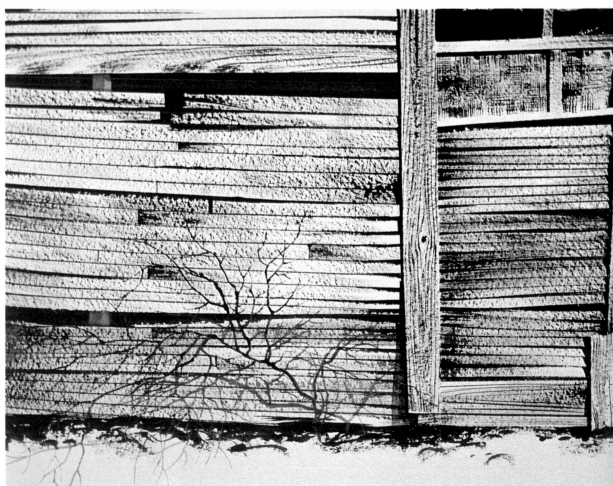

Step 3. Using a soft, 2″ wide brush, I paint a dark shadow tone over all the wood. This is a mixture of raw sienna, burnt sienna, and French ultramarine, with a hint of cerulean blue in the windows. The temperature of this shadow mixture varies as I add more warm or cool color. With loose, ragged strokes and a bit of spatter, I add sunlit texture to the foreground with raw sienna, burnt sienna, and cerulean blue, leaving patches of white paper between some of the strokes.

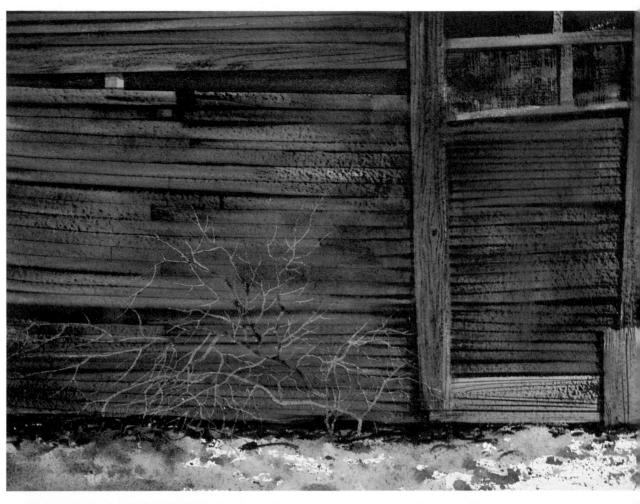

Step 4. Now comes the dramatic part. Planning my shadows with the greatest possible care, I wet the sunlit areas with clear water, scrub lightly, and blot away those pale patches to reveal bold, diagonal shadow shapes. Then I go back into the dark, horizontal spaces between the boards and reinforce them with sepia, burnt sienna, and ultramarine blue. Peeling the Maskoid off the twigs, I glaze them lightly with a very pale wash of raw sienna. When this is dry, I apply a few dark touches to give texture and modeling to the branches. Finally, I paint the thin lines of the cast shadows of the twigs, and add more darks to the rough ground.

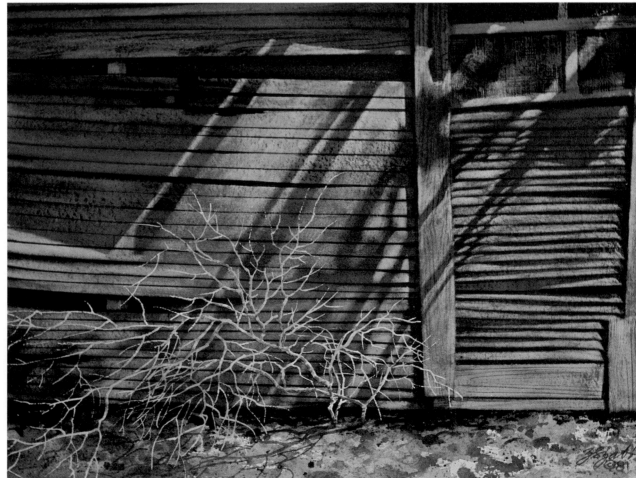

DEMONSTRATION 30. WEATHERED WOOD

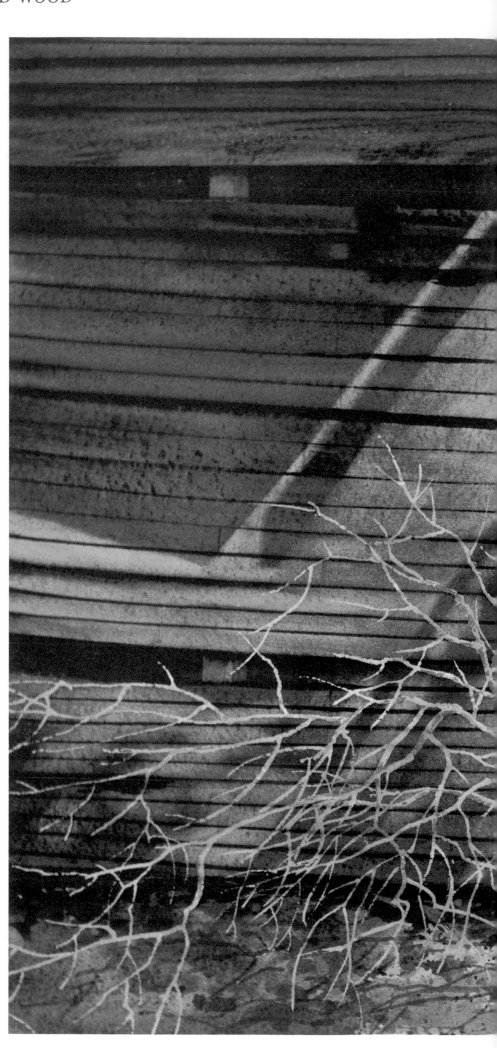

Finished Painting. Looking back at Steps 1, 2, and 3, you can certainly say that a lot of those drybrush textures seem exaggerated. But I've done that on purpose, knowing that the scrubbing and lifting operation in Step 4 would reduce many of those drybrush textures in the lighted areas. In the same way, the shadow tone in Step 3 seems terribly dark until you look at the final stage of the painting, when I lift out the light to create that powerful contrast between the diagonal shapes of the lights and shadows. Now those dark shadows make sense. And because I've painted the drybrush textures first, followed by the shadows, those shadows look luminous and transparent, revealing the textural detail underneath. Notice the important role that the dried branches of the shrub play in the composition. The weathered face of the old building consists entirely of straight lines: horizontals, verticals, and diagonal shadows. The curly, irregular shape of the twigs provides a lively change of pace to contrast with the geometric shapes. I'm very restrained in tinting and modeling the twigs so that I *don't* obliterate the sunlit edges that form such an intricate, lacy pattern. On the ground beneath the shrub, I place enough brush lines to suggest the shadows of the branches, but I don't paint the shadow of every single branch. *Unfriendly Neighbor* is 11″ x 14¹/₂″ (28x37 cm).

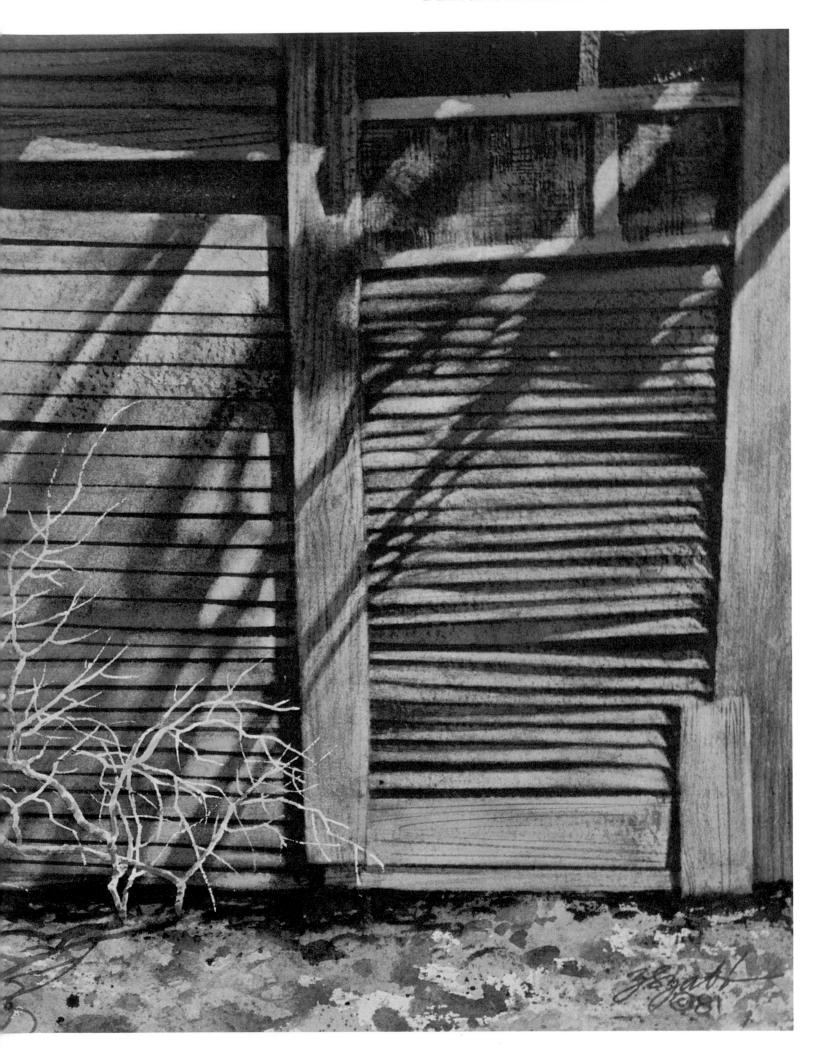

DEMONSTRATION 31. SPIDERWEB

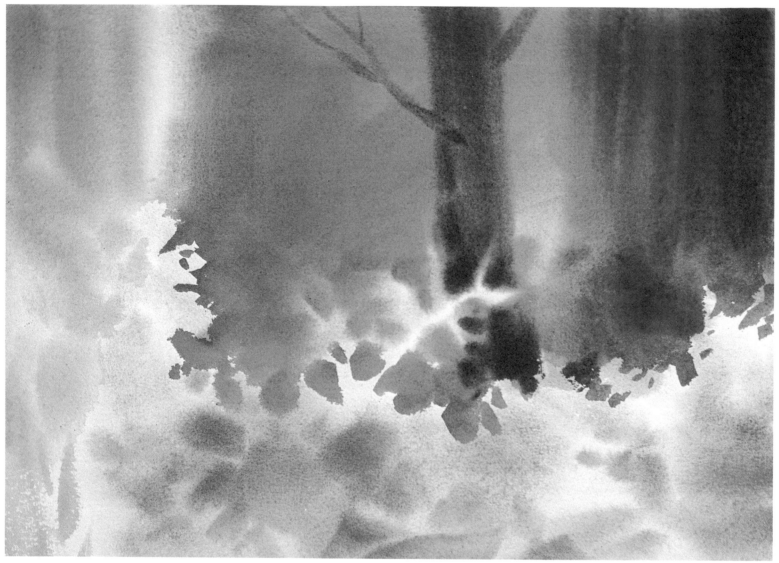

Step 1. One of nature's most amazing abstractions is a spiderweb. In this demonstration, my strategy is to begin by painting the background, the treetrunk, and the leaves that will frame the web. Working on wet paper, I brush in the cool color of the leaves in the foreground with cerulean blue, new gamboge, and French ultramarine. The dark background is Winsor blue, alizarin crimson, and some burnt sienna, with a much paler version of this same mixture suggesting the trunk at the left. As the foreground washes begin to dry, I paint the last few background darks at the edge of the leaves, where the shapes are more distinct.

Step 1 (detail). When you work on wet paper, keep an eye on the drying time. The soft, blurred shapes of the leaves are painted first, when the paper is wettest. I begin the dark background tone while the paper is still quite wet. But then I wait until it's somewhat drier before I add those last few dark strokes, which are more distinct. Another approach would be to paint the foreground leaves first, let them dry, then rewet just the dark area and repaint it down to the edge of the leaves.

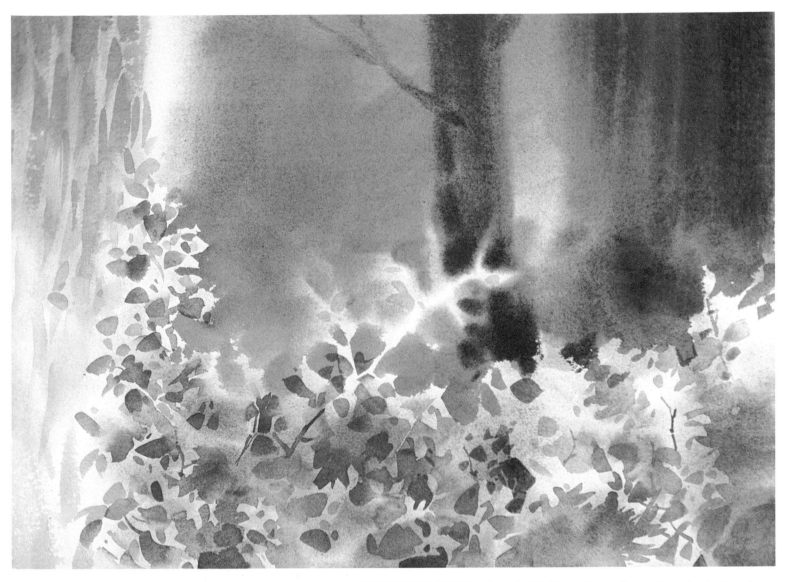

Step 2. Working with medium values, I paint the clusters of foliage with French ultramarine and new gamboge. Where the strokes overlap, there are softly blended edges (lost edges) which hold all the details together and add an element of unity to the shrubs. I don't really try to paint individual leaves, but let the natural shapes of the strokes suggest the leaves.

Step 2 (detail). When you examine the execution of the leaves more closely, you can see that I place the crisp, hard-edged strokes here and there, often losing them with wet edges at one side of the stroke. Thus, these leafy strokes don't look distinct and isolated, but are integrated with the surrounding blur of color that remains from Step 1. I also allow lots of sunny gaps between the darker strokes to suggest light coming through the leaves. And I resist the temptation to add more than a few twigs.

DEMONSTRATION 31. SPIDERWEB

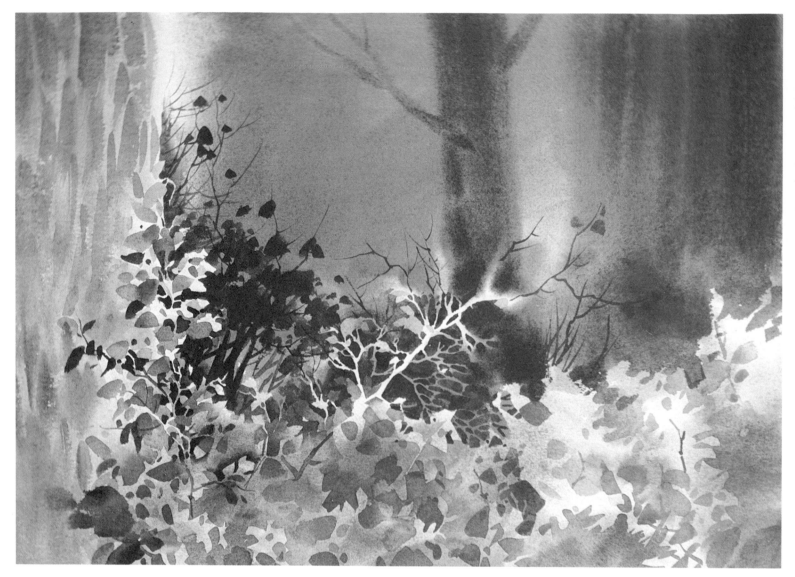

Step 3. Behind the sunlit foliage in the foreground, I build up the dark branches and shrubs in shadow with Winsor blue, alizarin crimson, and burnt sienna. I keep these shapes a simple silhouette, placing touches of this mixture in the gaps between the foreground foliage, so that the dark shape won't be isolated in the background. At the center of the painting, a twig slants upward into the sunlight. I define its shape with negative painting, placing darks around the bright silhouette.

Step 3 (detail). As I paint the dark leaves and branches in the background, I work with flat, simple tones. Thus, the dark silhouette doesn't conflict with the brighter, more detailed foreground. I leave spaces between the dark strokes to suggest light coming through. As I work around the bright silhouette of the diagonal twig, I design my small darks to form a lively, unpredictable pattern. I silhouette a few dark, bare branches against the sky, but I resist the temptation to add too many, for fear of distracting the viewer. I also don't want these dark branches to conflict with the spiderweb, which comes next.

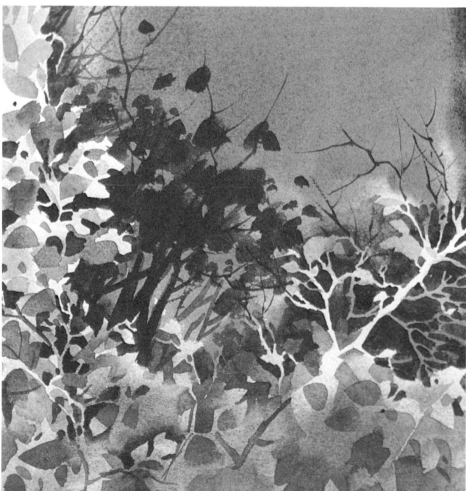

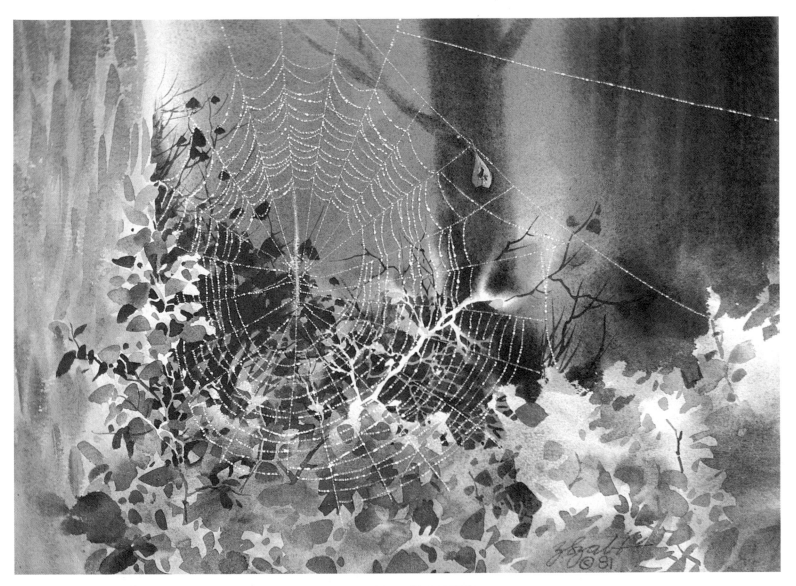

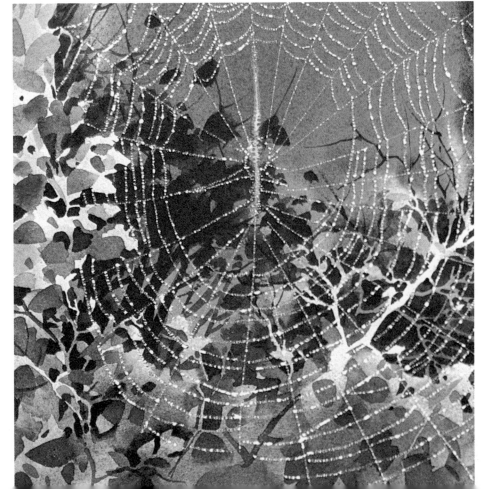

Step 4. When the sheet is bone dry, I use the sharp tip of a new razorblade to scratch out the white lines of the web with firm, rapid movements. I don't dig deeply into the paper, but press just hard enough to make scratches that you can see from a distance. With a small, wet bristle brush, I lift out the tiny leaf caught in the web, let it dry, and paint it with a bright mixture of new gamboge and alizarin crimson. The center of the web is silhouetted against the darkest area of the distant leaves.

Step 4 (detail). The filaments of the web aren't mechanically smooth like strands of silver wire. They have a ragged look that suggests the flickering light of the forest, or perhaps droplets of moisture. As the blade moves over the textured watercolor paper, the rough surface breaks up the scratches. This irregular texture is important because lots of forest color comes through, making the web seem part of its environment. It would be a great mistake to draw the web with mechanical drafting instruments and white paint! *Homebody* is 11″ x 14½″ (28x37 cm).

DEMONSTRATION 32. LEAF CAUGHT IN BRANCHES

Step 1. Where a flash of sunlight catches a single leaf and a few pine needles, I mask them out, wet the paper, and paint the values of the branches. I paint the background with varied combinations of new gamboge, brown madder, burnt sienna, French ultramarine, and Antwerp blue. There's a bit more new gamboge in that glow around the center of interest. Just before the paper starts to lose its shine, I paint small strokes of clear water into the damp color to suggest lighter needles.

Step 2. When Step 1 is dry, I develop the complex detail of the foliage. These needle-like strokes are painted with quick touches of a 3/4″ nylon brush that has a very sharp edge. When these slender, straight strokes are left alone, silhouetted against the light, they suggest dark needles. When I allow the strokes to run together, the hairline gaps between them look like light needles. I suggest more sunlight on some of the branches with mixtures dominated by new gamboge.

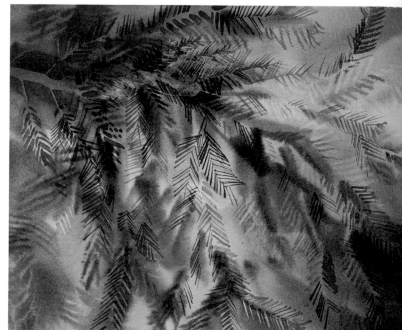

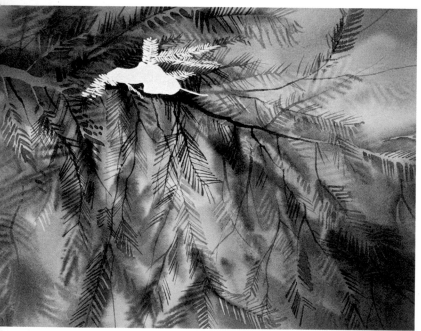

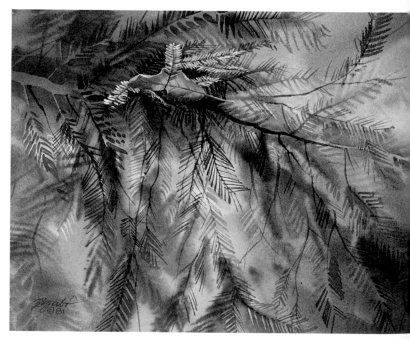

Step 3. So far, the composition is rather diffuse, so I add connecting branches with burnt sienna, brown madder, and Antwerp blue. I'm using both a rigger brush and the blade of my palette knife. Now all the positive and negative shapes are tied together and the picture has a more continuous structure. At the end of Step 3, I remove the latex. The leaf and sunlit needles are now an interesting white silhouette.

Step 4. Just below the focal point of the picture, I paint a soft blur of Antwerp blue, burnt sienna, and brown madder to accentuate the contrast with the sunlit leaf and needles. Then I paint those needles with a pale, sunny mixture that's mainly new gamboge. My final operation is to paint the bright leaf with a blend of brown madder, new gamboge, and burnt sienna. Where the edge of the leaf turns downward, I darken this mixture to suggest a shadow on the underside.

DEMONSTRATION 32. LEAF CAUGHT IN BRANCHES

Step 4 (Detail). Observe the modeling on the leaf. The top edge catches the brightest sunlight. Where the edges of the leaf turn in, there are soft pools of shadow that then give way to the glowing center of the leaf, where the sunshine comes through. The veins of the leaf are painted on slightly damp paper, so the lines are softened. The brightness of the leaf and sunlit pine needles is accentuated by the surrounding darkness. The pattern of branches and pine needles has been designed so that everything leads toward the focal point of the picture. The execution of the foliage gives you a concrete sense of three-dimensional space because the more distant foliage has been painted on wet paper, while the near foliage has been painted with sharply defined strokes on dry paper. Notice the color scheme: in a pictorial design that's dominated by cool color, that single leaf and the sunlit pine needles are the only warm note. *The Drop-In* is 11″ x 14¹/₂″ (28x37 cm).

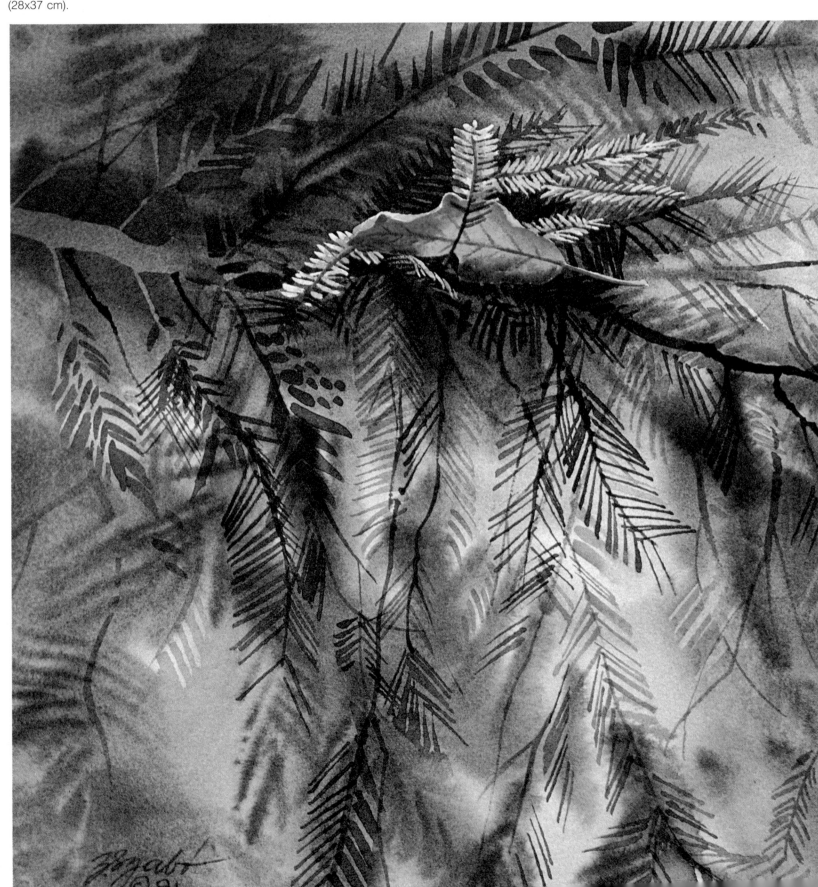

DEMONSTRATION 33. DRIED WEEDS AND SHADOWS

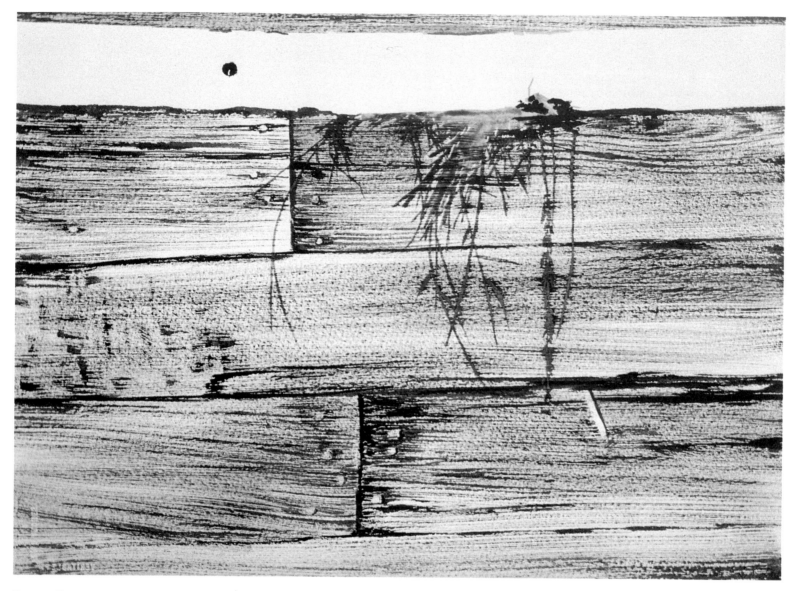

Step 1. The most inconspicuous subject can often produce a charming abstraction, like weeds casting their shadows on some wooden boards. After I mask out the dried weeds, I paint the texture of the old wood, using a firm, ¾" bristle brush that's richly loaded with very dark sepia. Because there's so much erratic texture in the worn finish of the wood, I can work very loosely, making the cracks as dark as possible—darker than they'll look in the finished painting.

Step 1 (detail). At this stage, the strokes of Maskoid on the weeds appear to be the same color as the dry-brushed texture of the wood. The wood grain is painted with a split brush. That is, I press the damp hairs of the brush gently against the palm of my hand to separate them so they'll make clusters of parallel lines when I move the brush across the paper. The texture, or *tooth*, of the watercolor paper breaks up these lines to suggest the ragged surface of the wood.

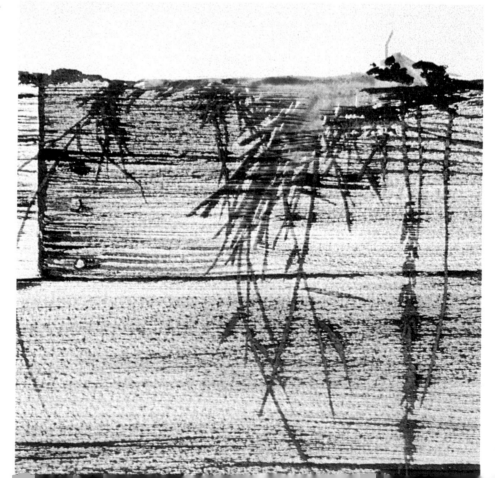

DEMONSTRATION 33. DRIED WEEDS AND SHADOWS

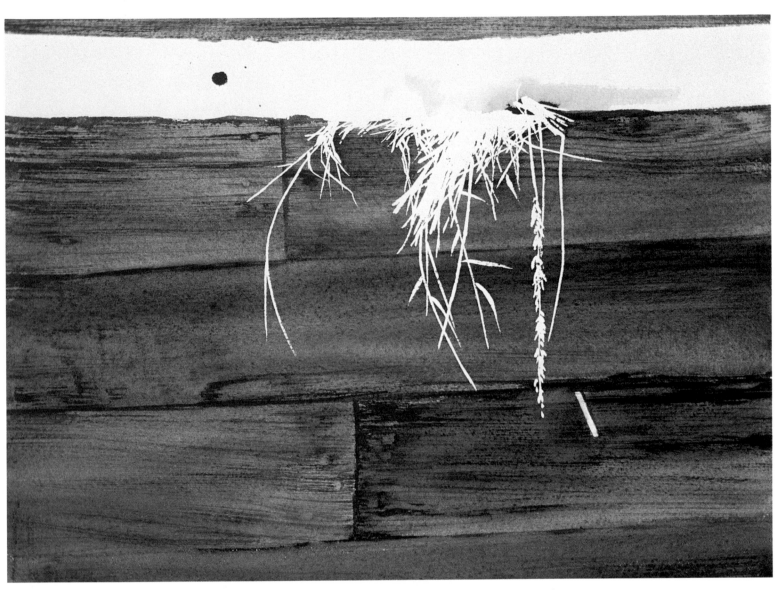

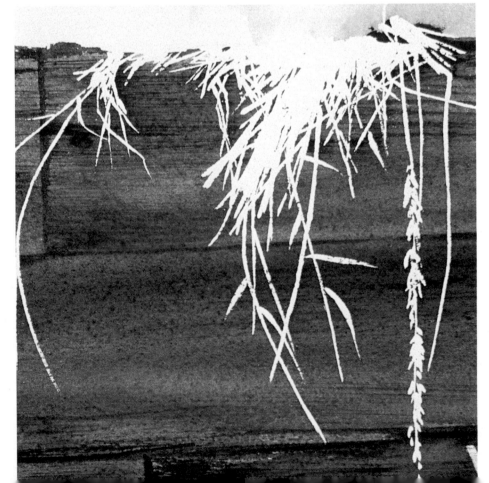

Step 2. I paint the natural color of the wood in dark tones, as if the entire surface is in deep shadow. This tone will later be wiped away to create the pattern of the shadows. It may seem wasteful to do it this way, but when the color is lifted away, the wood will have a much more convincing feeling of age than freshly painted color. This dark wash is a blend of raw sienna, burnt sienna, brown madder, and French ultramarine. I blend these colors on the paper with a 1″ sable brush. After the paint dries, I lift off the Maskoid with sticky tape.

Step 2 (detail). The dark shadow wash softens the drybrush texture of Step 1, which is now less insistent than it looked at first. Many of those drybrush strokes blur as the wet color goes over them. When the Maskoid comes off, the hanging weeds form a lively silhouette with lots of variety in the length and direction of the strokes. The strokes are also designed so that there are interesting spaces between them and no two spaces are exactly the same shape.

DEMONSTRATION 33. DRIED WEEDS AND SHADOWS

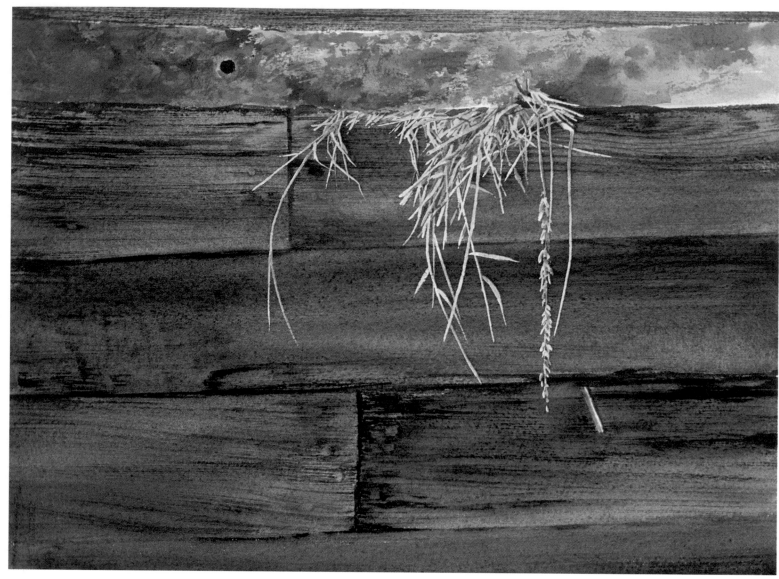

Step 3. I paint the weeds with raw sienna, burnt sienna, and Antwerp blue. The pale, warm color overlaps the thin, white shapes and soaks into the surrounding shadow. To give the weeds a feeling of three dimensions, I do a little modeling, introducing slightly darker values. You may be wondering what I'm planning to do with the white strip at the top. It's a strip of rusty metal, which I paint with brown madder, raw sienna, burnt sienna, and some French ultramarine. There are several layers of drybrush here—overlapping strokes of different color mixtures—to emphasize the crusty texture. At the lower right, the single rusted nail is painted with the same colors.

Step 3 (detail). Study the subtle color variations in the dried weeds, which are sometimes lighter and sometimes darker, sometimes warmer and sometimes cooler. To produce those ragged drybrush strokes for the rust, it's helpful to work with the side of the brush, rather than the tip. The irregular pattern of lights, middletones, and darks also enhances that rusty feeling.

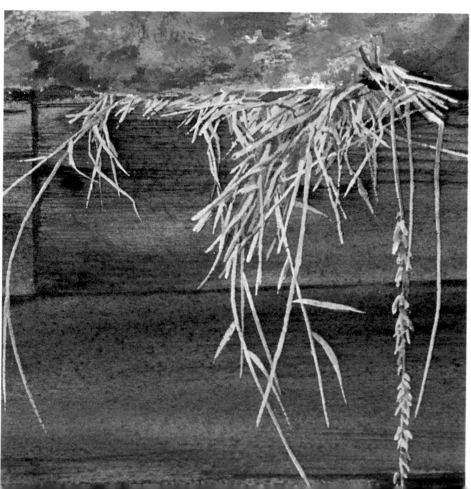

Step 3. At this point, I begin to link up the negative shapes so that the painting looks more unified, and realistic. Wherever the shapes are dark enough, I use a well-worn, short-haired, number 4 bristle brush with a good edge to scrub off the small white shapes of frosty, fern-like creatures. I blot away the wet color with a tissue. More of these small, fern-like shapes appear as I add dark strokes. Now, for the first time, there's enough realistic detail to suggest the branches and foliage of the evergreens.

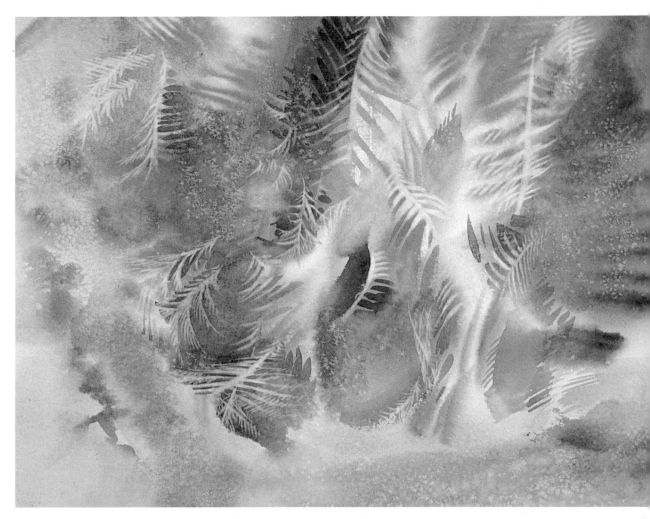

Step 4. The final touches in Step 4 are subtle, but essential. I strengthen the dark, (particularly the shadowy hollow beneath the center) with mixtures that are mainly sepia and cerulean blue. Still more darks appear along the lower edge. As I place these touches on the paper, I sprinkle more salt on these areas. Now the dark foreground gives a more solid base to the painting, and leads the viewer's attention *into* the landscape, not just *around* it. Although this watercolor is based on something I actually saw, I feel free to improvise, letting the shapes take over, and letting the brushstrokes suggest ideas and rhythms.

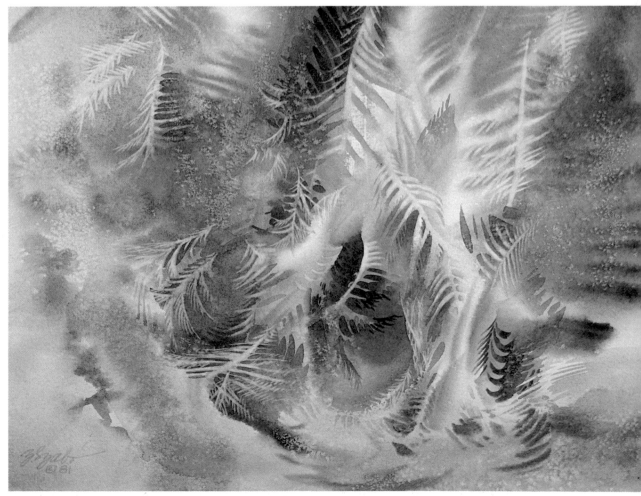

DEMONSTRATION 34. FROSTY EVERGREENS

Finished Painting. The completed painting is a large, rhythmic web of light and dark shapes. Whatever the original subject may have looked like in its natural setting, those pictorial elements are redesigned to produce a satisfying abstraction. The frosty shapes are produced by a varied combination of techniques. Many of the pale, spiky strokes are liftouts, made by a small bristle brush that never gets down to the bare paper, but always leaves a delicate stain on the painting surface. There's also lots of negative painting, where I've painted darks around the spiky lights to define the sharp edges of the evergreen needles. The soft blurs of light, like those at the top and the three corners (but excluding the dark corner at the right) all survive from the wet-in-wet execution of Step 1. And all those frosty flecks against the darkness are created by salt crystals, thrown on the wet painting surface. When you scatter salt, you've got to decide just how hard to throw it and how far your hand should be from the painting. Do you want to concentrate those crystals or spread them around? Experiment with different distances and velocities so that you learn to control this magical, but unpredictable technique. *Winter Sorcery* is 11″ x 14½″ (28x37 cm).

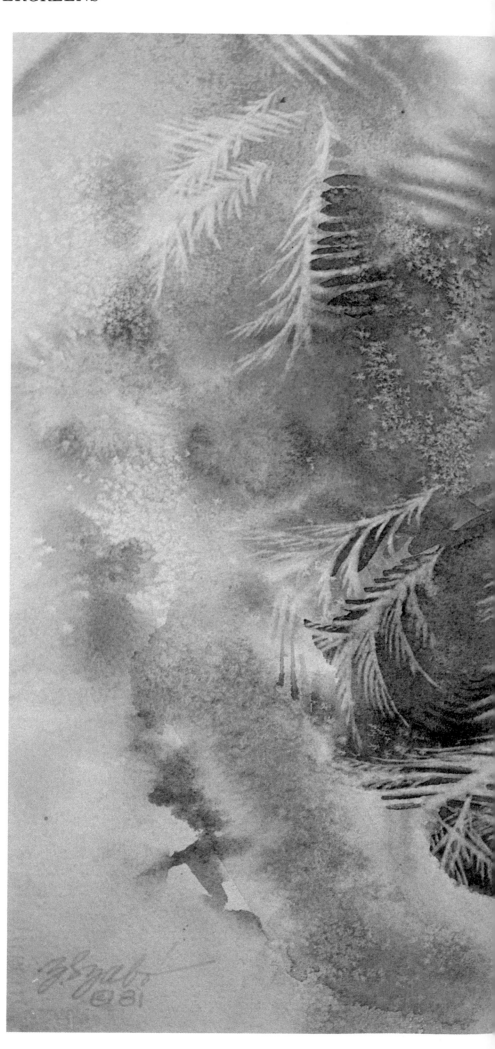

DEMONSTRATION 34. FROSTY EVERGREENS

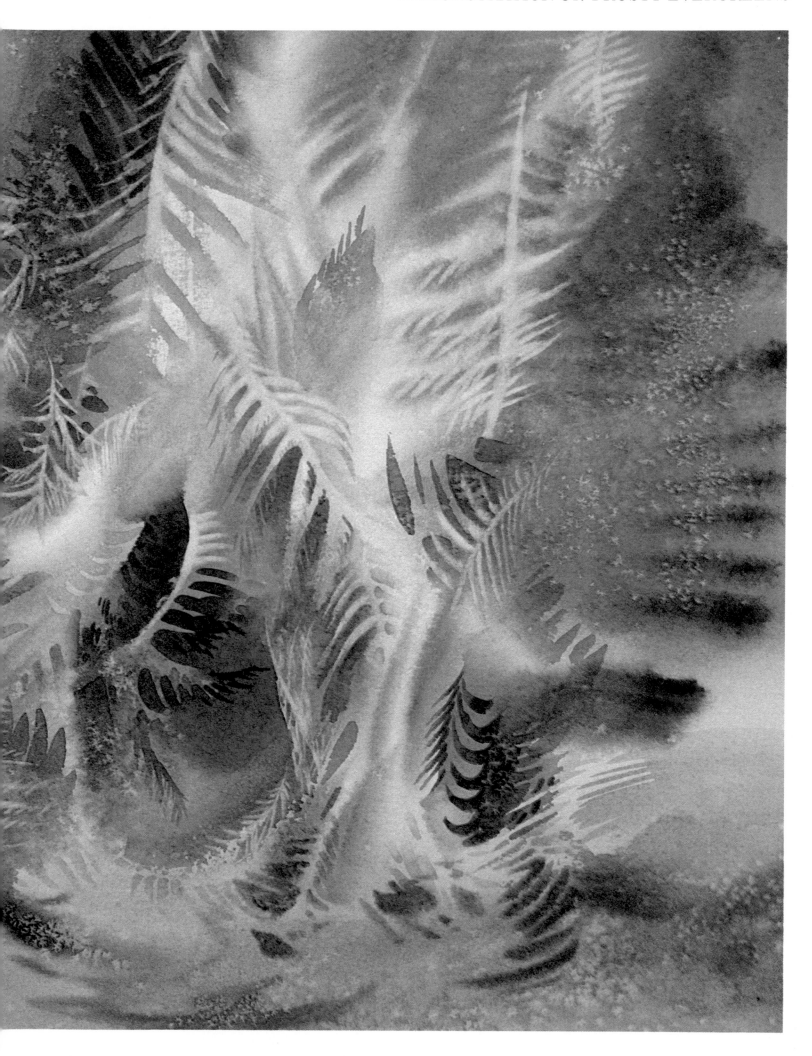

DEMONSTRATION 35. NESTS

Step 1. Here's another one of those interesting textural subjects. I cover the mud nests with drafting tape, cut to fit the curving shapes. Then I drybrush the grain of the boards with a ¾" bristle brush that carries pure, thick sepia. The gradations are built up by multiple drybrush strokes of dark paint—not by adding water to the color. (To get the edges of the boards straight, you can use strips of tape.)

Step 2. Peeling off the tape mask that protects the nests in Step 1, I drybrush the nests with short, curving strokes of pure, thick sepia once again. To accentuate the contrasts around the center of interest, I build up the grain around each nest to look darker than the nest itself. To paint the dark openings in the nests, I add just a bit more water to make the paint more fluid.

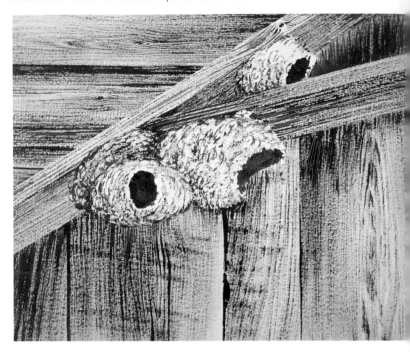

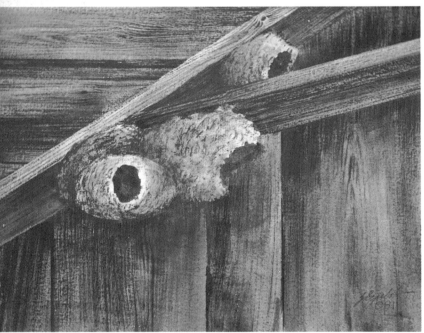

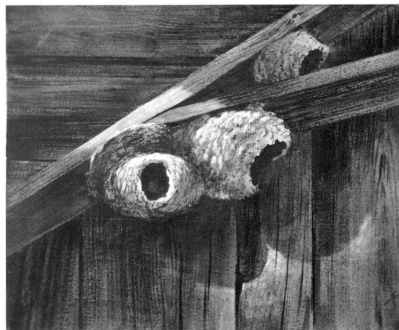

Step 3. Now I paint the tones of the wooden wall and the nests with various mixtures of burnt sienna, raw sienna, French ultramarine, and Antwerp blue. The burnt sienna dominates. Each piece of wood is a slightly different color because the boards age differently. This is a convenient time to scratch my name into the wet paper at the lower right. The wet color soaks into the scratch to make a dark line.

Step 4. When the color is thoroughly dry, I wipe away the sunlight as I've done in earlier demonstrations. I wet a small area with a number 4 bristle brush, scrub that area to loosen the pigment, and then blot the color away with an absorbent paper tissue. I clean the brush and repeat the procedure until the design takes shape. Finally, I add the dark cracks to the wood with sepia and Antwerp blue.

Step 4 (detail). I use the liftoff technique not only to lighten the boards and create an interesting pattern of light and shadow, but also to brighten the sunlit areas of the nests. Lifting color from the nests is an intricate job. I wet, scrub, and blot each tiny area separately. The sepia underpainting gets a thorough wetting in Step 3, and certain parts get a firm scrubbing in Step 4, yet the drybrush strokes survive because sepia is a staining color that clings tenaciously to the paper. Bearing this in mind, I clean the sepia off my palette at the end of Step 2. I don't want any sepia in those later mixtures, which *must* consist of colors that lift off easily and don't stain the paper. *Vacancy* is 11″ x 14½″ (28x37 cm).

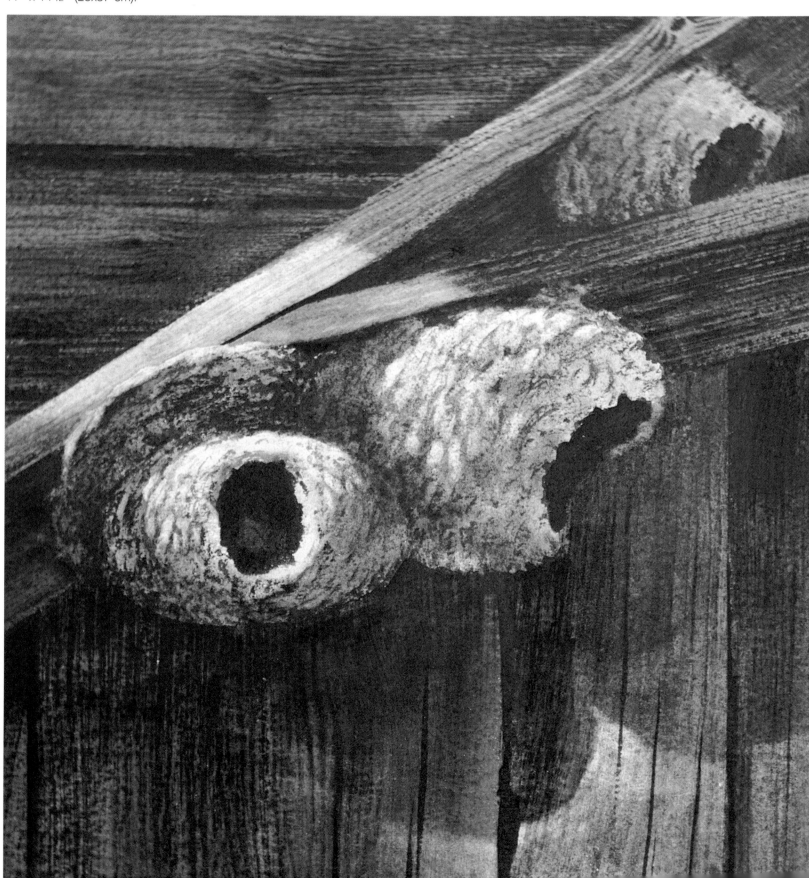

DEMONSTRATION 36. GARDEN CHAIRS

Step 1. The most familiar objects, like a couple of garden chairs, often give you a fascinating abstract pattern of positive and negative shapes. Wetting the paper, I establish the large shapes boldly and without detail. I play warm and cool colors, and light and middle values, against one another. The colors are various mixtures of burnt sienna, new gamboge, brown madder, Antwerp blue, and French ultramarine. The darkest hue behind the chairs is a mixture of brown madder and Antwerp blue. Notice how the brushwork above the chairs already begins to suggest the texture of the bark of that massive, old tree.

Step 2. I define the shapes of the old chairs by strengthening the darks around them, adding the darks on the chairs themselves, and carefully drawing the dark lines between the wooden strips of the backs and seats. Now there's an interesting interplay of light and dark, negative and positive. (The shapes between, around, and within the chairs are an essential part of the design.) As I paint the sky in the upper right, I work around the bare paper to render the picket fence, and I use the same negative painting technique to suggest some weeds at the extreme right. I begin to develop the darks on the grass beneath the central chair.

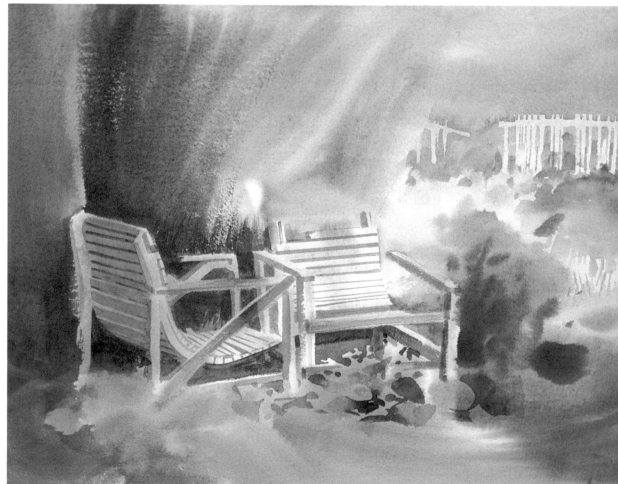

Step 3. I've been holding sap green in reserve because it's a powerful staining color. But now I mix the sap green with brown madder and drybrush this dark mixture on the tree-trunk and the shrub at the right. As I build up the darks in the foreground, I also rely primarily on sap green, plus a little less brown madder. Notice how the tree mixture is used to solidify and darken the shapes between the arms and legs of the chairs. A few leaves begin to appear in mid-air around the shrub at the base of the tree.

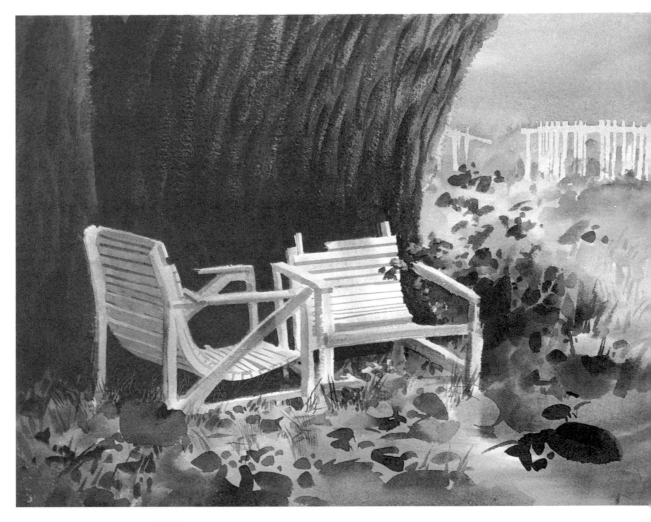

Step 4. I paint a light wash of sap green and French ultramarine into the soft, shaded planes of the chairs to show the influence of the reflected color on the white wood. As I connect the leaves to the shrub by adding branches and twigs, I carry one of those branches over the arm of the central chair. I brush in some more leaves and blades of grass, and then knife out some paler twigs, as well as a few blades of grass, in the shadow beneath the chair at the left. Some drybrush touches of cerulean blue add a final suggestion of luminosity to the tones of the chairs. *The Escort* is 11″ x 14½″ (28x37 cm).

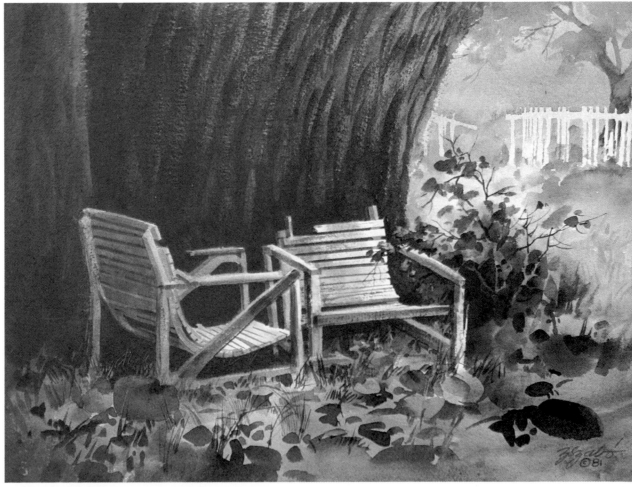

DEMONSTRATION 37. FEATHER AND PEBBLES

Step 1. Sometimes a single, tiny object can trigger the idea for a painting—like this feather found on a pebbly path. Because I plan to paint the feather last, I seal it off with Maskoid. Then I make a tape mask to protect the big pebble behind the feather. One by one, I paint the rest of the pebbles, working with small washes that gradate from dark to light. The light comes from the upper right, so the shadows are on the lower left sides of the pebbles. The basic mixture is burnt sienna and French ultramarine, but each brushful is newly mixed so that there's color variation in the pebbles.

Step 1 (detail). I don't expect to splash color over the entire sheet, so I protect only the *edges* of the big pebble with tape. (Some very thin tapes are flexible enough to bend very easily.) Study the lost-and-found edges. Each shadow tends to have a hard (found) edge on the dark side and a blurred, or ragged (lost), edge as the shadow gives way to the light. Sometimes the wash contains more water at its lighter edge. At other times, the stroke simply becomes more ragged because I'm working with the side of the brush.

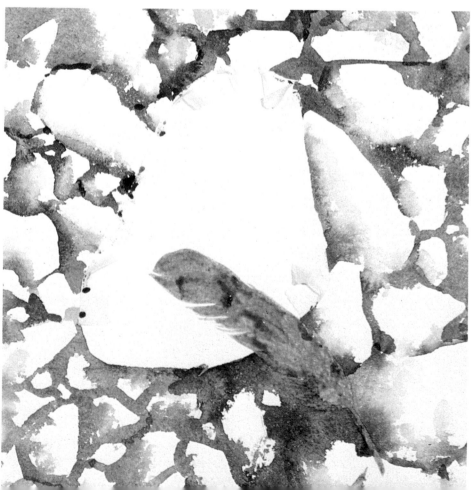

DEMONSTRATION 37. FEATHER AND PEBBLES

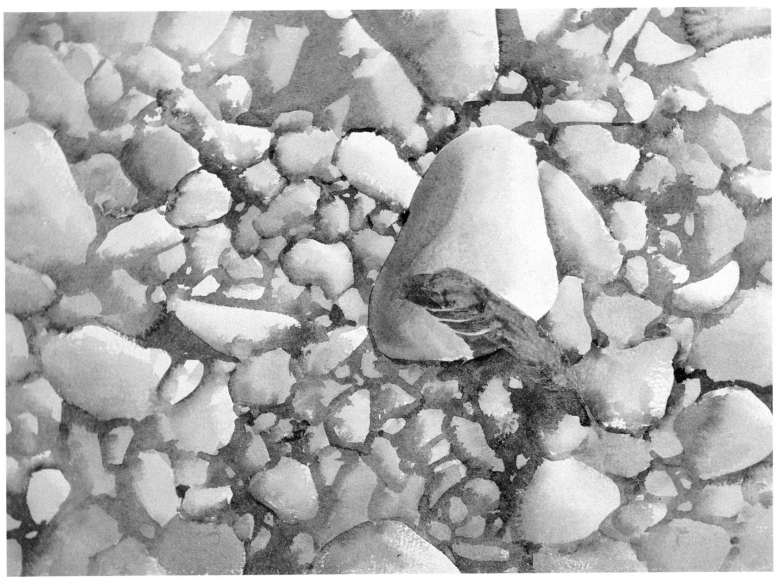

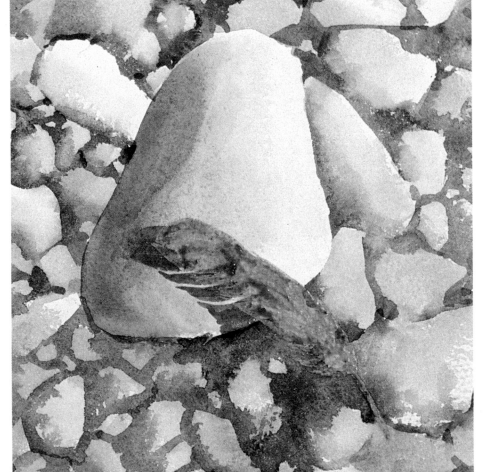

Step 2. I paint the colors of the stones with varied mixtures of burnt sienna, raw sienna, sepia, Antwerp blue, and French ultramarine. The transparent washes allow the modeling of Step 1 to come through very clearly. Now I strip off the protective tape from the big pebble and give the shape a warm wash which is distinctly warmer than the surrounding pebbles. There's a strong shadow on the left-hand side of the big pebble, making the form stand up more boldly than the smaller pebbles around it. While the feather is still masked out, I paint its shadow on the big pebble beneath.

Step 2 (detail). Like the surrounding pebbles, the big, warm pebble starts with a cool shadow tone, over which I glaze a warmer color. The shadow of the feather is the same color as the shadows on the smaller pebbles. (The latex on the feather is almost indistinguishable from the shadow tone.) A few of the surrounding pebbles are warm in color, but most of them are distinctly cooler than the big one. This contrast of color temperature emphasizes the center of interest.

DEMONSTRATION 37. FEATHER AND PEBBLES

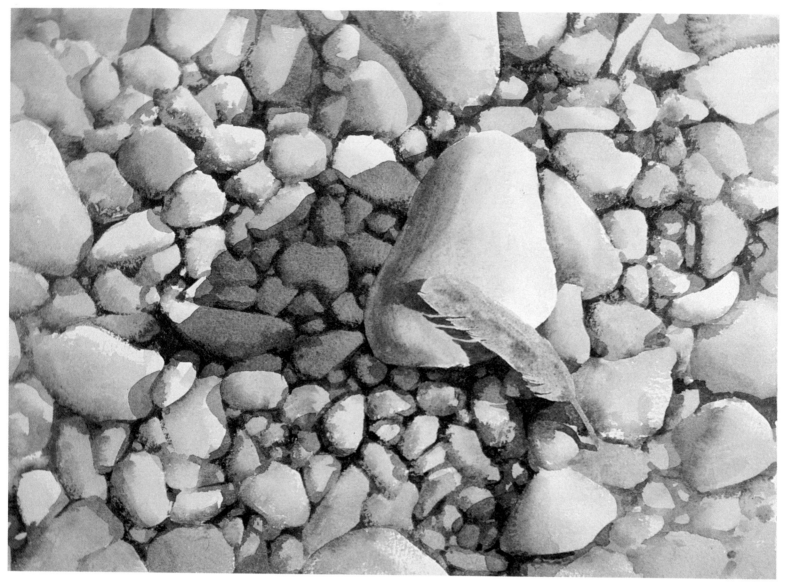

Step 3. Now I paint the big, cool, transparent shadows with a mixture of burnt sienna, French ultramarine, and Antwerp blue. Actually, French ultramarine is the dominant hue. Knowing that watercolor always dries lighter, I make sure that the color is dark enough to *stay* dark after it dries. Then I reinforce the darks between the stones with Antwerp blue and sepia, placing the strongest darks near the center of interest.

Step 3 (detail). The large shadow at the left of the big pebble adds greater emphasis to the warm-cool color contrast that dramatizes the focal point of the painting. The strongest shadow is beneath the biggest pebble, fusing with the shadow of the feather. I've also placed lots of small, strong darks around the little pebbles that are closest to the big one. As I deepen the darks between the pebbles, I don't go methodically over every single shape. I add these dark notes very selectively, sometimes leaving the paler shadows as they are at the end of Step 2. Here and there, a hint of drybrush accentuates the granular texture.

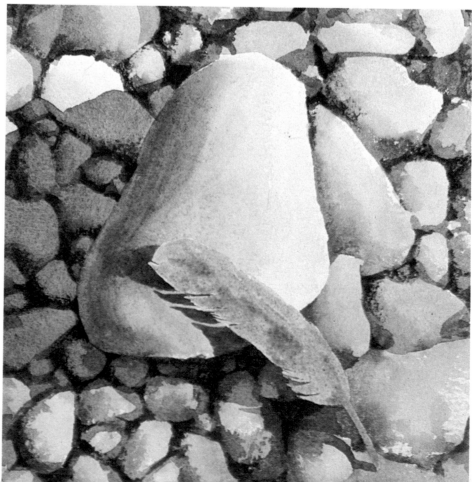

DEMONSTRATION 37. FEATHER AND PEBBLES

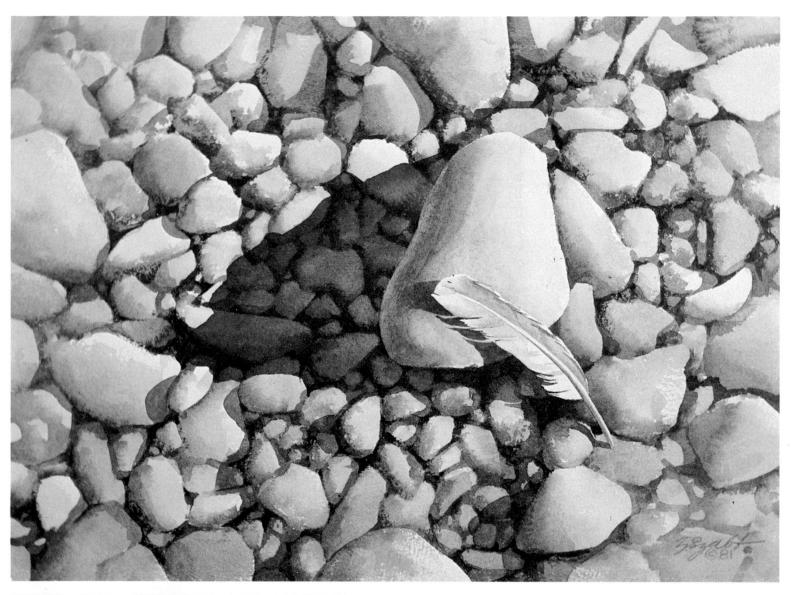

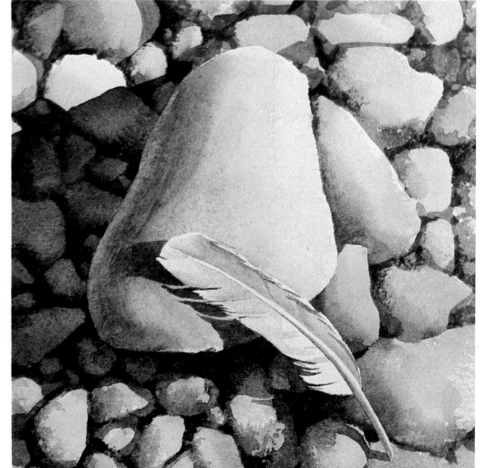

Step 4. Removing the latex mask, I reveal the white shape of the feather. Then I paint the tones of the feather with extremely pale versions of the mixture I used to model the pebbles in Step 1. The feather divides into two planes. The lower plane is lighter because it receives more sunlight, while the upper plane is darker because it bends inward and tends to be in shadow. Where the upper edge of the feather curls over, I leave bare paper for the sunlit edge and indicate tiny strips of deep shadow. The completed feather still contains a fair amount of bare, white paper in the sunlit parts.

Step 4 (detail). The feather is painted very simply. Along the edge, you can see that I've isolated the silhouettes of a few individual fibers. But there's practically no detail *within* the shape. That shape consists mainly of very soft lights and shadows. There's no need for further detail—which might actually make the feather look heavier and less delicate. The last touches are a few additional darks between the pebbles. *Streaker's Path* is 11″ x 14½″ (28x37 cm).

DEMONSTRATION 38. OLD BOOT

Step 1. I mask out the shape of the old, worn-out boot with liquid latex so that I can work freely on the surrounding weeds and clutter. Then I wet the whole paper and paint in the approximate shapes with varied mixtures of raw sienna, burnt sienna, new gamboge, French ultramarine, and Antwerp blue. I use a firm, 2″ bristle brush that holds plenty of paint and not too much water. I try to keep the shapes fairly distinct. One thing that helps is to use raw sienna in all my mixtures, since this color tends to keep the strokes from running too far on wet paper. As a bonus, the raw sienna also unifies my color scheme.

Step 2. While the shape of the boot is still protected by the mask, I paint in the darker values and the weeds. Moving a ³/₄″ bristle brush in varied directions, I brush on small areas of thick color, containing very little water. While this color is still damp, I knife out the light lines of the weeds with my palette knife and the handle of my nail clipper. The colors of Step 1 shine through the marks of the knife and clipper, so the lines aren't pure white. With vertical strokes, I suggest the texture of the wooden boards at the top of the painting.

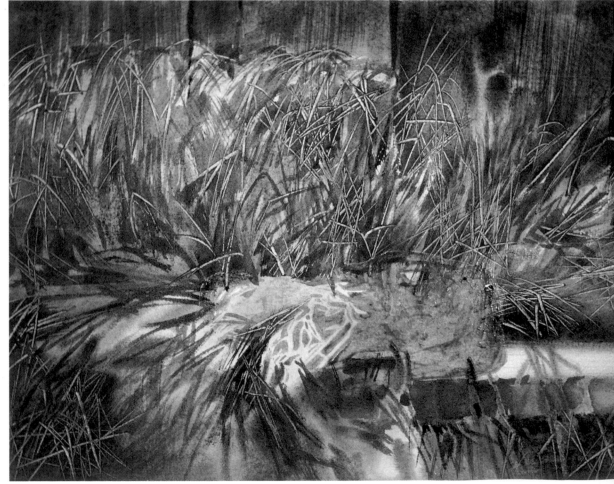

Step 3. Stripping off the dried latex, I paint the boot with a combination of burnt sienna and French ultramarine. Burnt sienna dominates the mixture. As I model the gradations of light, middletone, and dark, I vary the proportions of the two colors, and also vary the amount of water, to give the old leather a faded, irregular appearance. I begin to add detail to the yellowish, dried weeds that droop over the boot, paying particular attention to the small, dark shapes between the weeds.

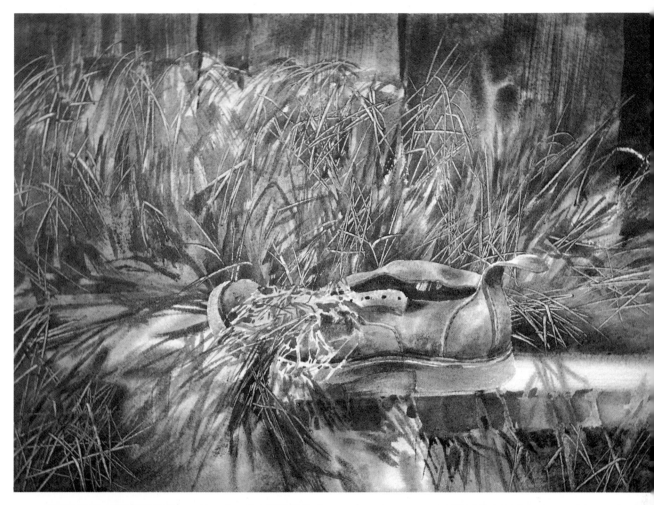

Step 4. Now I build up the darks with sepia and Antwerp blue. I carefully paint around the light lines of the weeds, building up the darks under the boot and below the step on which the boot sits. My strategy is to surround the boot with lots of texture so that the smooth leather will stand out by contrast. Where I want to lighten the weeds, I wet and wipe away some of the blades. The chicken wire should be light against dark, so I moisten the dry, dark color and squeeze out the light lines with the handle of my nail clipper.

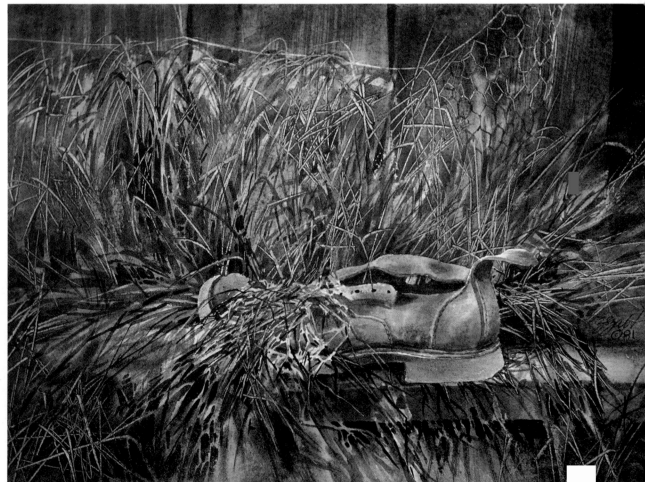

DEMONSTRATION 38. OLD BOOT

Finished Painting. The old boot commands attention because it's the only quiet spot among the profusion of surrounding detail. Yet those masses of weeds aren't painted at random. They're planned so as to lead your eye to the old boot. And the brightest weeds—the yellow, straw-like shapes—bring your eye to the boot because they literally fall on top of it. The strongest light-and-dark contrast also occurs at the focal point of the picture. The shadowy inside of the boot contrasts strongly with the smooth, faded outside. There are also strong, but inconspicuous shadows beneath the sole and heel. Observe that the light lines of the weeds are painted in two different ways: some of them are squeezed out of the damp color with my palette knife blade and the tip of my nail clipper, while others are the products of negative painting. This picture is another example of the kind of quiet, poetic subject that you can easily pass every day without realizing that it might make a memorable painting. *Cinder Allen's Slipper* is 11″ x 14½″ (28x37 cm).

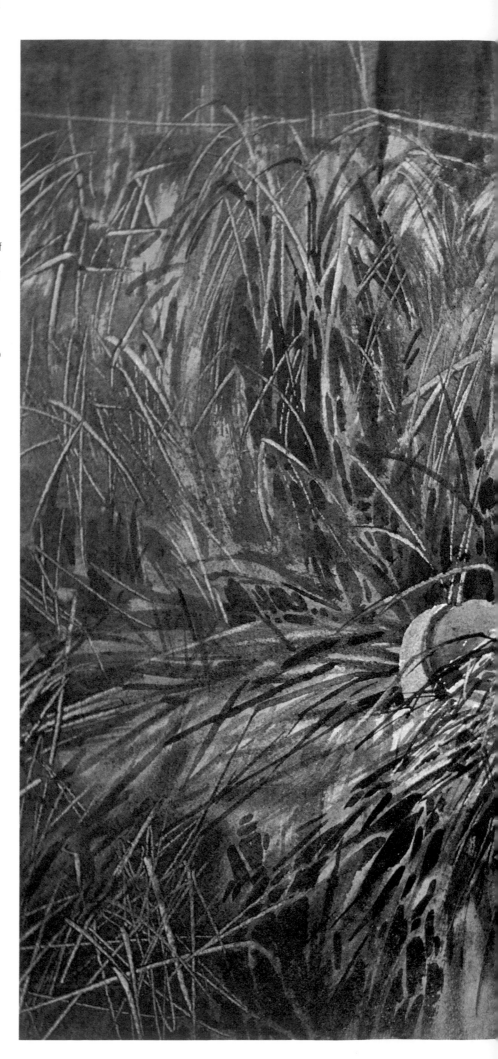

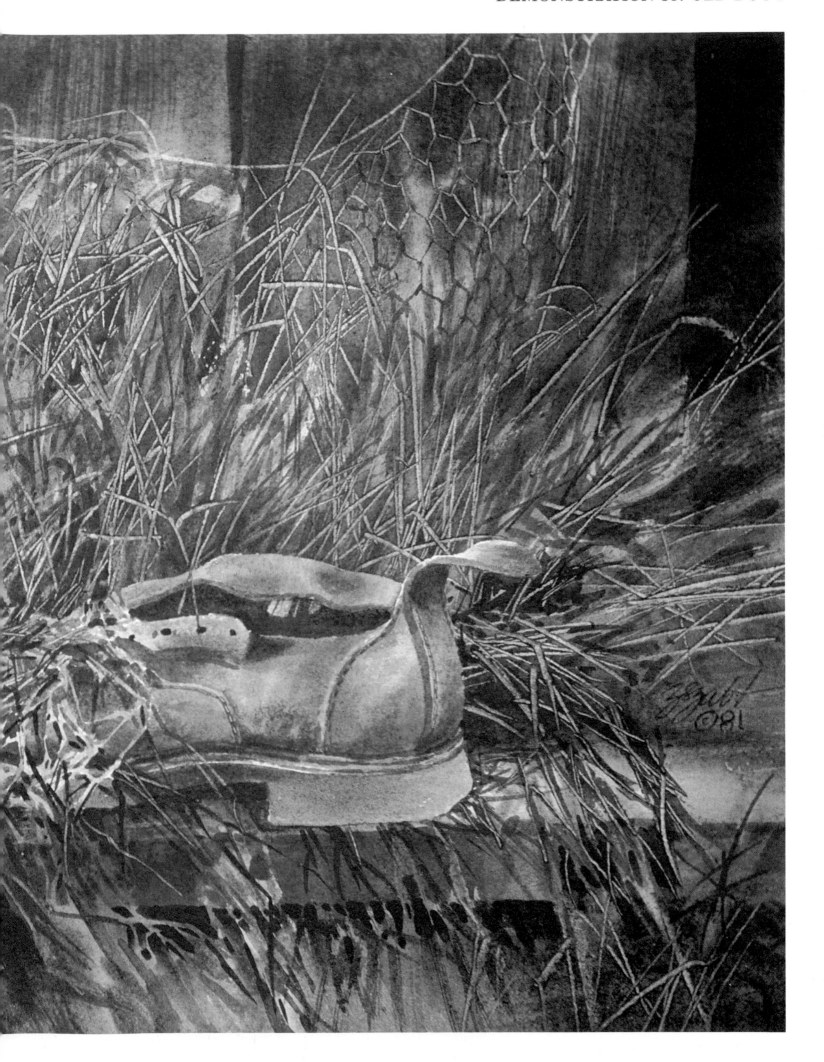

DEMONSTRATION 39. DEAD TREE: FOUR VARIATIONS

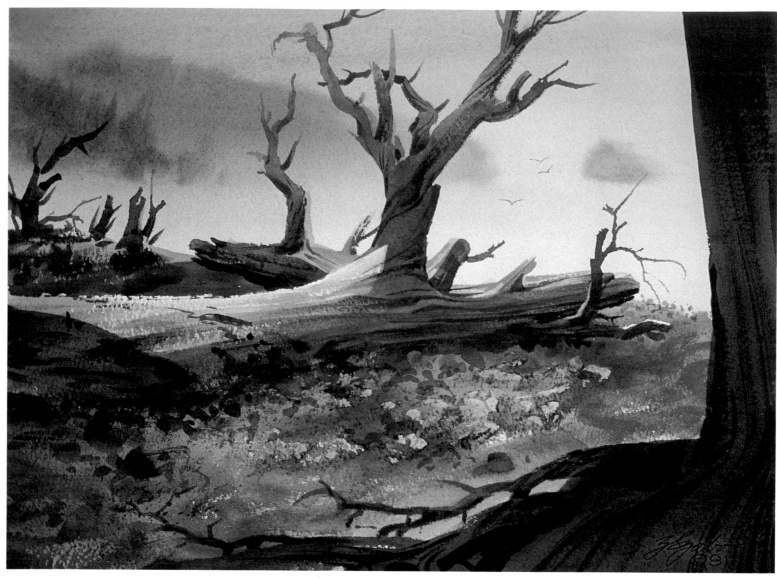

Variation Number One. Many outdoor subjects, such as this fallen tree, can be painted from so many different angles, and in so many different kinds of light, that you can paint a whole series of variations on this single theme. My first version of the subject emphasizes strong contrasts. I start on wet paper and paint the background with cerulean blue, Antwerp blue, and burnt sienna. Then I follow with the middletones of the big stump, the smaller stumps in the background, and the surface of the ground, leaving out the sunlit area on the large tree that forms the center of interest. Finally, I add the darks on the trees and the very dark, upright trunk at the extreme right with sepia, burnt sienna, Antwerp blue, and French ultramarine.

Detail. I play up the dark silhouettes against the pale sky, as well as the contrasts of light and shadow on the shapes. My brushstrokes follow the curves and twists of the dry, warped wood, suggesting the texture of the bark with occasional touches of drybrush. *Victory Sign* is 11″ x 14½″ (28x37 cm).

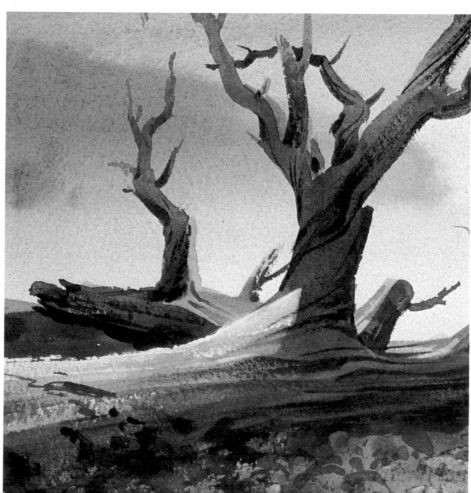

DEMONSTRATION 39. DEAD TREE: FOUR VARIATIONS

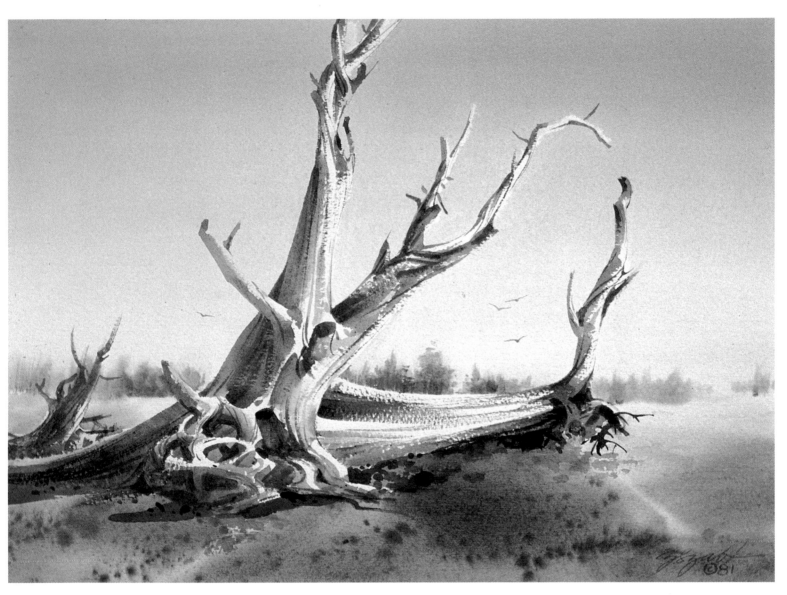

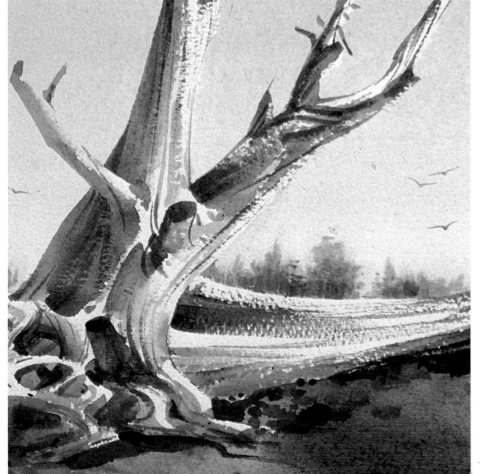

Variation Number Two. Walking around to look at the sunny side of the large root structure, I simplify the painting by focusing on fewer forms, placing the dead tree against a clear sky, and lowering the horizon. The entire picture is sunnier, higher in key, and lower in contrast. As I model the dead wooden shapes, I work mainly in middle values. Then I paint the pale, sunny sky. After washing in hints of the foreground, I knife out some rocks. And I finish with the distant row of pines to give the painting a suggestion of perspective. In all four versions, I'm working with the same palette: raw sienna, burnt sienna, sepia, cerulean blue, Antwerp blue, and French ultramarine.

Detail. Because I'm looking at the sunny side of the subject, the shadows are paler and more transparent. I paint them mainly in middletones with a few strong darks in the deep hollows. As in the first version, I follow the curves of the shapes with my brush and suggest the texture of the wood with drybrush strokes. The sunlit areas are pure, white paper. *Morning Visit* is 11″ x 14¹/₂″ (28x37 cm).

DEMONSTRATION 39. DEAD TREE: FOUR VARIATIONS

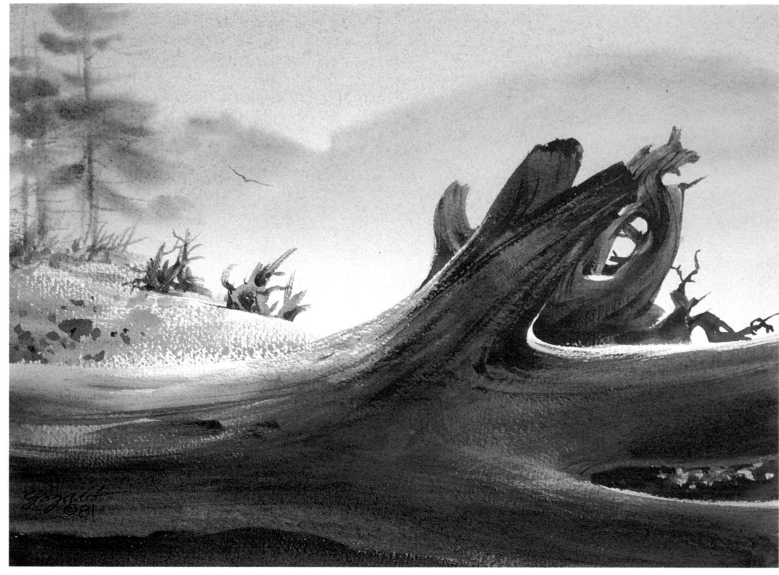

Variation Number Three. Continuing to circle around my subject, I move in for an extreme closeup. I'm no longer painting the entire fallen tree, but just one small part that looms darkly against the pale distance. Now the light is behind the center of interest to produce the dramatic effect known as backlighting. I'm facing the dark side of the tree. First I paint the misty sky with cerulean blue and sepia. While this area is still wet, I paint the hills and then the pines with Antwerp blue and burnt sienna. When the top half of the paper is dry, I model the shaded tree in the foreground with darks and middletones: raw sienna, burnt sienna, sepia, and French ultramarine. I add a few stumps in the middle distance for scale. And then I drybrush the texture of the ground beneath them.

Detail. Backlighting is sometimes called rim lighting because the shapes are almost entirely in shadow except for narrow bands of light along the rims of the forms. The dark, positive shapes make a jagged silhouette against the sky, and they also wrap around smaller patches of sky that read as negative shapes. *Resting Giants* is 11″ x 14½″ (28x37 cm).

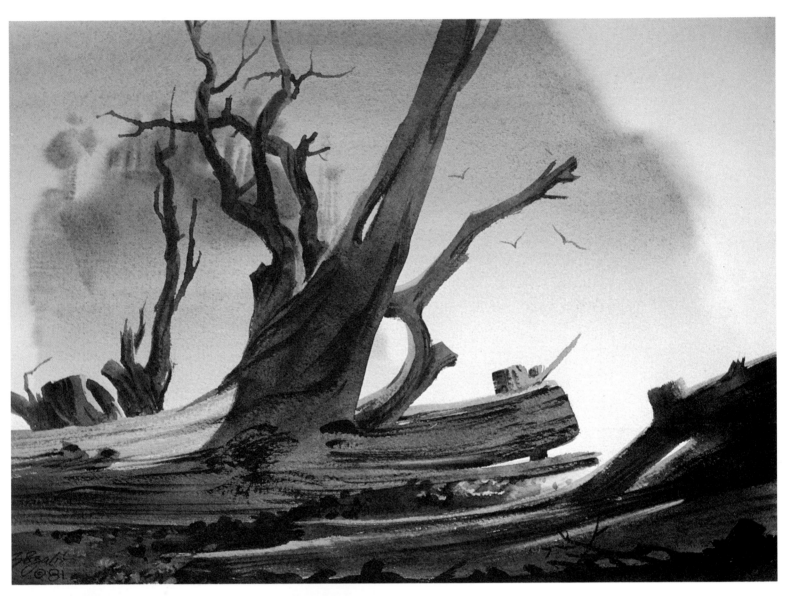

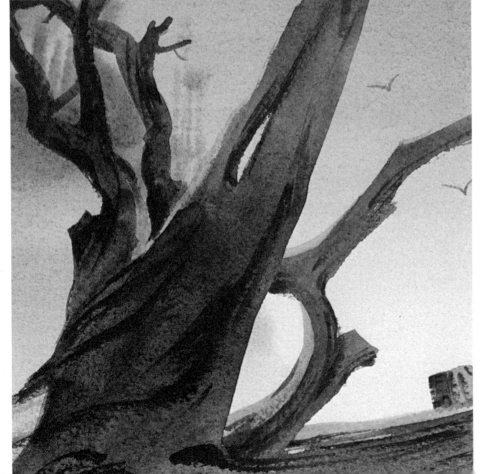

Variation Number Four. The upright shapes on another part of the tree give me another closeup. I begin by simplifying the background, making the hill just one large shape with a small patch of sky at the upper right. I paint that patch of sky, the big hill, and the shadowy mass of the distant trees at the left, all wet-in-wet. Those distant tones gradate to a much paler tone at the horizon. This gives me a strong value contrast when I paint the middletones and darks of the foreground trees. The middle values are cerulean blue, French ultramarine, and burnt sienna. Then I add the strong darks and the drybrush textures with sepia, raw sienna, and French ultramarine. To accentuate the size of these dark shapes, I design my picture so that the trunks and branches touch all four edges of my watercolor paper.

Detail. Once again, I design the center of interest so that there's an interesting interplay of positive darks and negative lights. The fragments of pale sky, showing between the dark trunks and branches, are essential to the success of the design. *The Blockers* is 11″ x 14½″ (28x37 cm).

DEMONSTRATION 40. TREE STUMP IN SNOW: FOUR VARIATIONS

Variation Number One.
Changing light and weather can give you countless variations on any outdoor theme, like this treestump, half buried in snow. On an overcast day, shadows are minimal. The snow and the background forest are painted wet-in-wet. The snow is a mixture of French ultramarine, burnt sienna, and a touch of Antwerp blue. The forest is burnt sienna, Antwerp blue, French ultramarine, and enough raw sienna to dominate the other colors. When the sheet is dry, I paint the darks at the center of interest with burnt sienna, raw sienna, and Antwerp blue and use my palette knife to lift out the light tree and to paint the dark root structure. *Hiding* is 11" x 14½" (28x37 cm).

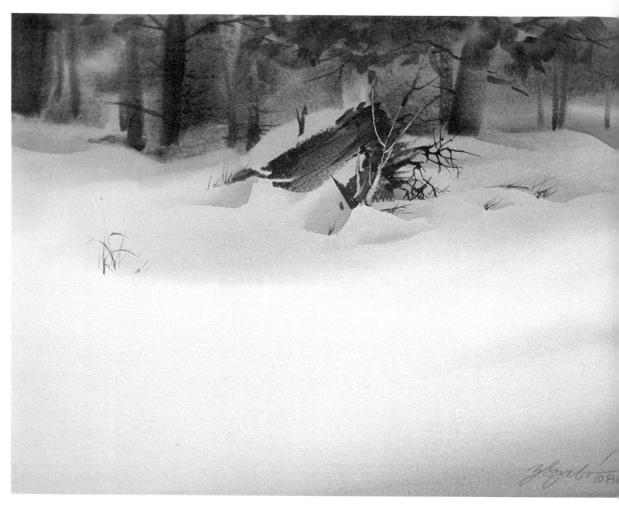

Variation Number Two. The same elements are rearranged slightly, but the subject is essentially the same, transformed into a totally new painting by the bright sunshine and glowing, cool shadows. The center of interest is caught in a flash of sunlight, surrounded by shadows that occupy nearly all of the foreground. The shadows on the snow are manganese blue, French ultramarine, and a touch of brown madder, painted on wet paper in the foreground—and then painted on dry paper to create the hard-edged shadows closer to the horizon. The patches of light within the shadow are scrubbed and lifted after the shadow tone dries. *Spotlit* is 11" x 14½" (28x37 cm).

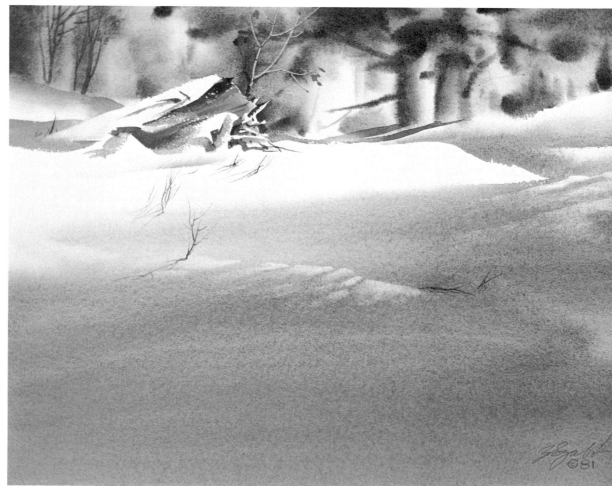

DEMONSTRATION 40. TREE STUMP IN SNOW: FOUR VARIATIONS

Variation Number Three. The sun is low in the sky, shining through a break in the trees. Now the stump and the foreground snow are all united as a single, massive dark. The medium values are in the middleground and the lights are in the background. I start at the top of the sheet with new gamboge, alizarin crimson, and a touch of cerulean blue on wet paper. I paint the trees while the paper is wet, using Winsor blue to darken those same colors. I paint the middleground and the shaded foreground snow with both blues and alizarin crimson. For the dark stump, weeds, roots, and twigs, I add sepia and new gamboge to this mixture.

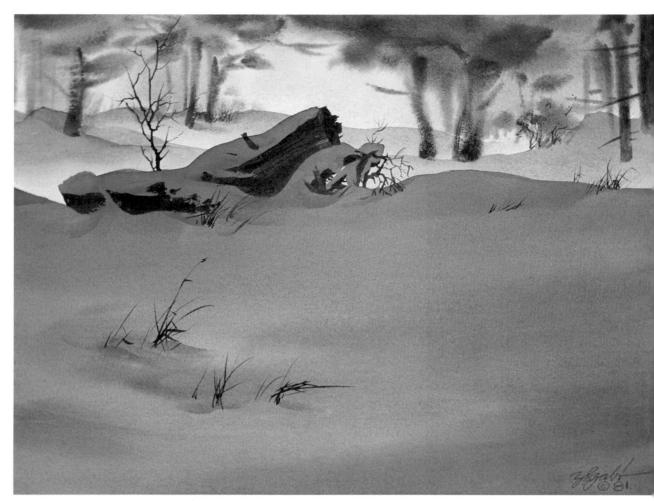

Variation Number Four. The blowing snow produces a foggy effect, which I paint on wet paper. A limited palette simplifies and unifies my color scheme. My colors are burnt sienna, raw sienna, cerulean blue, and French ultramarine. The darkest values, and *slightly* warmer color, are on the stump, which is the center of interest. Where the snow blows across the dark shapes in the distance, I wipe away dried color with a wet brush and blot the surface with a tissue. A few weeds add animation to the foreground. In the four versions of this snow scene, there's very little difference in composition, but there *are* strong differences in lighting and color. *Huff 'n Puff* is 11″ x 14½″ (28x37 cm).

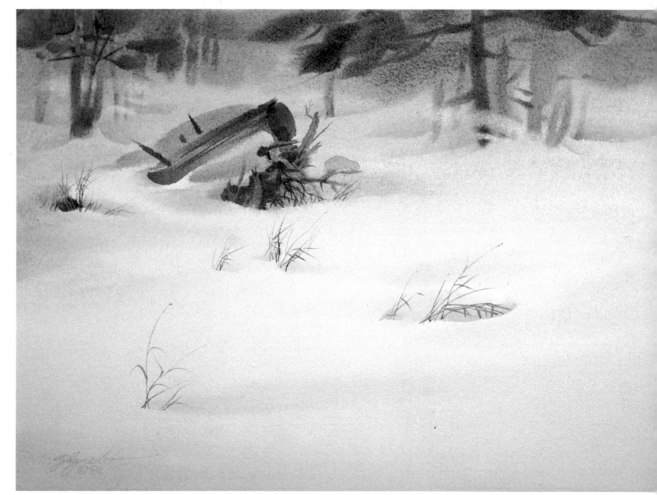

COMPOSITION—GOOD AND BAD

The Farm Next Door. Architectural shapes, combined with natural light, offer endless possibilities for abstract pictorial designs. Here the sunshine comes through the broken window of a deserted farm building to create a foreshortened image of that window on the ground. The trough adds a dramatic note of perspective. A second window echoes the shape of the first, cut off by the left edge of the sheet. Through the windows, you see tiny fragments of the sunlit landscape, with a different fragment in each pane. The geometric shapes are softened by the weathered textures of the old wood and the rough surface of the straw on the ground. *The Farm Next Door* is 14¹/₂″ x 11″ (37x28 cm).

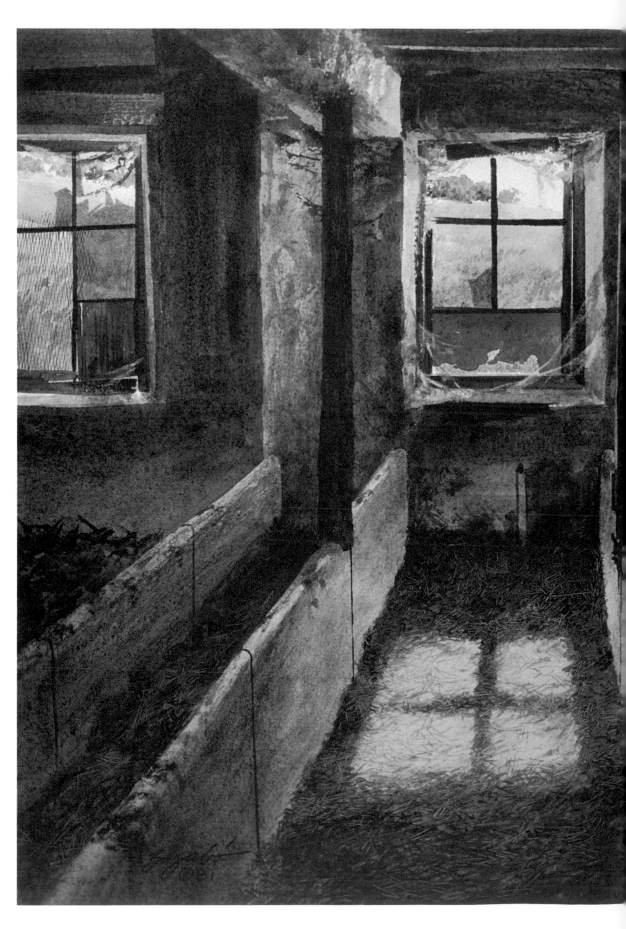

Good Composition. Although this is a simple closeup of the upper part of a single treetrunk and a few snowy branches with hanging icicles, all the pictorial elements fill the sheet in a lively way. The trunk is off center, producing an asymmetrical composition. The darks are concentrated at the top, but the hanging ice connects the dark shape of the tree with the lighter background below.

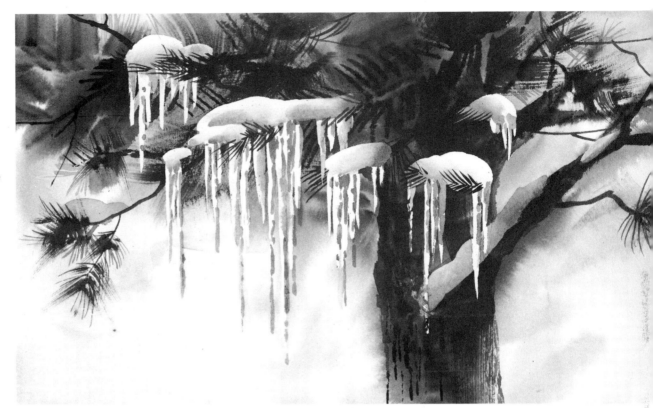

Bad Composition. This painting exemplifies many of the most common mistakes in painting closeups. Instead of filling the page in an interesting way, all the pictorial elements are concentrated in the center. The composition is basically symmetrical, which usually means *boring*. Those four empty corners act like huge white arrows, pointing outward and carrying your eye away from the picture. The icicles no longer act as bridges between the dark and light areas, but stand out as isolated verticals against the dark background.

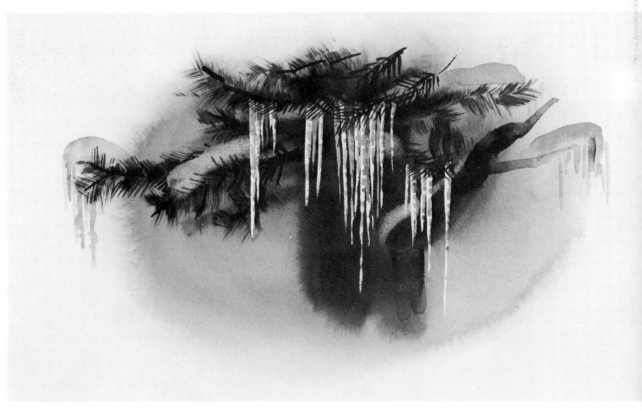

COMPOSITION—GOOD AND BAD

Good Composition. The shapes of the snowy shore are uneven, with a relaxed and natural rhythm. There's lots of variety in the contour of the shore, which leads around to the base of the large tree in the upper left. The young tree and shrubs on the right repeat the calligraphy of the twigs at the base of the large tree at the top right. The wet-in-wet surface of the water is softly painted with lively, irregular shapes that relate logically to the shapes they reflect.

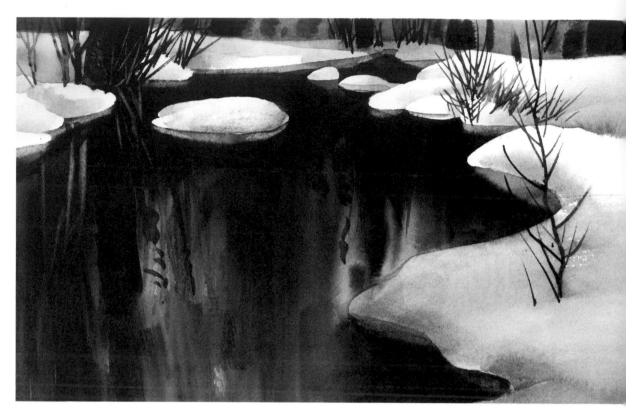

Bad Composition. The shapes along the shoreline are repetitive and monotonous. The big tree is now in the center and so is its reflection, splitting the composition down the center, and dividing the picture in two equal halves. The big tree is also too far back to play any significant role in the composition. And the islet of snow, placed in the center of the picture like a bullseye, breaks the dark reflection of the tree. The water is full of vertical streaks that might be reflections, but don't seem to have any connection with shapes on the shore. The lone little tree at the right is isolated and distracting.

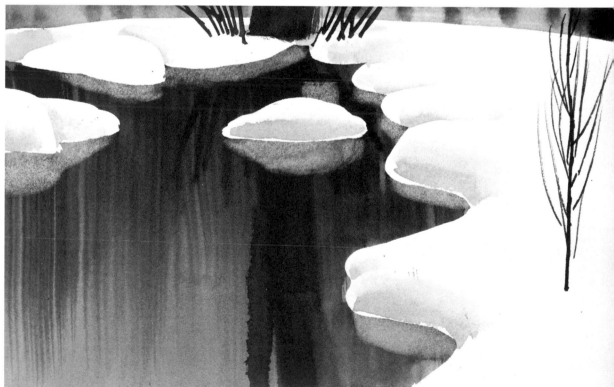

Good Composition. The center of interest is clearly the shining shape of the tidepool in the foreground, which is the lightest and brightest element in the picture. The focal point of the picture is also the area of strongest light-and-dark contrast. The more distant shapes are pushed further away because their shapes gradually diminish in scale and become lighter in value. Thus, there's a distinct sense of transition from the larger shapes and high contrasts of the foreground to the smaller shapes and more subdued values of the distance.

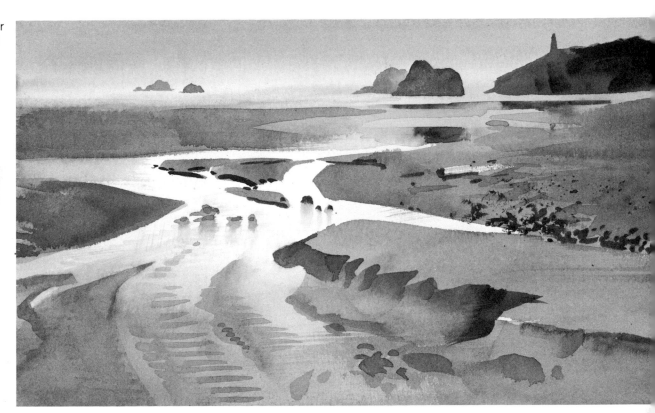

Bad Composition. Now the center of interest is uncertain. The reflecting pool and the dark rock compete because the former is the lightest element in the picture and the latter is the darkest. That dark, isolated shape is also placed dead center, drawing our attention away from the tidepool. The dark shape of the shoreline at the right also points to the dark rock like an arrow. The foreground and the distance seem equally close to the viewer, so there's no sense of emphasis or transition from near to far. The picture is confusing!

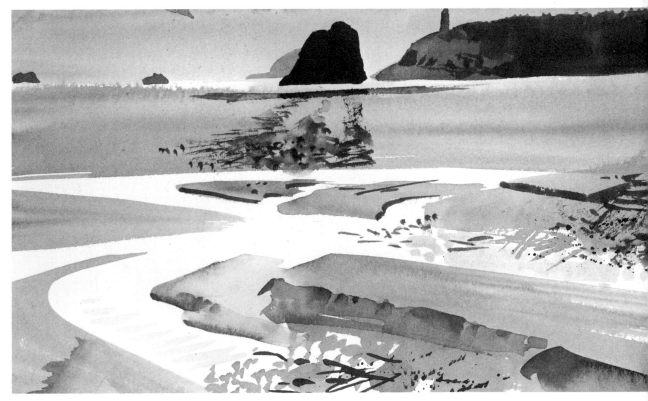

COMPOSITION—GOOD AND BAD

Good Composition. The road leads the eye through the composition in a gentle zigzag toward the sunlit area around the bright shrub just left of center, with its snowy branches silhouetted against the dark woods. A deep shadow moves across the entire foreground, uniting the path, the shadowy trees at the left, and the shrubs beneath the trees. The trees in the upper right are toned down to prevent any competition with the sunlit center of interest.

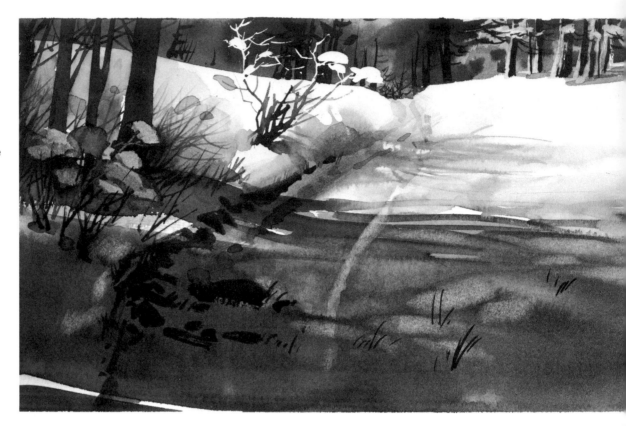

Bad Composition. The path leads back to a point on the horizon that's unrelated to the center of interest. It's not clear whether the center of interest is that point on the horizon, the sunlit trees in the upper right, the shrub to the left of the road, the dark trees in the upper left, or the road itself. The foreground is broken into unrelated positive and negative shapes. There are also technical errors. The large foreground shadows reveal smaller shadows within them, while the tree shadows in the upper right run in a different direction from the other shadows—impossible unless there are two suns! The upper end of the road is *not in perspective*, but seems to run straight up.

SUGGESTED READING

Biggs, Bud, *Watercolor Workbook*. Westport, CT: North Light, 1979. A solid book full of practical hints. Great for a purist who truly appreciates transparent watercolor.

Blake, Wendon, *Acrylic Watercolor Painting*. New York: Watson-Guptill, 1970. Exciting demonstrations by several fine painters who use acrylic as a transparent medium, written in superbly clear text.

Brandt, Rex, *Watercolor Landscape*. New York: Van Nostrand-Reinhold, 1963. One of the most complete watercolor books, full of sophisticated guides, by a great artist and teacher.

Cooper, Mario, *Watercolor by Design*. New York: Watson-Guptill, 1980. A powerful book on design and a personal statement on the creative use of watercolor.

Hawthorne, Mrs. Charles W., *Hawthorne on Painting*. New York: Dover, 1960. Short gems for a painter, easy to remember and well worth retaining.

Henri, Robert, *The Art Spirit*. Philadelphia and New York: Lippincott, 1960. A book filled with valuable principles for artists in all media.

Hill, Tom, *Color for the Watercolor Painter, New, Enlarged Edition*. New York: Watson-Guptill, 1982. A basic and lively text on the use of color in the watercolor medium. Valuable information for the beginner, intermediate, and advanced painter.

Hill, Tom, *The Watercolor Painter's Problem Book*. New York: Watson-Guptill, 1979. A well-written, beautifully illustrated book on common problems and their solutions.

Jamison, Philip, *Capturing Nature in Watercolor*. New York: Watson-Guptill, 1980. An exciting use of some conventional, some unique techniques for lovers of nature.

Kautzky, Ted, *Painting Trees and Landscapes in Watercolor*. New York: Van Nostrand-Reinhold, 1952. Simplified information on trees, their anatomy, and their use in landscapes.

Kautzky, Ted, *Ways with Watercolor*. New York: Van Nostrand-Reinhold, 1963. A fresh approach to nature, emphasizing drawing and value control for beginners.

Kinghan, Charles, R., *Ted Kautzky, Master of Pencil and Watercolor*. New York: Van Nostrand-Reinhold, 1959. A fine book on Kautzky the artist, his drawings, and watercolors.

Kingman, Dong, *Dong Kingman's Watercolors*. New York: Watson-Guptill, 1980. A fun approach to watercolor that is very rich in technique.

May, Rollo, *The Courage to Create*. New York: Norton, 1975. A force to trigger the reader's mind into understanding creativity.

Meyer, Susan E., *40 Watercolorists and How They Work*. New York: Watson-Guptill, 1976. Insights into the personal styles and methods of forty of America's best watercolorists.

Mongan, Agnes and Naef, Hans, *Ingres Centennial Exhibition*. Cambridge, MA: Fogg Art Museum. An extremely detailed book on one of the greatest draftsmen of all time.

Nechis, Barbara, *Watercolor: The Creative Experience*. Westport, CT: North Light, 1979. One of the most creative approaches to watercolor by a star watercolorist.

O'Hara, Eliot, *Making the Brush Behave*. New York: Minton, Balch, 1935. Great for watercolorists, but also emphasizes principles that are useful in any medium.

O'Hara, Eliot, *Making Watercolor Behave*. New York: Minon, Balch, 1932. An excellent beginner's book by a pioneer watercolorist.

O'Hara, Eliot, *Watercolor Fares Forth*. New York: Minton, Balch, 1938. Solutions of most of the traps that even intermediate painters fall into.

O'Hara, Eliot, *Watercolor with O'Hara*. New York: Putnam, 1966. One of the first and best books for beginners.

Orban, Desiderius, *What is Art All About?* New York: Van Nostrand-Reinhold, 1975. A great little book that stirs the mind.

Pike, John, *John Pike Paints Watercolors*. New York: Watson-Guptill, 1978. The beauty of transparent watercolor, demonstrated by a giant.

Pike, John, *Watercolor*. New York: Watson-Guptill, 1966. A strong book on varied subjects with exciting techniques, simply explained.

Schmalz, Carl, *Watercolor Lessons from Eliot O'Hara*. New York: Watson-Guptill, 1974. A review of the best watercolor techniques, as taught by a great painter and teacher.

Sweney, Frederic, *Painting the American Scene in Watercolor*. New York: Watson-Guptill, 1964. A good, solid watercolor book, well explained and well illustrated.

Szabo, Zoltan, *Creative Watercolor Techniques*. New York: Watson-Guptill, 1974. An idea book designed to show the versatile nature of watercolor and related media.

Szabo, Zoltan, *Landscape in Watercolor*. New York: Watson-Guptill, 1971. A structured book for beginners with many technical examples.

Szabo, Zoltan, *Zoltan Szabo, Artist at Work*. New York: Watson-Guptill, 1979. About the author's creative habits, philosophy, and his most favored techniques to date. Lots of substance about composition.

Szabo, Zoltan, *Zoltan Szabo Paints Landscapes — Advanced Techniques in Watercolor*. New York: Watson-Guptill, 1977. For advanced watercolorists, showing several solutions to each problem. Strong on color and reflections.

Tolstoy, Leo, *What is Art? And Essays on Art*. London: Oxford University Press, 1930. My artist's bible.

INDEX

Designed by Bob Fillie
Edited by Marisa Bulzone
Graphic Production by Hector Campbell